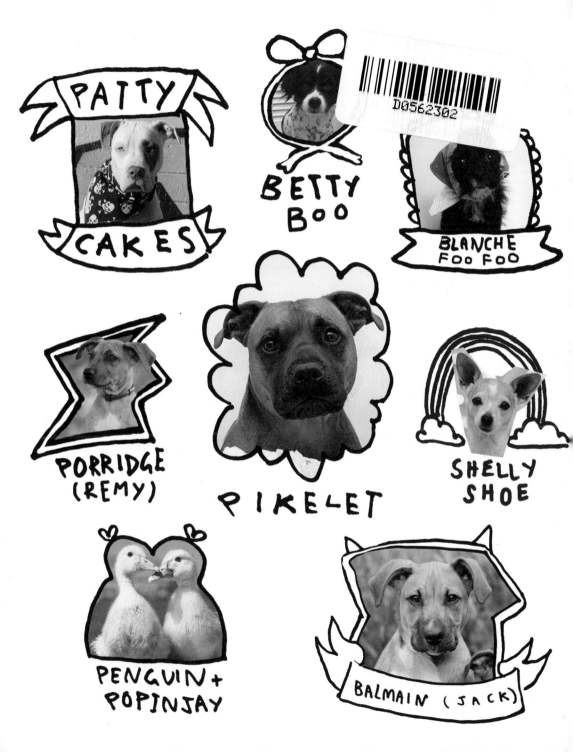

PATTY CAKES

BETTY BOO

BLANCHE FOO FOO

PORRIDGE (REMY)

PIKELET

SHELLY SHOE

PENGUIN + POPINJAY

BALMAIN (JACK)

THE
EXTRAORDINARY
LIFE
OF
PIKELET

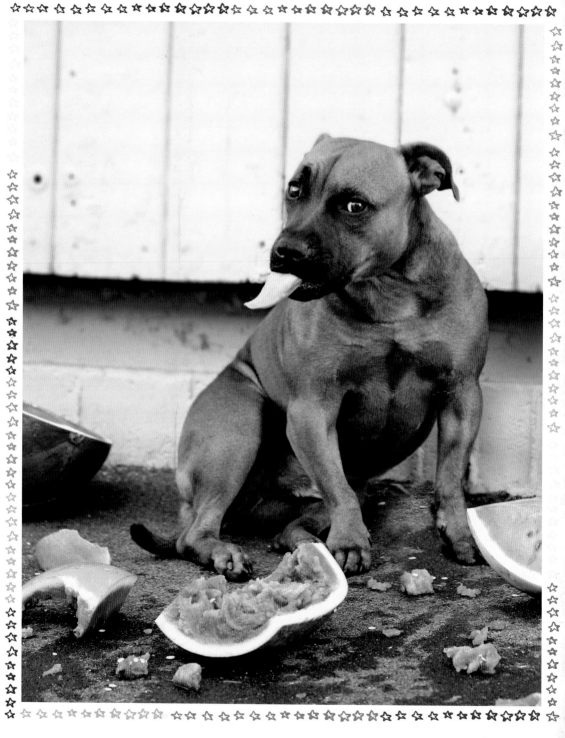

THE EXTRAORDINARY LIFE OF PIKELET

MEMOIRS OF A RESCUE PUP CALLED
PIKELET BUTTERWIGGLE STOLL
TYPED BY
CALLEY GIBSON
(PIKELET'S MA)

EBURY
PRESS

DEDICATED TO

THE MILLIONS OF FUR KIDS AROUND THE WORLD AWAITING THEIR FATE WHILE SITTING IN POUNDS, KENNELS AND SHELTERS, BEING CARED FOR IN FOSTER HOMES AND RESCUES, TRAPPED IN THE PUPPY FACTORY SYSTEM OR LIVING ON THE STREET.

YOU ALL DESERVE SO MUCH BETTER, AND MY HOPE IS THAT ONE DAY THERE WILL BE NO SUCH THING AS AN UNWANTED, KEPT-FOR-PROFIT OR STRAY PET.

FOR YOU, I'M TRYING TO INSPIRE CHANGE. FOR YOU, I'M TRYING TO PROVE TO THE WORLD JUST HOW SPECIAL WE ALL ARE, ONE FOSTER SIBLING AT A TIME.

SHELLY, YOU WILL ALWAYS BE IN MY HEART AND NEVER FORGOTTEN.

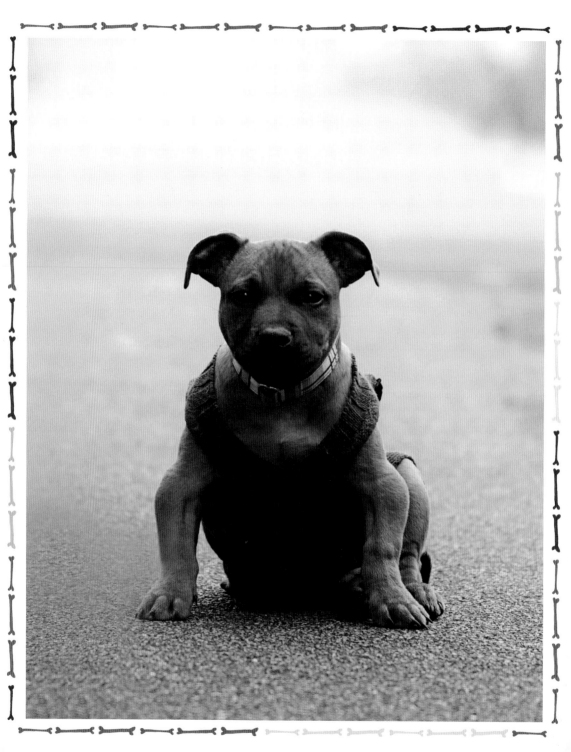

PROLOGUE

THIS IS DIFFERENT... TWO BIG HANDS REACHING DOWN AND GRASPING ONTO MY BELLY.

As my paws leave the ground, I look back at the spot on the road where I had just been sniffing a rather interesting bottle cap and nervously wonder what this stranger attached to the hands on my belly has in mind for me. I'm bundled up and placed into a car. It's warm in here, and the gentle motion of us driving to our mystery destination lulls me to sleep. It's been a while since I could close my eyes and rest. I like to think I'm a good judge of character and, as I take a big sigh and relax into the soft car seat, I feel trusting and a bit hungry (but I'm always hungry).

I awake to a whoosh of cold air as the car door opens. The voice belonging to those gentle hands whispers something about being 'safe now' as we walk towards a building with a large neon sign (I sound it out in my head and it says something like 'Vet Hospital').

'Okay, who do we have here?' an important-sounding voice says.

'Found this little guy wandering on his own in a back street. No one was around and no one seemed to know where he came from. Poor thing, he looks so young and he's been shivering since we picked him up.'

'Well, let's start by scanning for a microchip.' The important-sounding person waves some weird object back and forth over my head, back and body. Whatever it is they are doing, I'm not sure it's working.

'Nope, no chip. I'll call the shelter, they'll send an officer to come and collect him.'

This time I'm placed into a cage in the back of an old white van. It's warm like the car before but something feels different. The van has a lingering smell of many other dogs, the scent of their fear left behind in the very cage I'm sitting in. A rush of uncertainty hits me right in my gut. Where am I going now? Where are they taking me?

A chorus of barking, howling and crying pierces my ears as my cage and I are carried into a large complex. I peer out of the cage and lock eyes with each captive for fleeting moments as I am rushed past rows upon rows of concrete cages. The smells and sounds and energy of this new place are enough to make a pup feel very overwhelmed.

The cage door opens and I step out onto smooth, cold concrete. I'm in a larger cage now, and there is a bed and a water bowl. 'Here you go, little guy. You rest up and I'll go sort you out some dinner,' a kind voice says.

So this is my new home? Well, at least they say there is food on the way, but boy, I wish I was back in that warm car. It was softer and warmer and the world just seemed gentler then, even if it was only hours ago. But what's a pup to do? I've only got four paws and the fur on my back. I might be young and naive, but I'm going to have faith that something good will come of this. It has to, right?

Sitting here now on this big old plush brown couch where I spend a huge amount of my 'me' time, watching my favourite TV shows (*The Bachelor*, *Made in Chelsea* and re-runs of *The X-Files* to name a few), it's hard on the old heart to remember the details of my youth and the time I spent on death row at a Sydney dog pound. The good news is that this dog's life sure has changed. In fact you might say that so far I've lived quite the charmed life. And you know what? I'm no fool!

I know I'm one of the lucky ones. You won't read a single complaint from me. (Okay, maybe a few 'cause I have #firstworlddogproblems.) But I know I'm one very lucky pup. That day at the pound is really where the story of my life begins. Everything that came before that . . . well, I just can't remember.

How does an ordinary pound pup with pawfect cheekbones and extremely good looks like myself end up with such a charmed life, you wonder? Well, go grab yourself a cuppa, find a comfy spot on your couch and settle in. The story that I'm about to share with you is the very extraordinary life of me, Pikelet Butterwiggle Stoll.

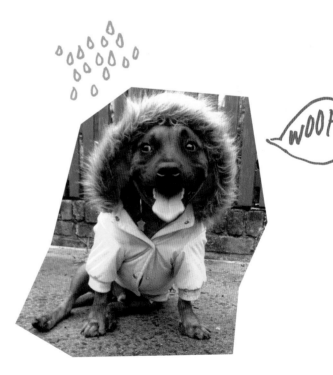

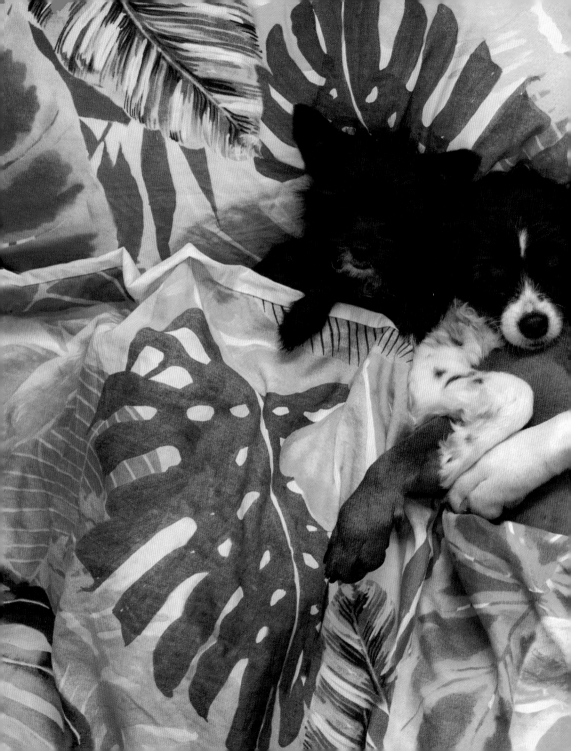

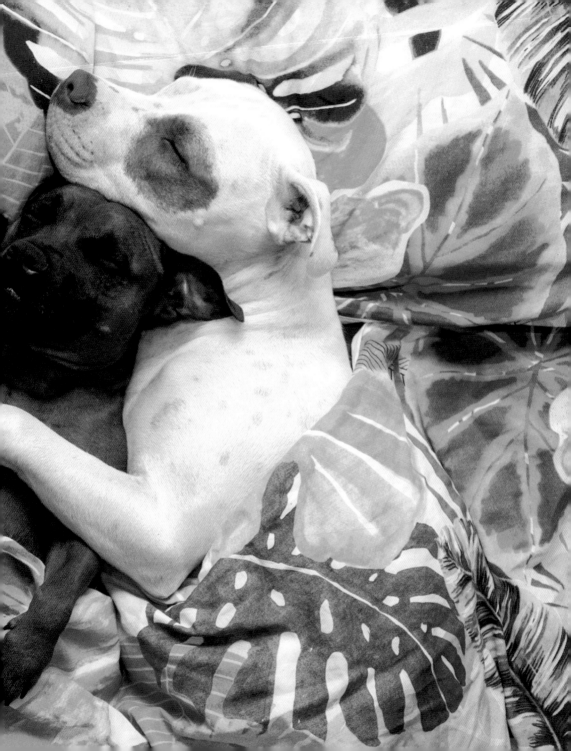

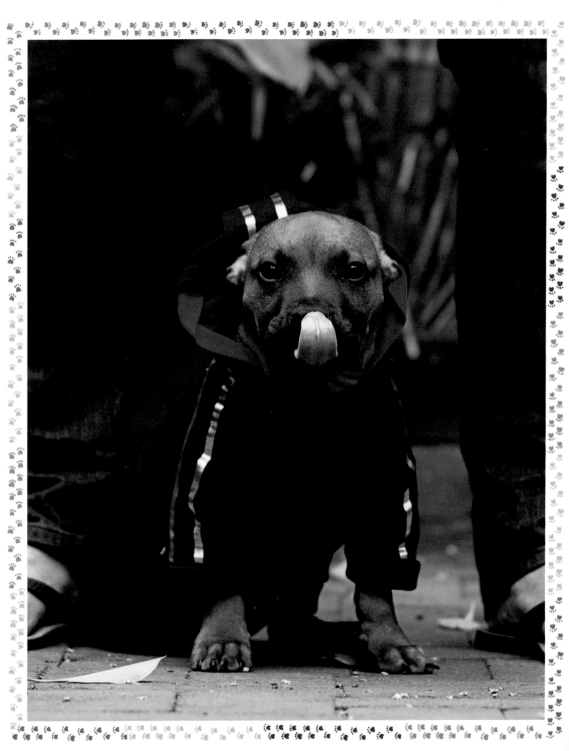

A DOG
WITH A
NAME

SO I GUESS
WE GO BACK TO THE START,
WHERE ALL GOOD PUP 'TAILS' BEGIN...

There I was, sitting in my council pound concrete cage. And for a little guy, it's big and spacious – the pound itself is jam packed with many others but here in this cage, it's lonely. There are no luxuries, just the bare necessities. You eat, poop, and sleep in the same space, day in, day out.

The sound of my neighbouring pups – some confused, some lonely, some sad – is loud and it never ends, not even at night-time. So many smells, but the one that sticks with me to this day is the smell of desperation. The humans that run the joint are nice and friendly enough, but they are rushed off their feet and don't have quite enough time to share around with each of us. I think I was a favourite or something, because each time a kennel attendant came by they made sure to give me some reassuring cuddles and pats, and sneak me extra treats. It might have had something to do with my age, which they guessed was around five to seven weeks old. But more than likely it's those good looks I mentioned earlier. No one can resist this level of cuteness – no one. To make me even cuter (as if it were possible), because it's starting to get cooler in Sydney as winter draws near, I'm dressed in a warm donated knit jumper.

7

Now apparently, as I was found as a stray, my time here is limited, but I'm afforded a bit more time than most. In Australia pups that find themselves in a council pound are given a certain amount of time they are allowed to stay. Those that are sacrificed or dumped at the pound by their owners have less time; they almost always become available for adoption immediately. This aspect is wonderful, as it can sometimes result in a forever home a lot sooner, but then on the other hand, it also means that the stopwatch measuring their time limit starts ticking. This is because it is unlikely their original owners will return for them, having knowingly relinquished their responsibilities and claims on the poor dumped pups. But if you are one of those pups that is found as a stray (like yours truly), then your time in the pound is extended just a tad longer. This extra time is given to strays just in case their owners do come looking for them, so they can happily return to their loving families. It also gives more time for new potential adopters or rescue groups to have the opportunity to step in.

Days went by and no one came looking for me. Lots of humans walked up and down the rows of concrete cages, pausing on occasion in front of mine before moving to the next. Every now and then one of my lucky neighbours would have their cage door opened and, with wagging tails and cries of relief and happiness, they'd get to leave with the humans.

There is no point in sugar-coating this next part because this is the harsh reality of life in a pound. You need to know this (though please skip the next little bit for any sensitive mini-humans) but don't worry,

I promise this story gets better after. Take a big slurp of that cuppa.

While some of my neighbouring fur friends would have their cage doors opened and leave with wagging tails and happy humans, it was a very different story for others. Time is a funny concept for pound pups. It can drag on and on, but for some

time will, more often than not, run out. Many poor souls would never experience the relief of being found or the joy of adoption, the feeling of being safe and loved once again or even for the first time. As cage doors opened we would all hold our breath with uncertainty. Some dogs would turn right, towards the doors of freedom. Sadly, some poor pups would turn left with a pound attendant, towards the big grey doors of no return. Last living moments lying on a cold metal table. A hard jab of a needle, the green liquid of forever sleep disappearing into a leg. Panting heavily, lungs filling with thick air and last breaths taken.

This is the reality of thousands of dogs every year. And one that I narrowly avoided.

Still with me? Good, from here on in it gets better, brighter and happier. Because, on one magical morning, I wasn't woken by the usual barking and howling (which I had now become so accustomed to after my first forty-eight hours at the pound). Instead I heard the sound of a cheery, almost giggly voice, possibly the sweetest sound I ever did hear. As I ran to the front of my cage I could see a warm, friendly looking lady standing at my door, smiling from ear to ear and pointing at me.

I don't remember her exact words but I do remember they were something like 'This one, add him to my save list, I'll send someone back to collect him on his due date next week.'

And really, it was as simple as that. A life saved from uncertainty. A life changed in a matter of moments. My life. To this day I'm pretty darn grateful and forever in debt to the kind lady, who I later learned goes by the name 'Mina'.

True to her word, on a crisp autumn Wednesday arvo (15 May 2013 to be exact), my own concrete-cage door was flung open and once again the warm hands of a kind stranger wrapped around my belly, and I was lifted into safety.

It wasn't a long drive, but again there was something about the warmth of this car that lulled me to sleep almost straight away. It's hard to explain to humans, but us dogs have a sense of many unseen

things. Just like our sense of smell is more perceptive and in tune with the world than yours, so too is our understanding of things that are and were and are yet to be. I'm not saying that I'm some kinda hokey fortune teller or anything, I could just sense that for the second time in my life this was a pivotal day and one I would remember fondly. This car ride was a ride to freedom, and I could tell that the lady driving was filled with hope and excitement and a sense of accomplishment.

This time when I stepped out of my travel crate, my paws felt the almost forgotten feeling of soft grass and good old-fashioned earthy, dirty, dirt. Oh lordy! I can't tell you how good something as simple as grass felt on the pads of my paws. Dirt never looked so good! The space before me was vast and I took the opportunity to stretch my legs, wiggle my butt and bounce the sillies out. I sped around the exercise yard, leaving my pee on every fencepost I could find. There were many friendly human faces gathered all around with their eyes fixed on me. I worked the yard like a politician on the campaign trial, pinballing from person to person. I made sure each and every human gave me pats and belly scratches, and when they paused for a moment because of a distraction, or to snap some photos or discuss other matters, I'd paw at their legs to get them back to focusing on the task at hand, me!

Now, any pup arriving at this new place they called 'Big Dog Rescue' would feel like they had won the lottery, so what happened next was like winning Oz Lotto on a Tuesday night *and* winning Powerball on the following Thursday.

RING
RING
RING

Mina was talking into a little black box-shaped chew toy (something I later learned was called a mobile phone/very hard chew toy) and I overheard the following: 'Heya, that pup has arrived and he is just adorable – so tiny and cute! But there is a problem. [Pause] You know how he was wearing a jumper last week when I sent you that photo? Well, when we picked him up today and they took it off I saw his legs properly for the first time. Now I know why this little guy must have ended up out on his own. His legs are . . . very deformed – they are bent

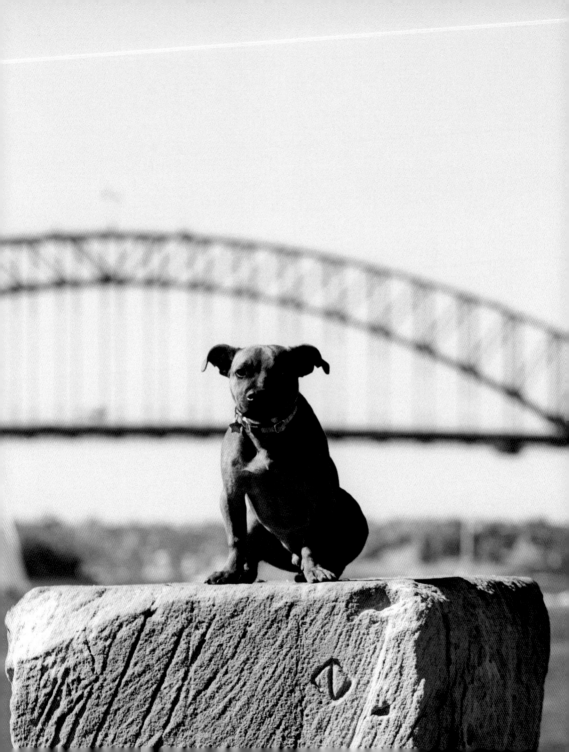

and bowed and his back has a large curve in it. I've got to warn you, he might be harder to rehome. Is this going to be a problem? Do you still want to foster him? [Dramatic pause]'

I can't tell you what the mobile phone/chew toy thingy told Mina in response, but whatever it said, Mina's reply was a sigh of relief and words to the effect of 'Oh good, we'll see you at eight o'clock then.'

For the next chunk of time on my day of freedom I was showered with attention, had my belly filled with a feast of yummy food and enjoyed the wide-open grass space. The sky eventually darkened to night and Mina and her pack of humans built a huge warm bonfire. It was getting late but it felt like we were all waiting for something.

Two bright lights moved steadily towards our bonfire. An engine stopped and I could hear car doors slamming. In the darkness of the night I watched as two new humans approached out of the shadows, walking towards our night-time autumn lawn party.

Yet again, a sweet, excited voice caught my attention. 'Is he here? Where is he?'

Mina spoke up. 'He's here. Well, he's here somewhere. He has been nonstop since we picked him up. Such a fast little pup, and very happy and confident. I reckon he's going to be a real character.'

And then a squeal rang out. 'Oh. My. Gosh. Is that him?'

'That little tiny thing scurrying around is a staffy puppy?'

'He has got to be mixed with some sort of tiny Chihuahua type breed, right? He is just so tiny! *Eeeeeeep!*'

Lifted up and cradled into the arms of my future.

This was another one of those all-important moments to remember. These two new humans were going to be taking me with them and were apparently to be my 'foster parents'.

At this stage I had no clue exactly what 'foster' meant (obvs that all changed very soon), but the word I focused on in this moment was

'parents'. I was going to have parents, or 'rents' as I would come to refer to them. Little scrappy old me was going to have a family, a real family. Oh, and there was something else I was going to have from this day on. I was going to have a name.

'"Pike", his name is. Short for "Pikelet",' my new (foster) mum exclaimed. So a dog has a name, I thought, and I'm that dog. My new foster dad pulled from his pocket a brightly coloured, fancy-looking collar. The sparkling star-shaped medallion caught in the light of the bonfire and the word 'Pike' shone bright. With a click of the clip the collar was placed gently but unceremoniously around my neck and, after a few more words exchanged between Mina and my new foster rents, it was time to go.

My foster rents (foster Ma and Pa as I also called them) bundled me up and carried me off into the night, and without looking back I started my new life as 'Pikelet'. But you can call me 'Pike' or 'Pikey' for short, most people do.

BARK

15

THE SPINSTER SISTERS AND ME

IT TOOK ME ALL OF FIVE MINUTES TO GET MY BEARINGS, LEARN THE INS AND OUTS OF MY NEW LIFE, AND WORK OUT HOW BEST TO GET MY FOSTER PARENTS TO ATTEND TO MY EVERY DESIRE.

This was no concrete cage. This was certainly no cold road leading to nowhere. I was washed in a warm sink filled with perfumed bubble bath upon my arrival at my new home, fed bowl after bowl of the most delicious food I had ever tasted, dressed in some snuggly PJs and placed (at a safe distance) in front of a roaring gas heater. Best of all, I could do as I pleased, lie where I wanted, sniff and walk and roll and sleep at my own leisure. I could get used to this!

My first week of Pikelet-living was all about bonding and making good with my new siblings (oh, and posing for many, many photos – more on that later, though). I'd had no idea that it wasn't just foster parents I was getting with my new life, it was a whole family. Two older sisters (like, *grandma* old) and another bouncy pup foster brother. I should probably start by telling you about my new bro, who my foster parents were calling 'Balmain'.

Balmain was beyond excited when I arrived. When my foster rents opened the front door and I walked inside that first night I didn't have so much as one moment to gather my thoughts before I was body-slammed by this new brother of mine. His tongue was on my face, in my mouth, in my ears, and I'm pretty sure he may have even wizzed on me a bit (clearly not aware that this is not how we greeted each other in the outside world).

17

Once this very welcoming new brother of mine calmed down and let me come up for some air he got to some in-depth explaining. Apparently Balmain was a little older than me (something he liked to and still does to this day regularly point out), but maybe only by a few weeks at most. Balmain also came to be here via sweet Mina over at Big Dog Rescue, though he had no idea about what a pound or concrete cage was. He had been born into very different circumstances, living with Mina and her pack. His dog mamma was rescued with a belly already full of babies and they all lived with Mina until the pups were old enough, and then Balmain was the very last one left of his litter that needed to find a family. That's when our foster parents got involved and took Balmain in. He told me he had already been here for a few weeks. He gave me a long list of tips and tricks he had learned, and also his study notes from puppy school, which he told me he had just graduated from with a report card full of As.

Balmain also told me that our foster rents had been working with Mina to find him that coveted 'forever home' we had both heard about out on the street.

It just so happens that in a little over a week Balmain would have his two future forever parents arrive at our front door to take him off into the sunset and start living his new life, where he would come to be known as 'Jack'.

A week of brotherly love and bonding in foster care was truly such a great start. It was the start that I needed, and that every pup deserves but some don't get. Now I had my second chance, returned by good fortune. I got to reconnect with my inner (and outer) 'puppy'. Balmain and I made the most of our time as brothers. We slept, ate and played nonstop together. We were kind enough to lend our youthful taste-testing abilities and keen sense of quality control on all the belongings in our foster parents' household. We left no unknown untested. Providing this safety for

our foster parents was the least we could do. Balmain took no notice of my strange-looking legs or the 'different' ways I had of moving around. He loved me for me. In one week our connection was so strong that we knew, if given the chance to stay in touch, we would be bros for life.

After Balmain went off on his adoption adventure and moved in with his forever folks to become Jack, my foster parents enrolled me straight into school and got to work, focusing all their efforts on 'Pikelet training' and growing me up to be a perfect puppy ready for my future family.

On the marvellous diet of good food, puppy milk and daily sun-bathing in the patches of autumn and winter sun, my legs started to really improve. My curved back did too. Everything that was curved or bent the wrong way started to lengthen a little and grow strong.

Through daily walks and park visits I met many local pups and made *billions* of new friends, all living in the same neighbourhood – a hood which, I will admit, was quite fancy; the lifestyle of my local friends was truly some kind of puppy paradise and almost all the humans had themselves a canine fur kid. Most local pups were much bigger and older than me, all different shapes and sizes, some with fancy hair-styles, designer collars and tongue-twister breed names. Many of these new friends just had no idea of the hard life former street pups like me had lived. It was as though they had been in a bubble of happiness and privilege their whole lives, not really aware that some of us had a whole other kind of experience, one that built character and learned us our street smarts. But, you know what? That's okay. I took every opportunity (with my foster rents in tow) to educate those around me. I started to become a little more self-aware and found that using my ridiculously good looks, charming smile and winning personality was a way to change the stigma of the label 'rescue dog'. I decided that being a 'rescue dog' was going to become something to be proud of. Something cool and trendy. Something that gave you mega bragging rights.

Now, before we get even further into the thick of things, let me get back to those two older sisters of mine that I mentioned before. Shelly

Shoe and Betty Boo, two rescue mutts themselves. My older, never been married, Spinster Sisters. The permanent and resident pup-matriarchs of the family.

Well, that's not quite correct – everyone knows you can only have one matriarch so I guess that would have to be Shelly Shoe, being the oldest and all. She was getting on to the approximate age of thirteen or fourteen years old (she won't let me see her driver's licence to fact-check this so you're just going to have to trust my guesstimate). Shelly was many, many, many years ago a private surrender or 'gift' directly to my foster Ma. Born from a show-bred miniature fox terrier mother, Shelly and her littermates were originally to be sold off and flown around the world to their new human families. In an unfortunate (or fortunate if you look at the end picture) turn of events, back when she was a tiny puppy, poor Shelly was in a car accident. Her shoulder was broken and she needed a metal pin placed in her collarbone, as well as some pretty serious patching up. Shelly's breeder had asked my foster Ma if she'd help out with caring for Shelly during her recovery. Weeks, possibly a month or two later, after Ma had been looking after Shelly on more and more days a week, the breeder finally decided that Shelly was no longer top show-quality and, instead of flying her over to Hawaii as was first planned, she said my foster Ma could just keep her. The exact words were 'She's a giveaway dog now.' I bet Shelly doesn't mind that she was referred to as damaged goods and a giveaway, though – it got her the life she has today.

I'll guess you're a little confused looking at photos of Shel, right? Shelly was bred to be a miniature foxy show dog but looks to be a Chihuahua to the keen eye. My foster parents thought that too. 'She has a Chihuahua head,' they'd often say. And back in the day breeders of many small dogs definitely used other smaller breeds to get the size into miniature form. So for sure Shelly has a great-great-great-Grandma or Grandpa that was a Chihuahua, quite possibly an unspoken family secret until now. (Everyone has skeletons in their closets!)

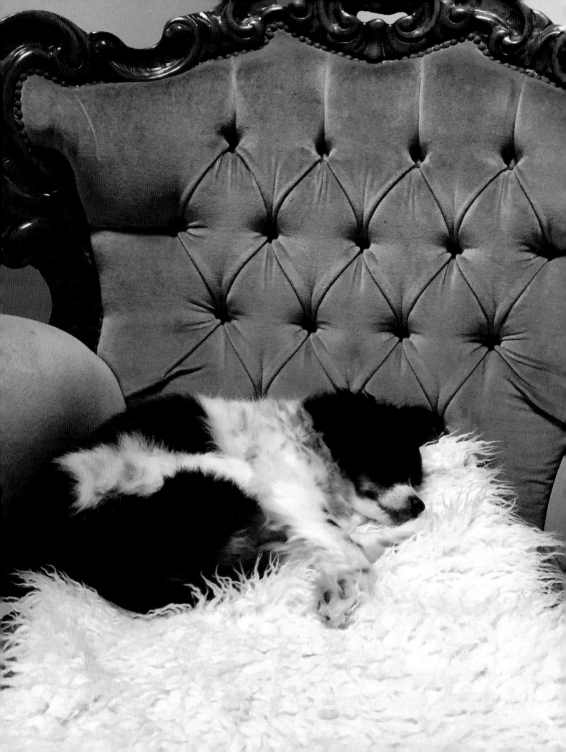

Betty Boo, my other foster Spinster Sis, has a different rescue story again. Betty was adopted by one of my foster Ma's family members at around the age of one. She was at a pound or shelter much like the one I was, and apparently caught the eye of the right person at the right time and was adopted on the spot. (I'm told she was quite the adorable puppy.) Betty and I share a similar background in more ways than one. No one really knows the full details of our previous lives other than that we were both found or dumped at the pound. What my foster parents and their human family members did deduce from Betty's behaviour is that she must have suffered some physical abuse at some stage in her past. She was always flinching and very nervy about sudden hand movements, and she has a quirky phobia of paper (even a tiny Post-it note sized piece of paper is enough to make Betty run from the room). The genetic make-up of Betty Boo is anyone's guess. It's thought with some educated guessing that she is most probably a spaniel mix of some sort. My foster rents do often remark that she could also be a hybrid of dog and cat, as she is quite lazy and has an 'on my terms' kind of attitude and way of life.

Betty also, like Shelly and myself, has leg issues, or rather a 'leg' issue. About a year after Betty was adopted by her original owner, my foster Ma's family member, Betty 'Houdini-ed' herself out of the back-yard and went for an Olympic sprint across a very busy highway one Sunday morning. Running into oncoming traffic (who knows what she was thinking?), Betty was hit and run over by a taxi, and left there for dead. Spotting her lying in the middle of the lane on a busy highway, one lovely couple of humans pulled over to help. Miss Boo happened not to have her collar on that morning, so the lovely couple did not know who she belonged to, so they spent their Sunday driving all around Sydney looking for a vet hospital that was open and could help with this little broken dog. Poor Betty was not in good shape at all but was incredibly fortunate to have found herself at a lifesaving hospital. Meanwhile, after frantic searches and a day of phone calls to what felt like every

vet in New South Wales, my foster Ma's family finally located their missing Betty. Two weeks of intensive care later the doctor broke the news that Betty had sustained such serious injuries that her left front leg was beyond repair, and as a result she was not showing any signs of recovering from the impact of the accident – her life was fading. There were only two options available. One was to let her go peacefully into her forever sleep, and the other was to remove her leg and hope for the best, hope for a second second chance.

Of course, you know the outcome to Betty's story already as she is here by my side today. Her left front leg was removed and, in an overnight success, Betty's health improved a hundred times over. Two days after her leg removal, the new tripaw Betty Boo was hopping about with a new lease on life. Thirteen or so years later, the old girl is still going strong. She has not a single sign of arthritis or issues with her mobility. Some might even say that Betty was born to be a #tripaw. I can confirm that she does put on a special three-legged hobble performance for any sucker with a soft heart and a bag full of treats.

A couple of years after Betty's big accident it was decided that she would come to live with my foster rents full time, still in the family but better suited to a lifestyle of inner city luxury living and away from busy highways! The pairing of Betty Boo and Shelly Shoe just seemed like a good fit and in their retirement days together the Spinsters play a very important role in the dynamics of my foster parents' home (as they also like to remind us all regularly). Together they watch over all the happenings and goings-on in the house when my foster parents are out at work. They certainly have the ear of my foster rents, and never seem to get any of the blame for the unfortunate chewed or missing items that mysteriously appear or disappear. I wouldn't be at all surprised if they have the rents on speed dial either.

So that's the very brief backstory of my (foster) Spinster Sisters and how they came to be where they are today. Needless to say that once it was just me and the old girls at home alone for most of the day after my bro Balmain (aka Jack) had moved on, we became pretty close. Both Shelly and Betty really seemed to take a shining to me. They stuck by my side on our park adventures and curling up together at night in front of the heater was always a welcome ritual. I reckon they quite liked having a runty little foster brother (with incredibly good looks). Who wouldn't?

DEPENDENCE
DAY

AS YOU CAN IMAGINE,
LIVING THE LIFE OF A FOSTER PUPPY
HAD REALLY GROWN ON ME.
I MEAN, WHAT'S NOT TO LOVE?

In just seven short weeks my life had drastically changed from being all on my own wandering the streets, scavenging for my next meal, to here – safe, warm, fed and happy. My foster rents, without a doubt, adored me. My foster Ma took me everywhere with her, and on the rare occasion when I couldn't go to work with her the Spinsters and I would have the run of the house and equal share of the TV remote.

I did, however, finally learn what the word 'foster' meant. It's not a bad word at all but basically the crux of it is if you take out the word 'foster' and insert 'temporary', that pretty much explains things. My foster rents were looking after me temporarily until they could find me a wonderful forever home of my own. Apparently this is exactly what foster care is about – the safe place or bridge, if you will, between past and future.

To add into the mix, the doctor Ma and Pa had taken me to see had diagnosed the condition he thought had caused my legs and spine to bow and grow bent. This condition is called 'rickets', and it generally occurs when a baby doesn't get enough nutrition from its mum in the early days, has a deficiency in calcium or lacks the vitamins you need in order to grow up healthy and strong. I was already on the path to

overcoming my rickets with the premium diet and puppy milk I had been eating, and all the time I had spent bathing myself in the sun's rays of vitamin D goodness. But the doc thought it best that, as an added precaution, my foster rents hold off on my big-boy operation, just to let my hormones kick in a little bit more and help me develop. I could not be rehomed into a forever home until my boy berries had been removed, so it was decided that an extra three months in foster care would be the best plan moving forward.

The hunt for the perfect forever home got underway nevertheless, with my foster parents starting to put out feelers and interview some very eager potential adopters. I had a couple of interviews with some really lovely families. But like a uni student fresh in the workplace, interviews were not my thing. I just froze up, shaking and panting with nerves. Meeting new people, and their mini-humans and fur kids, was not one of my strong points. I really can't explain what got into me during these interviews, but looking back now I do suspect that there was a part of me kinda setting myself up to fail.

Around the four-week mark in my stint in foster care I overheard my foster Ma pleading (in a whisper so I wouldn't hear) with my foster Pa. My foster Ma commented on how well-behaved I was and what a great fit I was turning out to be with my foster Spinster Sisters. My foster Pa instantly reminded her of the agreement they had obviously made prior to signing up as foster parents. 'No! You promised that you would never ask to adopt one of our fosters, so don't put that on me now. Two dogs is more than enough.'

'But Pikelet is different! You know he is. When will we ever find another pup that is so calm and sweet and gentle? The girls love him and he isn't the least bit naughty . . . *Pleeeeeeeeeeease*?'

This wasn't just a one-off thing, either. It started as a passing comment one Saturday while I was doing my homework for puppy school, and was repeated regularly until it became almost a running joke that each morning, as my foster Ma would climb out of bed, she'd

turn to foster Pa and say 'Can we keeeeep him? Can we adopt him?' Foster Pa wouldn't budge or waver (though I could tell that she was wearing him down a little). Then one fateful morning 'it' went missing.

What was 'it', you ask? Well, 'it' was my foster Ma's sparkly emerald-cut diamond engagement ring. The fanciest thing she ever owned (according to her).

At the start of each week, foster Ma would remove her special diamond ring and place it safely on her bedside table. There it would stay until the week's end. Foster Ma's job at the time was owning and running a very popular local dog-walking business – not the kind of job where a glamorous diamond ring should be worn.

Never even thinking twice about said ring during the week, it wasn't until a Friday morning that Ma rushed out of her bedroom in a fuss, turning the house upside down and tearing it inside out as she went.

I watched her get more and more flustered as she pulled apart the bedroom. She was on the floor one minute, looking in the gaps between the floorboards, and then pulling the sheets off the bed the next. As I followed her round like the stealth shadow of the night that I am, I could see her face fill with hot tears as the panic of losing her fancy diamond ring sank in. Finally, after running up and down the stairs between the two levels of the house numerous times, she looked up, turned, and then looked straight down at me. Some sort of realisation came across her flooded eyes and blotchy face. With those eyes digging into my soul she moved slowly and picked up her iPhone.

'Foster Pa,' she said. 'My engagement ring has gone missing. [Dramatic pause] I have just spent the past three hours looking all over the house and nothing... Please don't be mad but I think – I think maybe Pikelet ate it... I'm going to take him up to the vet now and see if they'll X-ray him for me.' And with that I was ushered down the stairs, through the living room, out the front door and into the car.

After we had arrived at the vet hospital to some cheery vet nurses, who found the whole thing rather funny, the doctor pulled my foster Ma into the scan room and pointed up at the X-ray. 'Nothing! No ring, nothing!' he said. Laughing a little, the doctor teased my foster Ma, saying that she certainly couldn't blame the missing ring on me. He suggested that I probably couldn't have eaten and pooped it out, anyway, as a ring would be far too big for my tiny puppy bottom. My foster Ma snapped right back at him, 'I disagree, the first poo he did after arriving at our house from the pound I found a full-sized bottle cap completely intact lodged right in the thick of it. I just *know* Pikelet had something to do with my missing ring.'

Welp, the next few days were not so fun for the foster rents. When foster Pa got home that Friday night he and foster Ma devised a plan to pull apart the entire house. They also agreed that all the bins and the back courtyard needed to be checked for old poop of mine just in case I had actually eaten and pooped out the ring already. No joke, gas masks were involved. Rubber gloves and gagging foster parents were enough to keep me and the Spinsters well out of sight.

My dear foster Ma still had the balls to wake up on the Saturday after missing-ring Friday and ask the same question she had every single day for the past few weeks. 'Can we adopt him?' she said sheepishly, not even looking at my foster Pa.

'You know what?' foster Pa exclaimed. 'Yes, we can keep him, if, *and* only *if*, you find that bloody ring!'

I believe it was after five days straight of searching every inch of the house that my foster rents finally gave up all hope of finding the ring.

It had been a rainy, grey week and everyone was feeling mopey and down. I was lying in bed feeling sorry for myself when foster Ma answered her phone early on Thursday morning.

30

'Hi Mina. No, still no luck. It's gone. I just have to face it that I'm not supposed to own nice things.' Still on the phone: 'Oh, okay, by this afternoon? Well, if we have to then we have to. No, he won't budge. Only if we found the ring, then we could adopt. Yes, I'll go through the rest of the applications today and make the calls. I'll let you know who we pick.' Foster Ma put down her phone and pulled the bedcovers back up over her head.

Not even minutes had gone by when my ears pricked up and I heard the soft thud of foster Pa's feet rushing up the stairs. The bedroom door swung open and he walked in.

Ma let out a groan and asked in a raspy voice, 'What is it? I'm trying to get back to sleep.'

'*Look!*' exclaimed foster Pa. Ma peeled back the covers and looked at Pa's outstretched hand. In it was a dog poo bag, and inside the poo bag was a dried-up mush of what looked like bits of bark, rocks, a hair elastic and possibly a chocolate wrapper.

Ma looked back up at foster Pa and said, 'So? What exactly am I supposed to be looking at?'

'Look again,' said foster Pa. Squinting now and sitting up with a bit more zeal, foster Ma looked again.

'*You found it?!* My ring! Is it all there? I mean, is the diamond intact and everything?'

Rushing back down the stairs to the kitchen with foster Ma following close behind, foster Pa replied, 'Only one way to find out.' Boiling up some water and brushing off the silver ring-shaped glint in the middle of the squashed, poo-shaped, found-objects mush, foster Pa dropped the glob into the boiled water and they watched as debris dissolved from around foster Ma's perfectly intact ring.

Looking completely elated, Ma turned to me and bent down to my face level. Cupping my cheeks in her tender hands, foster Ma said, 'You know what this means, Pikelet? Today is the day you become ours. Today I'm going to adopt you!'

And so, on the fourth of July, a rainy Thursday morning in 2013 – the day my foster Ma's diamond engagement ring was found after a week of being missing, in an old piece of my poop that had been washed by the rain from the backyard into the line of sight of my foster Pa – the very morning Mina from my rescue had called and given foster Ma the hard word that today she would need to find my forever home – this day – this day would be my adoption day. The fourth of July 2013 is and will always be my 'dependence day'.

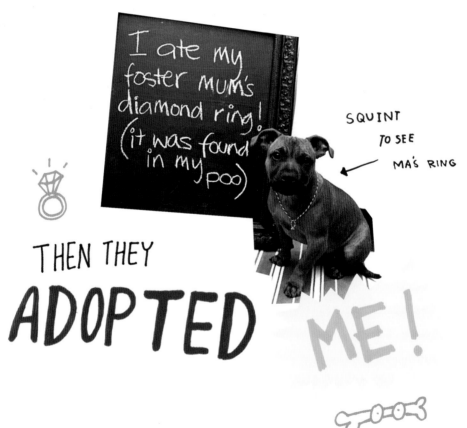

SQUINT TO SEE MA'S RING

THEN THEY ADOPTED ME!

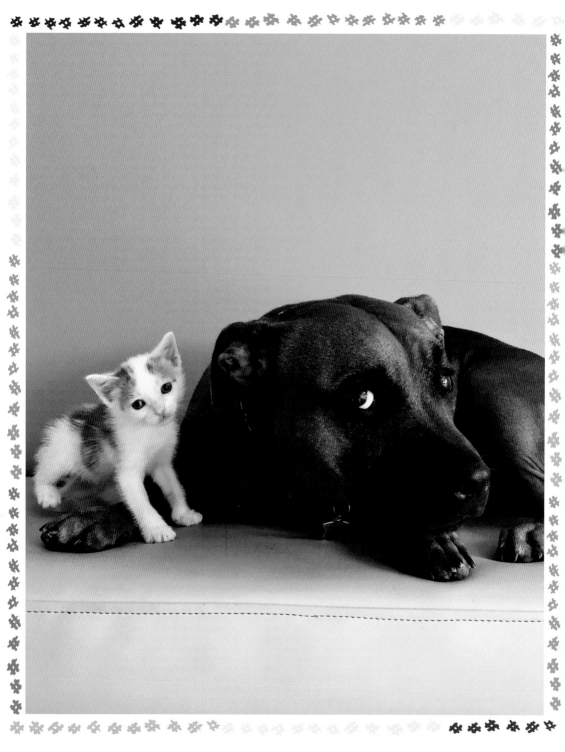

HASHTAGS
AND SELFIES

WHEN YOU GET YOURSELF ADOPTED BY A PROFESSIONAL
PET PHOTOGRAPHER MA AND ADVERTISING
ART DIRECTOR PA, WHAT'S THE VERY FIRST
THING AN INCREDIBLY GOOD-LOOKING YOUNG
RESCUE PUP SHOULD DO?

Why, open Facebook, Instagram and Twitter accounts of course!

Okay, so maybe this wasn't the very first thing I did once I got myself 'dopted. It actually took a little over a week before my now–forever rents helped me join Facebook. Maybe a whole year after that before I even looked at Instagram. Twitter is still quite a new thing for me today. Social media probably isn't the first thing every proud new rescue dog owner thinks about sorting out when they adopt a pup. But my new forever rents are just a little different like that. Ma certainly agreed with me that I was blessed with the looks of a young Brad Pitt in dog form, and definitely agreed that this kind of beauty needed to be shared with the world. And I guess Ma also felt there was something lacking out there in the Australian social media community. There was little to no popular representation of your common ex-pound puppy or adopted rescue mutt.

You'd be hard-pressed to this day to find another Australian rescue dog making it big on the social media scene. For some reason us Aussies are a little bit behind the times when it comes to celebrating the 'cool factor' and 'trendiness' that comes from owning and supporting rescue mutts. Head over to the US of A and it's a different story!

You're not a 'somebody' unless you have an incredible rescue story of triumph in the face of despair to share with the world. To be honest I just love that mentality – celebrating the 'underdog' is how it should be, should it not? Don't get me wrong, there are many, many cute fur kids in Australia making a splash on Facey, Snapchat, Insta, Twitter and all the other social apps out there. But most, if not all, of the other popular Aussie fur-celebs are your 'in vogue' type breeds, usually purebreds or designer mutt combos like pugs, jugs, –oodles, dachshunds, bulldogs or Frenchies. Even my own major breed (English Staffordshire Terrier) has a few famous fur faces representing it big on the social scene in Oz.

Of course, there is tons of room out there for all of us to trot the red carpet and snap up our fifteen minutes of internet fame. This isn't really the heart of why my lovely new forever rents got me on Facebook. Ma and Pa had the seed of an idea. Rescue advocacy brought to you in the form of a daily dose of cute photos, mixed in with some real and important content, information and issues delivered to your smartphone (or computer during your sneaky peeks while at work), all from the viewpoint of little old me.

You might be wondering right about now why we're having so much tech talk. All this social media stuff is pretty important in the highlight reel of my life thus far. Honestly, I wouldn't be here today, writing my own memoirs, having you (my new best friend) read all about it, if it wasn't for my interest in keeping up with the hipster happenings of the world wide interwebs. It's what makes the life of Pikelet the Life of Pikelet!

Anywho, now that I was a fully-fledged forever member of my sweet little family and, as I mentioned, it would be a whole week before I made my debut on Facebook, truly the next thing my forever rents did (after confirming with Mina from Big Dog Rescue, signing my adoption papers and celebrating the best day of their human lives) was finally christen me with a full name. My surname, 'Stoll', was the same as my Pa's, as tradition would have it, and my middle name could be

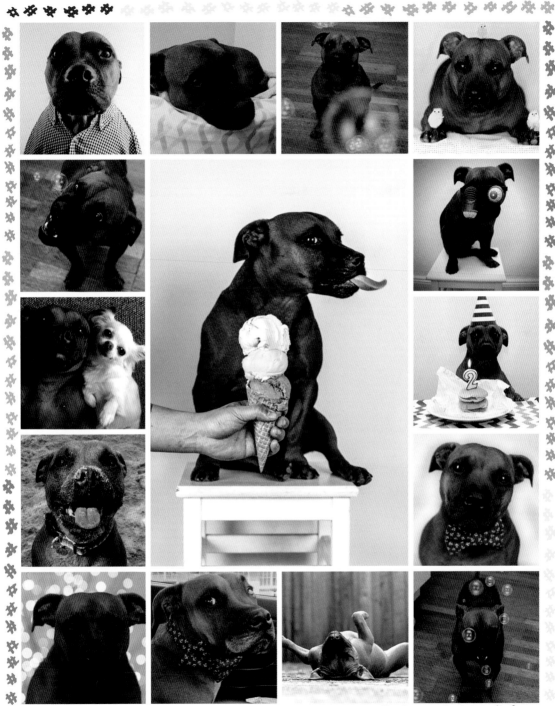

nothing other than 'Butterwiggle'. Why? Well, how else could one possibly describe in one word both my tender, butt-wiggling ways and the 'butter wouldn't melt in my mouth' sweet, sweet demeanour I have? Everyone knows that a middle name is make-or-break in the big city, and I had plans to make this town mine.

So yet again a dog had a name. This time it was Pikelet Butterwiggle Stoll. A dog also now had a forever family. And a dog had a mission.

The first few months of my forever life were the cherished childhood all pups dream of. Ball games with Pa in the park before and after work, cafe and weekend lunch dates with my many human aunties, uncles, cousins, friends and neighbours, bonding time with my retired Spinster Sisters, tag-along play dates with Ma's daytime work fur babies, pub crawls, beach days, froyo dates, swimming lessons and all the other usual activities of a carefree adolescent – most of which were opportunely captured in photographic memories shared with my modest but growing online pack of rescue-loving Facebook friends.

Before I knew it, I had what some would call a small 'cult following' of loyal fans watching all my daily antics and early days of blurry selfies. My hashtags were basic, but for some reason I couldn't quite put my paw on, people really started to take notice of what I had to say. I didn't put too much thought into it, really; expressing myself on Facey just organically became part of my daily routine. Kind of like a virtual journal, but with Ma occasionally taking over to feature other rescue pups and news.

By Christmas time me and my fam had moved house and were settling into our new place, just a few streets further up the hill in the same lovely inner-city neighbourhood. Now, with a little more space, a change of scenery and a well-adjusted teenager pup-son, Ma started to get the itch to foster again, though she was biding her time in approaching Pa with this idea, as for some reason they had agreed upon a 'three-foster-dogs-a-year' plan, and I had been number three that year.

Throughout the year we'd had many regular catch-ups with my former foster bro Jack (aka puppy Balmain) and Ma and Pa's first official foster, Nox, who had predated both Jack and me. Besides sharing all my fun times and everyday moments on my Facebook page, Ma, Pa and I made the effort to regularly feature and highlight many other pound pups who needed a forever home of their own, hoping to spread the word and get some much-needed eyes on these kids. Still, though, Ma felt we could be doing more.

It was about this time, right before Christmas, as though the gentle summer breeze in Sydney had heard Ma's inner thoughts, whispered out loud in the sunny daylight-savings evenings only to a dog named Pikelet . . . right at this time, fate would have her phone ring with a request to foster that she couldn't say no to.

RiiiNG
RiiNG

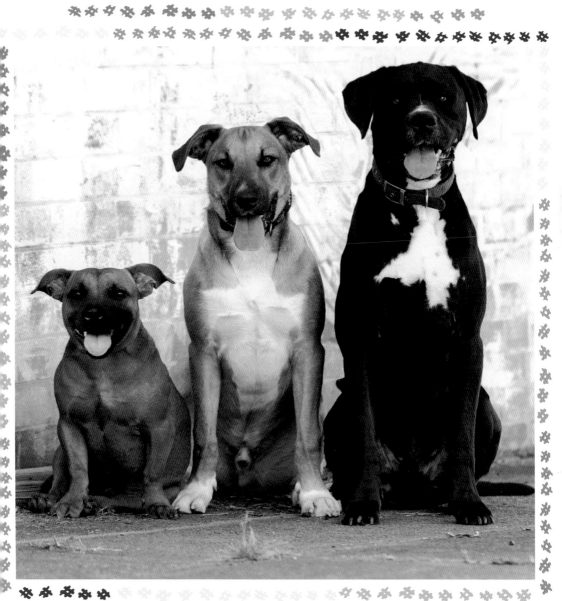

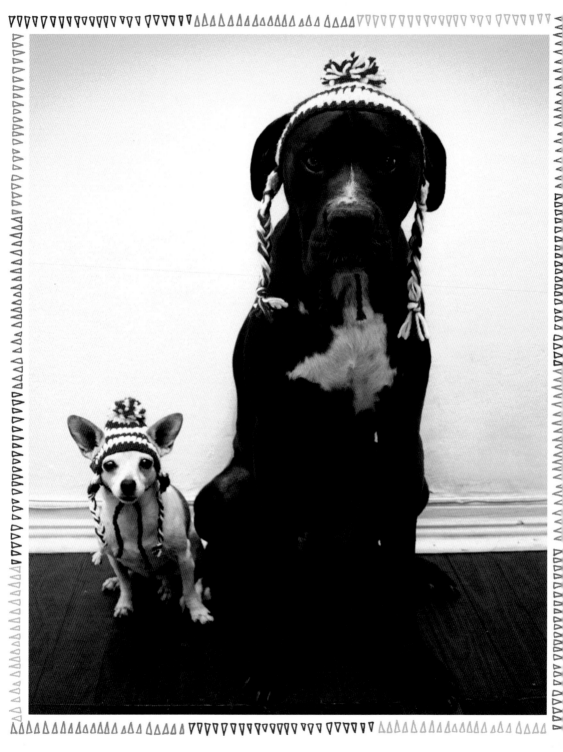

SECOND TIME AROUND

'RETURNS' IN THE RESCUE COMMUNITY IS NOT SOMETHING THAT ANYONE GETS VERY EXCITED ABOUT.

Unfortunately when Ma's phone rang it was for a reason that all foster parents hope never to hear. My rents' first foster pup-kid, Nox, had no option but to return back into foster care. Being the very first foster that my parents took in meant that Nox was a complete learning experience for them. Normally, once foster parents are experienced with the ins and outs of adoption and rehoming, they will have a lot to do with the interviewing, vetting and decision about the family for their foster kids. Because they were still learning the ropes with Noxy, the rents really took the lead from the rescue organisation in his adoption process and placement. This is not to say that the rescue placed Nox in a bad or unsuitable home; just that my rents didn't really get to be as involved as they later would be.

Nox's sweet adoptive family had stayed in touch with my rents and he and I had already become close unofficial foster brothers by association. However, sometimes life throws a spanner in the works, and his adoptive family now found themselves in a predicament that meant being unable to take Nox overseas with them on an imperative family relocation. After unsuccessfully exhausting all avenues trying to find a solution of keeping Nox with some of their local Aussie family members, they made the heartbreaking decision to return Nox back

to my parents, where they knew he would have the best opportunity to find an amazing forever home.

Come January 2014 it was finally the day of Nox's arrival back home with my rents to what was now known as 'Le Chateau Pikelet' (according to me).

Ever heard the saying 'peas in a pod'? Well, if ever there were two happier peas in a pod then I'd like to see it. I always knew Nox and I were a match made in heaven. Finally I got to have him to myself 24/7, and that Facebook profile of mine could really stretch its muscles and get some serious rescue advocacy and rehoming work done.

For the first few days Ma didn't leave us alone for a moment to our-selves. She knew better than to leave two boisterous brothers to their own devices unsupervised. But the time did come when she had no choice but to head back to work. Leaving the Spinsters in charge as she usually did was a futile exercise. That other saying 'Silence is golden, unless you have a dog or two' completely applied to us two pod-peas. Some days, after watching back-to-back eps of *The Block*, we would try our paws on some home redecorating. Other days, we would work our magic on the courtyard. Never once did Ma or Pa show their gratitude. We all like a bit of praise and acknowledgement for our efforts but Ma and Pa never seemed to appreciate it.

Being that Nox also had extremely good looks (it runs in the family) and had an all-round lovely 'family dog' temperament, it only took four weeks of being back in foster care before adoption applications began to flood in from all around the country. My Facebook page (and now Instagram account) had started to work as Ma and Pa had intended. There were many eyes on Nox's adoption profile and many people lik-ing and sharing his story far and wide.

It was during this time that a young family in Melbourne had spot-ted a photo of a beautiful black mastiff pup pop up in their Facebook feed, after a friend of theirs had given it a 'like'. Not even in the market

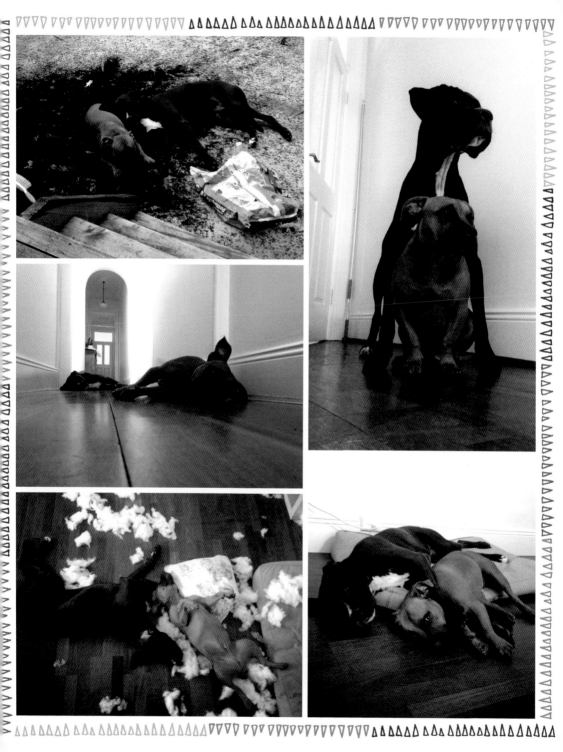

for a new fur family member, there was something about Nox's soulful face staring through the computer screen that pulled right at their heartstrings. The mum of this family couldn't stop thinking about Nox. She knew Nox had previously been adopted by a family with a little toddler (so he was good with kids), and despite the fact that he had had up to eleven different homes (many of those being pounds, shelters and even death row at one point) and had some cigarette scars and scissor marks down his back, face and head, she read that Nox still had a gentle loving nature. Going with her gut feeling, the mum sent in her adoption application and left the rest up to the universe.

Of course, my rents decided to really take their time on the decision-making for Nox's adoption. They knew they needed to get it right this time. Nox needed to land on his paws in one last home that could provide a solid 'forever'. Ma must have spent something like twenty hours all up on the phone over the course of a week. She can talk the ear off just about anyone given the chance, and adoption phone interviews are no different. It finally got to a point where Ma had decided on pursuing the application from that sweet Melbourne family. They had never adopted a rescue dog before and confessed that they were not really on the hunt for one at the time either. But there was something about Nox that made them sure he was meant to be theirs.

After all the back and forth over the phone and lots of photos and videos exchanged, Nox's new forever mum made the long nine-hour drive from Melbourne to Sydney. It was instant love at first sight. After an overnight sleepover in our guest bedroom with his new forever mum, Nox broke the news to me that he would soon be heading off on his forever-home adventure. He and I would miss each other bucketloads, as catch ups would be almost impossible with him living so far away, but neither of us could deny that this was the best possible outcome.

No tears were shed, just a last sniff and headbutt to send him on his way. Foster bros for life and family forever. And as I watched the car with Nox and his forever mum in it disappear at the end of our street, I felt pretty darn proud to have played a part in such a well-deserved happy ending. It was nice to be on this side of foster care, and now that I had a taste of playing the role of foster brother, it was something I reckoned I could get used to.

Nox and his mum were greeted in his new Melbourne home nine hours later by his excited golden retriever fur brother, three human sisters and a loving dad. Pampered and well cared for, Nox has been enjoying his forever life for over three years now. Like me he's developed a few silver-fox grey chin whiskers, but other than that Nox is still Nox, and one day I know we'll meet up again and it'll be just like old times.

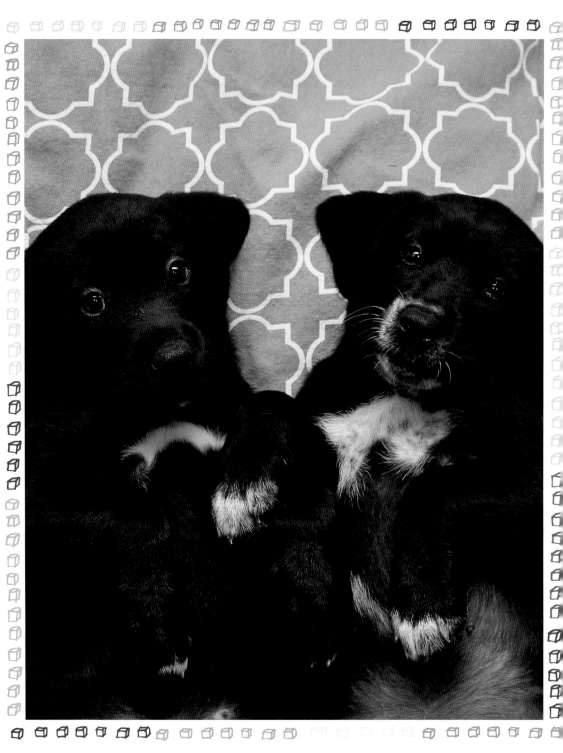

FOSTER BROTHER
✳ EXTRAORDINAIRE ✳

NOX REALLY DID START THE BALL ROLLING FOR MY RENTS
TO GET BACK INTO THE SWING OF OPENING UP THEIR HOME
AND HEARTS TO NEEDY, IRRESISTIBLE LITTLE RESCUE MUTTS
ONCE AGAIN.

The success of my social media accounts made them a great avenue for my rents to get their foster kids more attention and have them rise to the top of Australia's most adoptable and sought after.

Before too long we came across two fresh-faced babies who needed some foster-care loving and a big bro to show them how to dog. A litter of labrador-cross-kelpie puppies and their mum had been surrendered into rescue. They were coming all the way from country New South Wales to the big city of Sydney. Ma and the mum of my cousin Tinoh drove out late at night to what felt like a dodgy undercover rescue sting. A bunch of willing foster carers met at a car park in the middle of nowhere familiar and, when the van pulled up, the puppies and their mum were handed out to the carers.

Ma and Tinoh's mum were handed the two baby girls. So tiny, little black bundles of squeaks and #stankasspuppybreath. Their mum had stopped wanting to feed them, so she needed some space. They were still only five- or six-week-old babies, so Ma and Tinoh's mum decided to co-foster and keep the sisters together for the first two weeks. One week with Tinoh and his mum and the next at Le Chateau Pikelet. When it was decided that they were old enough to be split, one of the cute squirms would stay put with me.

Not since I came onto the scene had my rents had the opportunity to name a new little critter. A labrador crossbred pup in the house had to have herself a fitting name. Thinking about what might have a good ring to it next to 'Pikelet', Ma came up with 'Pudding', assuming that one day Pudding might grow into her name (it's common knowledge that most labs develop a little extra tub, being the breed with the most renowned food connoisseur skills).

Pudding and her sister Murphy were my baptism of sorts, proving my rents' theory that I was both puppy- and bomb-proof. The two wriggly little mites were equally a joy and an annoyance to my comfortable lifestyle. Remember, I was probably only about a year old myself at this time, so having the responsibility of being a mixture of big bro and dogfather was a lot to take on. However, I came into my own, and things did get a little bit more chill when Murphy moved back in with cousin Tinoh and his mum.

Puds became the black ninja shadow sister I never knew I'd always needed. Her cheeky adorable rescue-mutt ways got a huge amount of online affection from my Facebook friends, and applications for her adoption flew in within the hour after it was announced. As it happened, my rents did not need to look much further than two doors down the road for the perfect adoptive family for puppy Pudding. After having her big girl op and all the necessary needles and vet work, Pudding got to keep me as her neighbour-bro and moved in with her forever fam. Oh, and she got to keep her name, too, though to this day, Puds has surprised us all by being by far the most streamlined labrador-mix pup you'll ever meet. She *loves* her food and has a huge appetite but has apparently found the secret to keeping it hidden that people would pay millions for.

Of course, Murphy found a wonderful forever home too. Tinoh's mum (also a foster care veteran) found a fantastic home for Murph just outside of Sydney, living with an adopted rescue kitty sister.

So what happens once a foster puppy sister leaves after adoption?

Withdrawal starts to set in. Days, maybe a week went by before yet another litter of puppies from country New South Wales needed some rescue foster care assistance. Ma's hand went back up to volunteer to take a new little babe on. This time she convinced Pa by 'letting' him choose the name.

I didn't get to go with my rents when they went to pick up the next little kid but I'm told they had their choice from the whole litter and they chose a little boy that seemed all too familiar looking . . . Yes, you guessed it. My next foster bro looked a heck of a lot like me – maybe a little lighter in colouring and with longer legs (he was thought to be a mix of staffy and kelpie). In fact, the resemblance was so strong that Pa came up with the 'original' name of 'Pancake'. There was a theme starting to emerge here . . . I'm not sure I was entirely comfortable with my unique one-of-a-kind name becoming the standard go-to theme! I would have to see how this played out before making any firm judgements.

Pancake was much like Pudding and Murphy. Tiny, very young and absolutely clueless when it came to appropriate behaviour. Panny got away with more than I ever did. He was a talkative little guy and had the gift of the gab when convincing me to get in on his harebrained schemes and ideas of fun (which usually involved deconstructing found objects and turning them into 'art').

Before I knew what was what, weeks had flown by and adoption applications were rolling in once more. I'm pretty sure Pancake's popularity had a lot to do with the compromising sleeping positions that my Ma managed to snap us in while napping together. I know I'm a big softie and love me a good cuddle sesh, but it's totally embarrassing when all those mushy snaps surface on the internet right when you're trying to woo the ladies and play the field.

Just like my previous foster sibs, Pancake found himself a forever home fitting of a prince. Moving in with his new fur brother (an ex-rescue dog himself) and forever rents, Pancake enjoyed his first few years by the seaside in Sydney's Eastern Suburbs. Like my foster sibs before him, we made sure to have some catch-ups and play dates. Pancake was the mini-me of yesteryear no more; he grew himself into a big, beautiful, solid pup probably about three times my size. It's funny how little siblings can and often do outgrow me! Just recently, Pancake (who was renamed 'Buddy') and his family packed their bags and moved overseas to a little town called Paris in a fairly unknown country that goes by the name 'France'.

Pancake's departure from my home after his adoption was very much considered my rents' third and final foster pup of the year, according to my Pa at least. Remember that verbal agreement he and Ma had discussed? Something along the lines of 'If we adopt Pikelet then we are only ever going to foster a maximum of three dogs a year. *Maximum.*' With his human hand held up in demonstration he would count off his fingers while listing the names. 'Nox,' (even if it was the second time around 'it still counts') 'Pudding, and Pancake. Now I could always assume that Murphy is a part of this too . . . that would make us already needing to foster one less next year.'

Ma was having none of that. Silly Pa – Ma knew that our little family and her golden-child fur son (me) had truly found a calling. Fostering was probably always going to be a part of our life. Ma just needed to ease him into it. She thought she could.

GONE N GOTCHA DAY

'HAPPY BIRTH-'OH WAIT, THAT'S RIGHT. NOBODY KNOWS WHEN 'MY ACTUAL BIRTHDAY IS!'

However, a whole year had flown by since the day my foster rents became my forever rents. Some things had changed, and some things not so much. Now pretty much at my full-grown adult size (weighing in at about sixteen kilograms), my once stumpy little bow-shaped front legs had matured and straightened almost to 'normal', the way Mother Nature intended. However, I still had a unique kink reserved just for me, so my silhouette remained instantly recognisable. I was now bigger and heavier than the Spinsters, with a lot more muscle definition as a result of all those hours at the gym. I was also a billion times wiser. I'd been around the block and in one short year of adoptive life I'd been a foster brother to four siblings, a little big bro to the Spinsters and the pup-son my rents always knew they wanted. Gone were my ring-eating tendencies, and as the fourth of July 2014 crept closer and my Facebook pack of online 'fans' grew bigger, my rents decided to throw me a first-adoption-anniversary shindig.

In Straya we Aussies call the anniversary of your adoption your 'Gotcha Day'. Why? Well, it's the day they went out and got'cha (must be said with a thick Aussie ocker accent), silly! Also in Straya it is customary to celebrate just about any occasion, including the most important one of all, your rescue dog's adoption anniversary. So, putting out an open invitation to a few hundred of my closest Facebook friends and all my local

peeps, my wonderful parents put on a most fabulous First Gotcha Day celebration. It was the best party I ever had. It was held at a local fave park of mine and the day couldn't have been any more pawesome. So many long-time and new friends stopped by and brought all kinds of treats and gifts and toys, and if that wasn't enough, we had a dog rescue charity collection tin (which was intended to be filled in lieu of presents) that raised a couple of hundred dollars. Ma outdid herself with a huge peanut butter, dog biscuit and cream-cheese frosting pupcake, big enough for all my friends to have seconds. By the end of the day I was zorsted. Gosh I felt like one special and loved-up pup, though.

While I thoroughly enjoyed my Gotcha Day and all the hype around it, celebrating my 'dependence day' anniversary (I heard my American friends had parties and fireworks all around the country in my honour), I reflected on the thought that I very nearly missed out on this kind of life. I couldn't forget, nor will I ever, that there were pups sitting in concrete kennels right next to me back on death row that never got their second chance and never got to know the feeling of a soft touch, a warm heart and a life filled with wonder and joy. In fact it's not just them I thought about, it's all the others still out there waiting and holding out hope. There are still litters of pups being born daily that end up with little to no chance of this kind of life.

I sat my lovely rents down and we had a good chat about their plans for future rescue and volunteer work, and how I really thought that their foster parenting and my foster brothering should continue. We were on a roll, and Success was my middle name (well, I'm sure in some languages 'Butterwiggle' means success). Three foster kids a year was just ridiculously out of touch (sorry Pa, but it's true), so if opportunity came knocking on our door again then we would need to take it.

And like a walking magnet of good luck, or perhaps a jinx, opportunity did come to our door, but she didn't knock – she was left there in a box.

THE

SURRENDERED SIDEKICK

SPEAKING OF GOTCHA DAYS, AND OTHER GIFT-GIVING OCCASIONS, I KNOW MANY YOUNG KIDS WISH FOR THE THE LATEST TOY OR FANCY GADGET.

Some pups wish for a new food bowl, bed, collar or leash. Me, on the other hand, I always, without fail, wish for a box full of puppies! Even when it's not Christmas, or my Gotcha Day, I used to always wish to be that lucky guy who finds himself peering into a box of abandoned puppies. Because, let's face it, who better to stumble upon such a thing? I've always wondered who those people are who come across a box of puppies sitting by the roadside.

Now, don't get me wrong, being abandoned in a box isn't something I'd wish on any pup, and the reason why one might find a box of puppies doesn't warm my heart. However, the day a box turned up on my doorstep with one tiny, dirty, screaming puppy . . . well, let's just say it was rather bittersweet.

Before we go down the 'box of puppy' road I do need to back my paws up a little and fill you in on the kid that arrived just before all this malarkey went down.

Remember how I said I had gotten myself a little bit of a social media following? Well, all that fame usually comes with a price. My Ma, who sometimes doubles as my manager and PA, was checking some of my private messages on the ol' Facebook page when she stumbled across a plea for help.

A young lady had written in on behalf of a 'friend of a friend' (wink-wink) who had bought herself a 'pedigree' American staffy puppy from a backyard breeder. Now this 'friend of a friend' was only young herself, straight out of high school, and she had thought that the perfect thing to do as a fresh-faced human adult of eighteen years old was to go and buy a puppy. This idea had not quite panned out as she thought it would and the very cute, very little puppy was quickly growing. Quickly becoming more and more boisterous, more and more energetic, and more and more needy. And it had only been two weeks! Funny that, hey?!

So now this well-meaning, puppy loving young human (who was only doing the best she could at adulting) was in a position where she truly needed some help and needed to surrender her little pup into the safety of someone experienced. That's where my Ma and Pa stepped in.

One Friday evening after dinner Ma got in our car and drove off into the night. A few hours later she returned home with a bundle of what I assumed could only be freshly baked doughnuts (the way she was protecting the bundle, you couldn't blame me for thinking this). She marched straight out to our courtyard and unwrapped the most un-doughnut looking puppy I'd ever seen. As she placed him on the ground and I moved closer to have a sniff, I heard her tell Pa, 'I think this little one is going to be "Porkchop".'

With that, Porkchop was my new little foster bro, but also quickly became my new BFF (Best Foster Friend). Porky and I found our groove within the first hour and from then on we were quite the dynamic duo. We slept in each other's arms, we wore all the same fashions and we just plain did everything together. I'm not going to lie, I actually thought the rents might cave in and adopt him (apparently they were pretty darn close to doing so, too).

BARK BARK

Gosh, I'm going to sound like a broken record here, but like my foster bros and sis before him (and many more after) we truly did bond and did get up to a billion fun adventures together. Truth be told, Porky's journey here as my little sidekick was probably the start of the journey for many of my social media fans too. Ma and Pa somehow managed to capture many cute photos of me and Pork and provide a wonderful example of what a great team two rescue-pupkids could be, proving what a fun and rewarding experience foster care can be. And from all those cute pics a lot of my more famous 'foster family photo traditions' were born.

Before Porkchop eventually moved on, as they always do, to his wonderfully loving forever family, two sweet and memorable photos were snapped and shared on social – our ever happy and cheerful #bathface photo (made famous by our scene-stealing expressions of joy), and a sweet spontaneous bedtime cuddle pic. These two were just the start of something big, and Porkchop was really the inspiration that started it all.

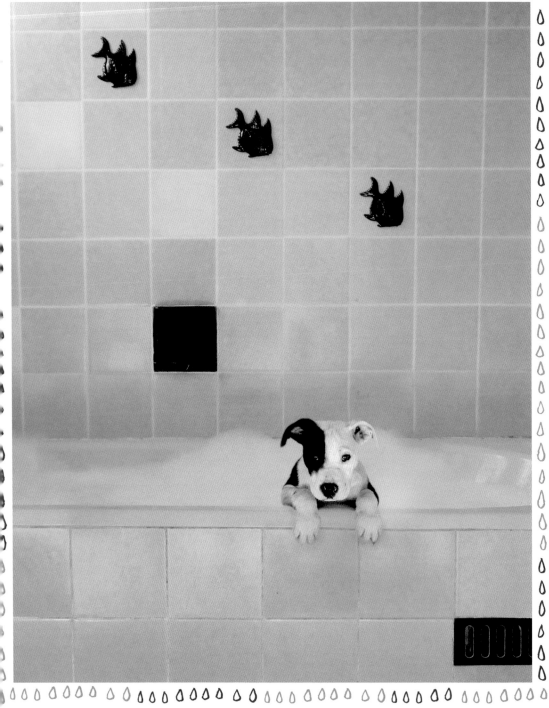

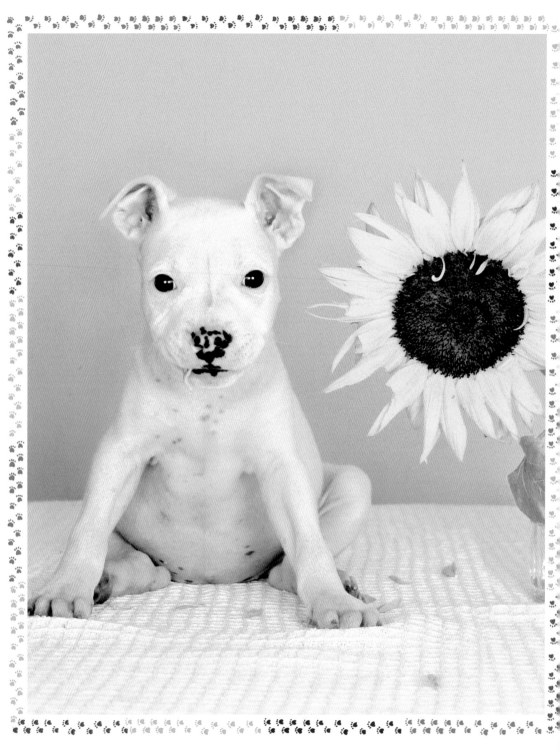

ALL I WANT
IS A BOX OF
PUPPIES

OKAY, SO NOW WE'RE BACK WHERE WE WERE BEFORE WE GOT SIDETRACKED BY ALL THE ADORABLE PORKY'N'PIKEY LOVIN'

The part about the box on my doorstep filled to the brim . . . with one teeny-tiny puppy. Ever heard the saying 'Be careful what you wish for'?

By now my rents had been in a very long-term binding promise that one day they would be married (probably to each other, I'm guessing). My humans claimed that finding some spare time and extra pocket money to fund a big wedding is incredibly difficult when you have a (rising social media star) fur son, two Spinster Sister doghters and a foster fur kid or two needing your full and undivided attention. But finally, after their almost four-year engagement, Ma and Pa had locked in a date to run off and secretly elope later in the year.

One Monday afternoon, Ma drove out to a fancy wedding-dress maker to have a final fitting and bring the special gown home. It must have been quite a fancy dress indeed, as Ma was gone for a fair few hours before returning in the darkness of the early evening. It was Pa who came home first from work, and as he walked down our street he could hear the most bizarre screeching or yelping noise, seemingly coming from our house. Thinking it was me or one of the Spinsters, Pa quickened his pace and arrived through our front gate with key in hand, ready to barge in and tell

YAP
YAP
YAP

us off for making such a racket. But blocking his way, sitting upon our doorstep, was a large cardboard box, taped closed with packing tape, with a handful of tiny, roughly carved holes punched all over it. Folded and stuck on the top was a typed note.

Bending down over the box, it was clear to Pa that the screeching, yelping noise was coming from inside. Sensing the urgency and not wasting any time, he broke open the sealed tape to find inside one tiny, very distressed little puppy. This puppy was covered in filth and all she had inside the box for comfort was a dirty, poop-sodden tea towel.

Just as Pa scooped up the screaming little pup and started to read the note attached to the box, he looked up to see Ma drive down the street and park across the road in the dark. Seeing Pa standing on the porch, Ma called out for a little help carrying her heavy, fancy new wedding dress. But after waiting a few minutes by the boot with no Pa arriving to offer his assistance Ma crossed the road, and as she got to our front gate, with her view blocked by the big dress bag, she asked in a slightly raised voice, 'What is all that noise, and what are you holding?' Pa manoeuvred the wedding dress out of Ma's hands and in exchange placed a screaming ball of stanky puppy.

Now, as I wasn't there at the time and I'm really just relaying the story as the rents like to tell it, I can't confirm if this next part is true. Word on the street is that when she inquired about the puppy she had clutched in her hands and the box at Pa's side, apparently Ma's eyes started leaking uncontrollably at the realisation that a very traumatised, very young, very sick little puppy had been dumped and abandoned on our doorstep.

The note read something like this: 'I saw you on Facebook and followed you home from that photography exhibition and know that

you'll take good care of this pup. Her name is Whitey and she is deaf. I can't sell her because she is deaf and I can't keep her either. She will make a good pet.'

That, my friends, is, no joke, pretty much verbatim what was typed. Can you believe that someone went to all that trouble? Followed my rents home from a charity photography exhibition, planned and typed a note, watched our house, waited until my Ma went out and, when they saw no one was home (well, no human, that is), they then left a young, unwell, deaf baby dog in a smelly, sealed-up box on a doorstep in the hot sun, not knowing how long it would be there for? (Later our neighbours confirmed they had seen the box hours before Pa came across it, sitting right in the spot where the afternoon sun lingers the longest.) Some might say the breeder/dumper did a kind thing. In fact, some people did say that to Ma and Pa. But really, if you're going to breed dogs and turn a profit from selling your dog's babies, then surely the kind thing to do would be to prepare and take responsibility for whatever and whoever is born, whether they are healthy or not? You don't go around stalking foster rents off their fur son's Facebook page and dumping your unwanted 'damaged' goods on their doorstep.

As the situation at hand started to sink in, my rents jumped into rescue mode. They brought the little puppybug inside and put her straight into the laundry tub to wash all the muck and poop off of her. Gently washing warm water over the pup, Ma noticed that the little white puppy with black dotted markings was not that at all. Under the bright glow of the heater light, Ma could see that those black dot markings were . . . moving? Not believing her eyes, she called Pa over to have a look. What they saw were giant, adult-sized, bloodsucking *fleas*! Puppy was riddled with fleas so big that anyone would have easily made the same mistake of thinking this pup was a spotty Dalmatian or something like that. Upon closer inspection, it was evident that a large flea infestation was not

69

the only thing this poor kid was suffering from. She also had ear mites and a very tight belly full of worms.

Calling some local rescue pals, Ma explained what the rents had arrived home to find and asked them to come over and help assess the situation. Sonja and Vanessa rocked up quick-smart, bringing with them some puppy wormer and a flea comb. The four humans huddled around the shivering little puppybug and picked off her fleas one by one, dried her down and fed her a meal and some worming meds.

While discussing the plan ahead and sorting out the rescue technicalities, it was decided that little girl puppy was to be named 'Periwinkle', a name that (I'm sure you would agree) suited her perfectly.

That night, after Periwinkle was de-fleaed, fed, washed and wormed (the worms started to evacuate within minutes of the treatment; Ma said she had never seen worms just fall out of a puppy's bottom so fast and in such volume), she was finally introduced to me and the Spinsters. We three had heard the whole thing go down from behind our living room door. We had listened all afternoon and evening, concerned and worried. It was very upsetting to feel so helpless. That day I really wished I knew how to use the phone to call the rents! So, it was a great relief that the distressing noises we'd heard echoing from the front of our house had now been resolved. Periwinkle's fear had finally eased. Straightaway my sister Shelly offered up her prime spot in front of the heater, and Periwinkle graciously accepted the offer and settled in. Probably for the first time in her life, this little 'Whitey' felt safe and comfortable.

That night Ma fell asleep with baby Periwinkle wrapped in a towel in her arms. She woke the next morning to see two black beady eyes staring back at her. She was such an innocent little thing, and couldn't have been more than five or six weeks of age.

I got up early, had my shower and was ready for duty before Ma had time to put the kettle on. I was ready to talk my new foster sister

through all the ins and outs, to tell her the ways of the world and let her know she had somehow ended up at the right place. This was going to be great! This was going to be easy! I had done this many times before and I knew it would be a piece of cake with this new kid, right? 'Foster brother extraordinaire' at your service, young PWink, so listen up!

However, when we did finally get to chat, it was like everything I had to say, everything I took time to explain, was falling on deaf ears. All I got back was a blank expression. That's when Pa sat me down and explained that Peri was deaf. Not 'selectively deaf', as my rents claim my Spinster Sister Betty is. No, PWink was really, truly deaf.

I had no idea that the whiteness of some pups, caused by the lack of pigment in their skin, was also sometimes linked to a lack of pigment in the skin of their inner ears, which can result in nerve damage and permanent full or partial hearing loss.

We hadn't had her tested yet, but it seemed that Periwinkle was about as deaf as she could be. But not being able to hear hadn't held her back in the smarts department – in fact, she was a bloody genius!

Imagine this, a tiny dot of a dog, barely bigger than a human foot, who can't hear a thing but who knows her voice is ear-piercingly loud? Knows she's cuter than a button and knows how to work a room so that anything she wants just falls into her paws? I call that #nextlevel.

Periwinkle had the lay of the land by day two. She was all but running the joint while the Spinnies and I just watched on in utter disbelief. The only time we got some well-deserved rest, peace and quiet was when our mini-hippo foster sis slept. You see, because she couldn't hear doors closing, TVs being turned on, squeaky toys or general noisy life stuff, little Periwinkle always slept like a log. Her deep, sound sleep was such a contrast to what she was like when she was awake that Ma would often say, 'She is just so sweet . . . when she's sleeping!'

Word of the supreme cuteness of my special new foster sister travelled quickly across Facebook and Instagram. It took less than a week for adoption interest

NEXTLEVEL

SQUEAK
SQUEAK

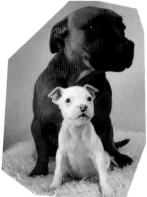

and applications to start filing in. Like always, there were many wonderful families keen to take home our latest famous foster and make her theirs forever. This time, however, the rents were really keeping an eye out for a special someone for Peri, more than they had for any foster kid before here, because a very special forever home was needed for this very special staffy girl.

One adoption application in particular stuck out from the rest like a sore thumb. It was sixteen pages long and had a veritable shopping list of outstanding qualities that any good foster carer would be thrilled to find for any foster baby of theirs. This was the one. A forever mum who had a history in animal care herself, already had deaf feline and blind canine family members, as well as a menagerie of other fur siblings and a lifestyle which prioritised them all. Periwinkle's bags were packed before you could say 'Boo!' and she was ready to make the drive to Canberra with her new forever mum, Michelle.

Periwinkle's rescue story didn't really end at her adoption, though. Within a short period of time after adopting PWink, mum Michelle had fallen so in love with the joy and uniqueness of owning and training her special deafie pup that she joined forces with a rescue organisation that is dedicated to rescuing deaf dogs (and sometimes cats) from all around Australia. Periwinkle has since become a recognisable ambassador for the deaf-dog rescue. And of course you know her foster family is as proud as punch of their little deaf 'puppy in a box'.

♡ YAP.' ♡ YAP
YIP

PUPS

MA & PA GET HITCHED

AFTER THE MOST UNEXPECTED ARRIVAL AND FOSTER CARE OF LITTLE PERIWINKLE, THE RENTS, THE SPINNIES AND I FELT TRULY EXHAUSTED.

It was drawing towards the end of the year and now felt like as good a time as any to try for a little break from foster care. It had been ages since I had had much of a social life and I was really looking forward to the holiday season, catching up with old friends, a Christmas party down at the park and some serious relaxation.

That non-wedding elopement of Ma and Pa's was booked and planned for. In just a few short days they would, for the first time ever, leave me and the old girls home alone. I would be in charge, of course, being that without Pa around, I was the man of the house. Right?

As the bags were wheeled out into the hallway and Pa hugged us and Ma kissed us goodbye, there was a loud knock on the front door. Of course, being left in charge was too good to be true. They had hired a pup sitter! But lucky for me they happened to arrange for one of my favourite aunts, Angie, to come to stay.

I don't know who liked Angie the most. She always let me have the ball at the park, knew exactly where to rub my belly in the right spot and let me burp unapologetically. Spinster Sister Shelly was allowed to sleep in bed with Angie and ride shotgun in the car on the way to play dates. And Betty was allowed to do pretty much anything

she darn well pleased. Hanging out with Angie while the rents were getting hitched was our version of a #staycay.

Meanwhile, down in Melbourne, the rents took themselves off to the marriage registry and made good on that long-time engagement, making me and the Spinsters finally legitimate fur-siblings.

Even though it wasn't any big hoopla fancy wedding, Ma and Pa's little, quiet, and somewhat secret wedding celebration didn't leave out the most important factor, *me* (well, Shelly and Betty got a look-in too). Right beside the cake at the celebration dinner were three handmade miniature figurines of their babies. And of course that old story about the engagement ring being lost, swallowed and pooped out by their most famous, best-looking fur son may have come up on the night as well.

Getting married was only one of the items on the rents' to-do list during their one-week getaway in Melbourne. Right there at the top of the list was another equally important item the rents wanted to check off. Can you guess what it was?

Do you remember when I told you about my foster bro Nox? That big, squishy, jet-black half mastiff, half pointer? The one who had cigarette burns and scars from scissor cuts on his body and head? The pup that had lived in no fewer than eleven places, many of which had been pounds, shelters and even on death row, who had been returned to foster care with Ma and Pa and quickly became my partner in crime as we practised our landscaping and redecoration skills? That beautiful, perfect family pup that had finally found his forever home with a young family down in Melbourne? (Is that enough clues yet?) Well, you guessed it; right after confirming the day they were to be married, Ma and Pa had booked in a time to go visit their very first foster kid. The pup that got them started, hooked on, even addicted to fostering.

Ma and Pa woke up excited and nervous on the morning they were to visit Noxy and his family at their house. They wondered what it would be like to see him again. Would he

remember them? Would he do his usual nonchalant 'hello', usually a combo of a quick sniff and a cold shoulder, as if you're just an ordinary part of his day? They packed up his old favourite treats and got in the hire car. Ma said she had butterflies in her tummy as they drove through the pretty suburbs of Melbs.

When they arrived at the Nox family house, opening the door to welcome my rents were Nox's mum and his human sisters, and pushing past them all was Nox himself. Did he remember his twice–foster parents? Course he did!! They were greeted with nonstop tail-wagging, cuddles and big-dog leaning.

After all the greetings were exchanged there was a lot of catching up to be done. Nox's golden retriever pup-brother Max was just as keen to get his share of pats and cuddles from Noxy's foster rents, acting like he had known them all along. Many treats were handed out in exchange for a lot of drooling, begging and well-mannered paw shakes.

How wonderful it was for these two families to reconnect over one special rescue pup. A few hours of chatting sped by and it was time to say their goodbyes once again. Nox is a great hugger (I picked up a few of his tips when we roomed together) and he made sure to give his foster parents some of his best hugs to last them until the next time they could visit.

Ma and Pa left Nox and his family with big smiles on their faces and the confirmed knowledge that they had played a vital part in that dog's happy life. They had given him the gift of a second second chance and unwavering love and commitment in their search to find him the perfect forever family of his own. And my, what a perfect family he has.

A text message beeped on Ma's phone as Pa drove back to the hotel. It was a photo of Nox standing by his front door with a message that read: 'He *sooooo* remembered you guys. He's actually a wee bit sad and has stood by the door for a good ten minutes after you left! He also paced down the side gate too. Bless him! The girls are trying to cheer him up now.' Seems like the rents had made as much of an impression on Nox's life as he had on theirs.

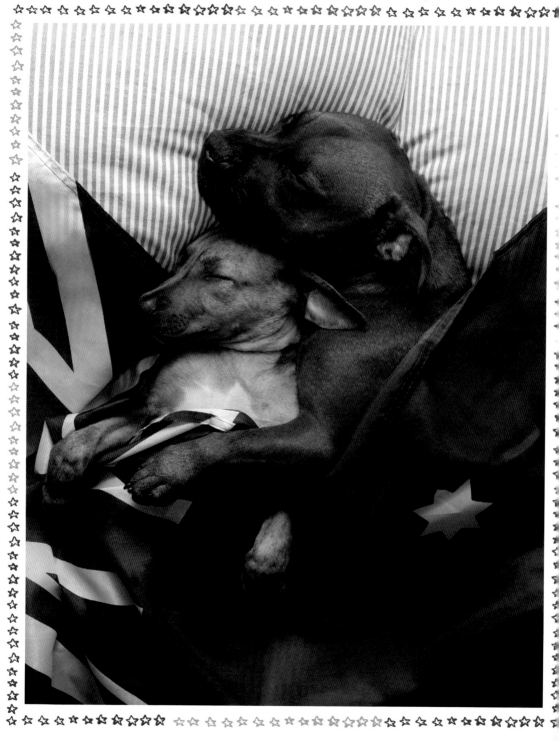

AYE

IT'S DELICIOUS, BUT THAT'S NO' HOW Y'MAKE

PORRIDGE!

THE LAST DAY OF EVERY YEAR IS ONE WHEN YOU REFLECT AND MAKE THOSE ALL-IMPORTANT NEW YEAR'S RESOLUTIONS.

And if you're lucky enough to be here in Australia, the last day of the year is right in the thick of summer. Hot days in the holiday season are best spent by the pool or down at the beach. It was 31 December, and in just a few short hours the year 2014 would be history. This New Year's Eve was a mid-week summer's day, and Pa was out in the yard listening to his fave tunes while putting up the over-sized inflatable 'kiddie' pool for he and Ma to enjoy. Helpful as usual, I was overseeing things from my own paddle pool. Later that night we'd head a couple of streets away to Theresa and Mike's house (two of my god-dogparents) for their famous New Year's Eve fireworks party. They had uninterrupted views of the city of Sydney and the Harbour when all the action went down at midnight. As with the previous year, I'd be heading over with the rents to join in the fun and hang with the resident pups Rusty and Little, and I was really looking forward to it. The Spinsters would stay home drinking tea and would watch the countdown on the TV, if they weren't already snoring their heads off (which was more likely).

As the sun started to fade we packed up some drinks and started to make our way over to the party. Spontaneously on the walk over Ma asked Pa and me what we thought of fostering a new pup over the next

couple of weeks. It had been a few months since Periwinkle was adopted, she said, and the busy period of elopements, birthdays (the rents') and Christmas were behind us, so how about we started the New Year doing what we loved? Almost at the same time, Pa and I answered, 'Let's do it!' We were all on the same page.

Ma couldn't help herself (she usually jumps right in before Pa changes his mind) and got her phone out to have a quick look and scan all the pound listings while we were still walking. And as predictable as ever, she of course found a listing she couldn't resist for a little pup needing a rescue save, only described as 'Male. Mixed breed. Approx. eight weeks old. Very underweight' with no photo attached. Ma knew that first thing next morning she'd be calling the pound to tell them she'd take him.

Happy New Year! After a late night of fun, food, drinks, fireworks and celebrations, Ma woke on the first day of 2015 and got straight to work. Calling the pound and the rescue, Ma had secured the little no-photo pup by lunchtime. By the arvo Ma and Pa had driven out to the shelter, collected the little tyke and were back home introducing 'Porridge' to me and the Spinnies. Just like that, the rents started 2015 by saving a life. And, little did I know it at the time, they had started me off on perhaps the biggest year of my life as Australia's best foster pup-brother extraordinaire, or as some like to call me, 'The Dogfather'.

Porridge was nothing more than a fur-covered bag of bones. Poor

kid was just as the pound had described him – very underweight. Another puppy with a huge belly full of worms and, this time, little Podge had the added bonus of a runny, snotty nose. It was clear after the first day with us that Porridge needed a medical assessment and some treatment. Ma took us up to the vet and there we got our wonderful Doctor Nathan to check Porridge over. Doctor Nathan confirmed that little Porridge was one

sick pup. He had a chest infection that seemed dangerously close to full-blown pneumonia. Fancy having pneumonia right in the middle of the hottest time of the year? It was no fun at all for poor Podgy.

Ma and Pa had their work cut out for them. The first few weeks of foster care for little Porridge would be all about getting him healthy and well. Naturally I would be in charge of the TLC aspect. With my new little bro, I was going to make sure this was a summer of Porridge-lovin' fun.

As soon as Podgy's face made its debut on social media he had an instant fan base, and his admirers grew and grew. There was something about a true mixed-breed mutt with big doe eyes that people really connected with. Podge may have been a small puppy babe, but from day one Ma had an inkling that Porridge might one day grow into his oversized bones. When questioned about all my foster siblings, 'What breeds do you think he/she is?', Ma is normally pretty quick to reply 'It's anyone's guess,' because truthfully no one can really be sure when you pick a pup up from the pound. Even when a dog looks very much like a specific breed, the funny thing is that dog genetics can be very deceiving on the visual side of things. Back when I was a tot the rents thought I might even be a mix of Chihuahua, dachshund and staffy! People always, always like to give their opinion and weigh in on the topic of guessing breeds. It's amusing to hear all the different things that different people see in the one dog. But this time Ma thought she had a pretty good idea that Porridge might be a mixture of Great Dane and a large sighthound, maybe a greyhound or whippet. Anyway, whatever Porridge was, the important thing wasn't his breed but his temperament and personality. Podge was a lovely, calm and chilled-out pup. He could often be found at the feet of my rents, lying on the floor, observing, whether they were cooking in the kitchen or brushing their teeth in the bathroom.

Porridge got on so well with me, the Spinsters and all our pup friends and visitors (including Porkchop, who made a special week-long holiday visit) that the rents made certain his new forever family had another doggy family member. Porridge, once adopted, was renamed 'Remy' and got to have a pup brother of his own to love and spend his days with.

Remember how I mentioned that the rents try, and usually succeed, in keeping in contact with all my precious foster brothers and sisters? Well, Podge/Remy's family lived not too far from my house, so did indeed meet up a couple of times. About six months or so later we invited Remy to a party we were having (all the goss on that to come). Lo and behold, when 'little' baby Podgy walked in almost everyone, including me, did a double take. Yup, she guessed it! Ma's theory on the mixed breeds was now almost confirmed. Today, if you saw Remy in the street you would agree he looks to be Great Dane crossed with a greyhound or whippet! Big pup? *Huge* pup! But still, the breed thing, it ain't important, is it? Not unless you're talking about our true breed – 'cause everyone knows 'rescued' is the best breed there is.

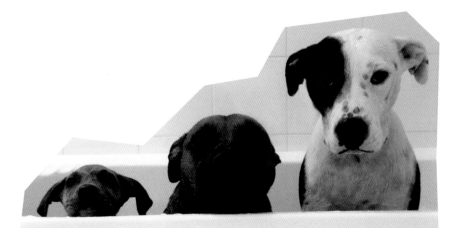

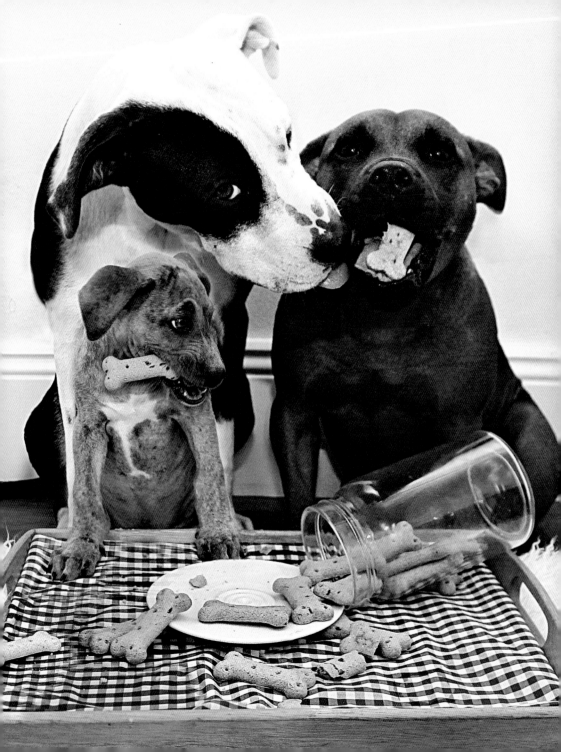

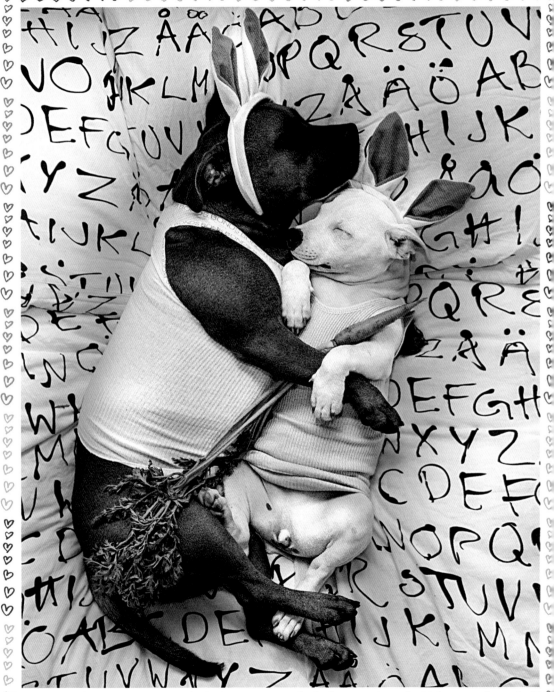

THE MONA LISA

OF DOGS

THE ARRIVAL OF THE MOST FAMOUS PUP FOSTER SISTER I EVER HAD WAS NOT TOO DISSIMILAR TO THE WAY PORRIDGE ARRIVED BEFORE HER.

She came from the same pound and, much like Porridge, Ma spied her listed on their website the very day she arrived. However, this time there was a photo attached to the listing. Whenever there's a photo of a puppy listed on one of the Sydney pound websites, usually those pups get snapped up and saved by a rescue group if not adopted straight away. No one can resist a young pup (unless they have a visible disability or illness like I did). So Ma saw this puppy girl, squealed over her photo ('cause maybe she was a tad cute) but moved on, thinking she would get herself adopted over the weekend. Which is exactly what happened. A week later Ma was contacted by the rescue group and asked if I could help out with my foster bro skills and take in one of eight German shorthaired pointer pups coming directly from a backyard breeder who was closing up shop and surrendering all his breeding dogs and current puppies to the rescue.

Naturally Ma and Pa agreed to let me lend my talents and the day had arrived for Ma to pick up my new foster sister that afternoon. Everything was set up, puppy-proofed and ready to go. Ma got in the car and started driving to pick up the only girl pup of the pointer litter. Already thinking of possible names, Ma had landed on

'Pollywaffle'. About three minutes into the trip Ma's phone started to ring. She pulled over to the side of the road and answered. It was foster care coordinator Marina.

'Remember that puppy you had your eye on over at the pound last week? Well, she's been re-dumped back at the pound. The people who adopted her last week don't want her anymore because they realised she is deaf. We know you've already had experience with a deaf foster puppy . . . this little one looks so similar, white, staffy and deaf. And we know if we send her to you for foster care she'll get much more adoption interest from living at Life of Pikelet HQ. What do you say? Want to take her instead of the pointer pup?'

Without much more convincing, Ma did a quick U-ey and drove straight out to the pound.

Once she was safely tethered in the car, sitting on the back seat, the little white marshmallow puppy of sweetness looked wide-eyed at Ma, and as Ma looked back at her she thought that the name 'Pollywaffle' couldn't be more suited to a pup. Ma called the now–foster carer of the jet-black pointer puppy and asked if she could possibly have the name back. 'I can't tell you how perfectly the name "Pollywaffle" suits this little girl, thank you so much for understanding.'

After the usual introductions and first few hours of settling in, I was pretty darn happy to have a new foster sister sidekick. And while Pollywaffle sure did look like Periwinkle (almost identical, in fact), Pollywaffle barely made a peep. Totally different. Periwinkle would have been barking and racing around, but Pollywaffle was a calm and quiet young lady.

I suspected that Pollywaffle might have a few fans once Ma and Pa put her up on Facebook and Instagram, as had my foster siblings in the past. But I swear to you, paw on my heart, from the very first photo on the very first night, almost every single photo of (me and) the Pollywaffle all but broke the internet!

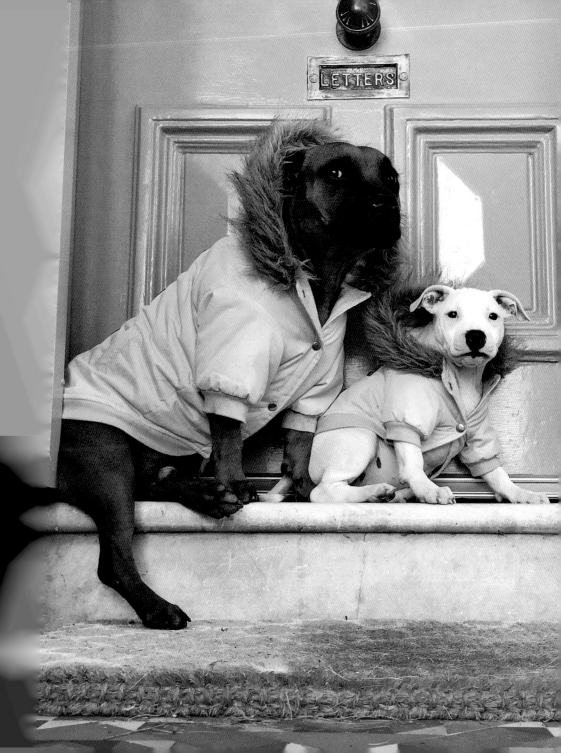

✳
P
W
A
F
F

Pollywaffle also got herself one of our famous shortened nicknames – for example, we've had Pancake ⇨ Panny, Pudding ⇨ Puds, Porkchop ⇨ Porky, Periwinkle ⇨ PWink, Porridge ⇨ Podge, and so on and so on. Pollywaffle was now commonly known to many as 'PWaff'. The hashtags #Pollywaffle and #PWaff were even trending! The ironic thing is, when you pick such a unique name for a pup like this, they'll never know it themselves. Both Periwinkle and Pollywaffle, being deaf, will never hear their cool-ass names. But I still reckon the rents know what they are doing. Two unwanted deaf puppies turned into well-known, social-media-famous-dogs . . . not bad at all, huh?!

I don't even know where to begin recounting all the adventures me and Pollywaffle had. The kid was pure rescue gold. She was funny, fun, kind, gentle, cheeky and looked as though she was always smiling. Even when her little black lips were pressed together and she was staring into the distance, it just looked like she had a smile on her face. This is probably the reason why Ma always used to call her 'Mona Lisa Pup' or 'Waffle-Lisa'.

This time round, with their second deaf foster pup, Ma and Pa made it their mission to get into some serious training. Googling everything they could find about how to train deaf dogs, they found that sign language and hand signals were a good place to start. Ma sat Pollywaffle down and started with the basics. An hour later, after her first round of sign-language training, Pollywaffle had learned 'sit', 'drop', 'shake hands', 'stay', 'no' and 'good girl'. One hour is all it took to train this twice-dumped little deaf staffy using pup hand signals. The coolest part was, later she also learned a sign for her name (Ma kept that easy, just the letter 'P') and a sign for 'love'. Ma and Pa would give this signal when they wanted cuddles or kisses with PWaff.

Combine all this with the aesthetic appeal of this little dog and you can totally understand why she quickly became the most popular foster sister I ever had. People from all around the world wanted her paw-tograph or a chance to meet her and rub that silky-smooth belly of hers.

During Easter our local community used to hold a Doggy Easter Parade down in the Town Square. Hundreds and hundreds of local dogs and kids and families would join in on the fun. This particular year PWaff and I decided to dress for the part, going as a captain and first mate duo. Who in the world knows why we won no prizes, we clearly had the best combo and costumes around!

I let our Facebook followers know we'd be at the parade in the lead-up to the event, and so while we may not have won a single prize, we did win the love and attention of many people that day. I recall a group of lovely giggling ladies who approached us after the parade as we were having some froyo. They came up almost screaming with delight (Pollywaffle had no clue, of course, and kept focused on her froyo). Apparently it was one of the girls' hens' parties and when they saw on Facebook we'd be out at the parade that day they quickly altered their plans to make sure they could add meeting us to the hens' day fun!

When it finally came time to sort out the adoption of the now-famous Pollywaffle, my rents were faced with the challenge of sifting through a never-before-seen number of applications. As I mentioned, PWaff had fans from all around the world and so too had adoption interest from all around the world. In the rescue community it is not common to entertain the idea of sending a puppy or dog out of your area, out of the state or out of the country – unless you reside in a somewhat remote area, meaning that you might not have a lot of suitable adoptive options so you need to broaden your search and consider sending your foster pup off on a plane to their forever home in another location. We, however, live right in the city (about ten minutes' drive away from the Sydney CBD) so finding a suitable adoptive forever family isn't usually that tricky. On occasions, like with Nox and Periwinkle, when Ma and Pa look at all the applications there will be a few that seem to stand out (like that sixteen-page adoption application that was sent by Peri's mum).

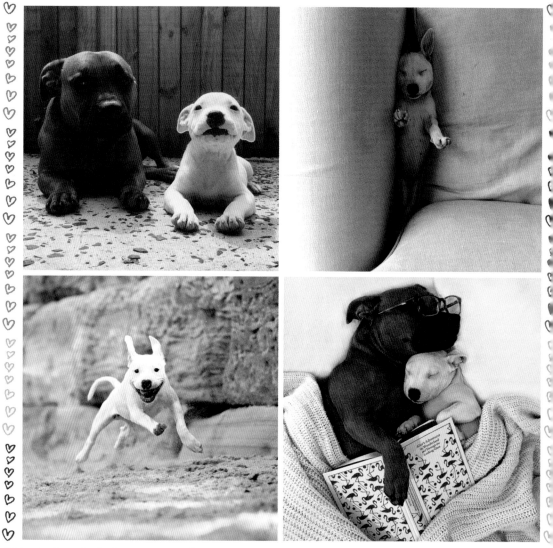

Pollywaffle's adoption applications had been culled down to the top fourteen candidates. Hours on the phone and a few days of 'thinking on it' later, Ma and Pa had narrowed that down to a top three for interviews. Before this there was even a Skype interview with a family who were travelling and just didn't want to miss out on the opportunity to apply.

Interview day was to be a Saturday, and this time it was decided that Ma and Pa would go to each new prospective home with Pollywaffle and interview the families in person. The on-site interviews were partly to do with the rents wanting to do both a home and yard check, but also, apparently, I was no longer allowed to be around for adoption interviews because I took all the focus off the interviewing. The rents had it in their head that I seemed to think people coming to our house for interviews were there to see me, and I was distracting from my foster siblings with all my charm, witty banter and movie-star good looks.

So it was that the rents and PWaff headed out for a full day of interviews, and when they returned they had a pretty good idea of where Pollywaffle was going to live forever.

One family in particular stood out. From the moment Pollywaffle walked through their front door she just seemed to be at home. They had two other older staffy sisters for PWaff to have as company and learn the ropes from, and they had a large human family, with three sisters. They had never had a deaf dog before but were willing to learn and enrol Pollywaffle in special classes. Once it was all decided and everyone had been notified, and the adoptive family congratulated, the day of adoption handover and for PWaff to leave the foster care nest was booked in. Our remaining time together as foster bro and sis was limited.

We spent the next few weeks living it up, with lots of snuggly sleep-ins, enjoyable outings and memories made. Pollywaffle's new family had been following me on Facebook for a while now and so they had promised that this wouldn't be goodbye forever, and that my little sis and I would get to catch up again down the track.

The morning of Pollywaffle's adoption was a little more sombre than most, only because PWaff had been with me a little longer than other fosters and we had formed a very tight bond. Ma worked her magic with one final photo that she uploaded to Facebook as she and Pa put PWaff in the car. I made the sign for 'love' with my paws one last time and watched her leave.

People often write to my rents in Facebook comments and say things like 'Oh no! You can't separate them', 'Can't you just adopt her/ him?', or 'Won't they miss each other?' We can guarantee at least a handful of these comments each and every time a foster sibling of mine is about to be adopted. I often have to reply and remind people that this is what foster care is. It's the bridge between no hope and happily ever after. I try to remind people that we almost always stay in close and regular contact with my past foster siblings. Of course there are some that I as well as my rents (and sometimes even Shelly and Betty) miss a little more than others. There is a very wise saying about foster care that goes something like this: 'You don't have to like all your fosters, you just have to love them.' But with Pollywaffle I can honestly say the whole family loved her. She was one of a kind.

But the revolving doors of foster-care fate would soon turn again. Who or what could possibly come after the most famous, the most lovely, the most beautiful, deaf, crisp white, Mona Lisa–smiling puppy named Pollywaffle? Who indeed!

AND ALL THAT, SASS

ONLY DAYS PASSED BEFORE MA WAS AT IT ONCE AGAIN.

She spotted a pound listing for an un-photographed stray puppy, seven weeks old (as guessed by the ranger), who had just been brought in, no microchip and no owners looking for her (sounds familiar, don't you think?). On the phone, Ma was told that this little pup had been taken home by one of the kennel managers who was experienced with young puppies, and this one would have to wait the holding time before being released into rescue. The pound told Ma it would be six to eight days before they would know if she could indeed go to rescue.

No less than three days later Ma's phone rang with the news that the pound had decided to release the little puppy into rescue early. Of course, Ma inquired why this was. 'I thought she was in temporary care with one of your experienced staff?' she said.

'Oh, she was, but this puppy is trouble! She is very noisy and is attacking the carer's own dog,' which was a giant mastiff.

'Really? But I thought she was just a seven-week-old puppy? Gosh, okay, I'll be there to pick her up in an hour!'

Ma turned to the Spinsters and me and said, 'I'm going to pick up your new little foster sister. It should be fun, but brace yourselves, kids, this one sounds interesting!'

Ma couldn't help but feel a nervous excitement while waiting in the office of the pound. Then, in came a kennel manager. 'Here she is!'

Ma looked to the ground, assuming she'd see a baby dog on the end of a leash. Nothing down there on the floor. Ma looked back up at the kennel manager a bit confused.

'No, here, this is her,' she said, unwrapping her arms to reveal to Ma a tiny little speck of a puppy. All this fuss over a tiny 700-gram Chihuahua?! Ma was speechless. Surely they had to be joking when they called saying this little dog – the smallest puppy Ma had ever collected from a pound – had caused so much trouble? Not really knowing what to say, Ma rushed through the paperwork, signed what she needed to, scooped up the little chi pup and walked back to the car. Ma had brought my little big sister Shelly's old puppy collar with her, and even that was swimming on this puppy.

On the drive home Ma went over a list of foster 'P' names in her head. Being so small and coming as she did with a warning of a 'big' personality, the name 'Pineapple' seemed to stick. Though Ma, being a clever Ma, had already decided by the time she parked the car back at home that puppy Pineapple would most likely go by the abbreviated name of 'Papple'.

Papple made not a peep during the whole journey home. When she was introduced to me and the Spinnies, same thing, not a sound. She seemed like a sweet little thing, quiet, a bit shy, but comfortable and alert enough to settle in and have a good meal and nap by the heater. Looking at her fully developed puppy teeth and the rest of her tiny figure, Ma knew from experience that this was no seven- or eight-week-old puppy; she was more like four or five months old. She would later confirm this guesstimate with Doctor Nathan.

'Pineapple' went to 'Papple', which quickly became 'Paps' and even sometimes 'Pap-Pap' or, at more testing times, the 'Papple-rat'. For the first few hours and even the first few days, the rents simply could not figure out what the kennel manager and pound staff were talking

about when they declared Papple to be 'trouble'. They also couldn't figure out how or why this little tiny thing could have ended up as a stray and not have a worried, frantic owner out there looking for her. Paps had come right on in and made herself at home. She followed me around like a little shadow (one that would occasionally nip at my ankles to let me know she was there). She'd curl up with me or seek out my sister Betty Boo for some gentle play rumbles, and Paps was even pretty respectful of the matriarch, my oldest sister Shelly. Most puppies take a couple of weeks to figure out the Spinsters. Not Papple, this kid had it clued in.

It wasn't until about day three or day four that the Papple-rat's inner 'sass' started to show. I should point out here, before I go any further, that Papple was never aggressive or violent or even mean. The difficult part of explaining the 'extremeness' of Papple's personality is that I can't really describe it more past saying that she was vocal – highly vocal. Lots of peeps who have little dogs or even Chihuahuas might be nodding their heads about now in a knowing kind of way, but let me tell you, Papple was like no other! It might be something to do with her tiny windpipes, but the exact pitch of Papple's squealing screams was *incredibly* ear-piercing. And to top it all off, she'd use her little voice at almost anything, at any time.

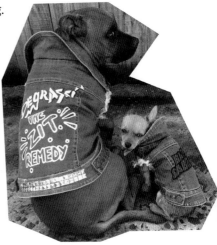

I remember clearly one morning when Papple had started chewing on our coffee table. Pa went to tell Paps off with a simple, firm 'No!' and a clap of his hands. He was standing in the kitchen and Papple was over by the couch, but even from that distance the clap of Pa's hands just once was enough to set Papple off. She *screeee-amed* her little head off and I swear to you, somewhere there was glass breaking! I really

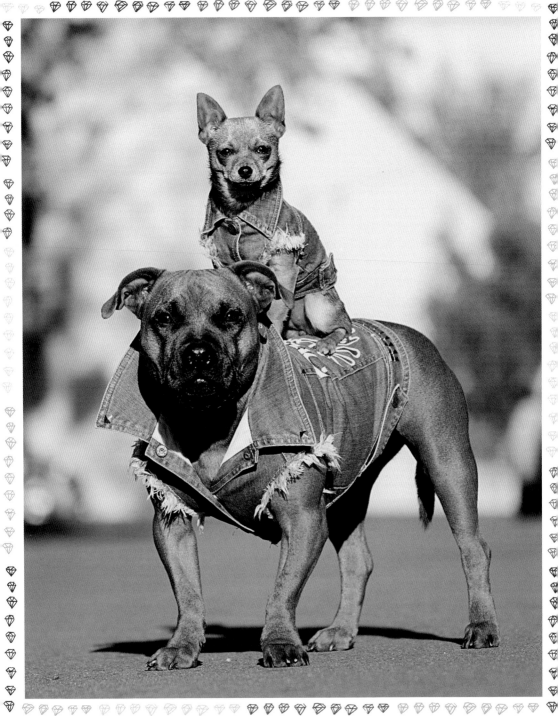

don't know who was more traumatised, Pa or Papple. Needless to say, from then on the rents trod on eggshells whenever telling Papple off when she was up to no good.

It's funny to think back now just how well Papple had my rents wrapped around her paw but if I think too much on the topic, the sad truth is that poor little Pineapple pup was an extremely traumatised kid. Wherever she had been before ending up at the pound could not have been a nice place. She had little to no trust in strangers and would always be on the defensive, ready to let people know there was no messing around with her.

Luckily, this behaviour did improve a little, and Paps changed a bit over time. Once she figured out that a kind and loving foster family with the best big bro were always going to have her back, then she really got into her groove.

Having to follow in the footsteps of the famous Pollywaffle on social media would have been a daunting task for anyone to tackle. Papple? No problem. The sassiness and charm of this little rat-like puppy won over even the biggest staffy-loving fans. How a foster will be received online is never really something that my rents put too much stock into when they take on a new foster kid – after all, the main attraction on our social media is and always will be me, of course. Fostering for Ma and Pa is all about bringing in a little mite or two that really just needs some tender loving foster care.

However, together, Papple and I were a duo like no other so far. Papple sitting next to me or often perched on top of me, riding on my shoulders and being my lookout, was far different from anything my Facebook and Insta friends had ever seen before in my photos. It was also something I doubt our neighbourhood saw too often, either. The best bit is that Paps being so tiny made me look huge! And considering I had little to no time to myself to head to the gym, this was wonderful for my image. I've never looked so ripped and toned. I highly recommend everyone having a Papple to boost your confidence.

Of course, the matching denim battle jackets that were custom made and sent to us from our Melbourne pals at Pet Haus were a total eye-catching, street-stopping draw when we'd head out for a coffee or strolling round the markets. Mine is a one-of-a-kind homage to my fave 1980s show *Degrassi Junior High*. And, perfectly suited to her, Papple had a tiny custom made 'Bark Sabbath' jacket. We made double denim cool again, and made no apologies about it.

Because of the unique personality of the one and only Pineapple, my rents knew that they really had to take their time and would have their work cut out for them when it came to rehoming Paps. She wasn't your usual puppy or even your usual Chihuahua pup. She was and still is a very smart crumb of a cookie and really knows how to work her humans. Whoever adopted this little kid would need to be okay with always being kept on their toes, have a lot of time for her and a lot of patience and love to give. Papple was a real 'rescue' case. She had a huge amount of potential that just needed to be realised and cherished.

A couple of weeks of foster care flew by and me, the Spinnies and the sass-queen had it all figured out. But of course, when things get 'easy' and comfortable, that's when you know change is a coming. Living with a famous foster bro in Australia's most famous foster house is never as easy as Pie.

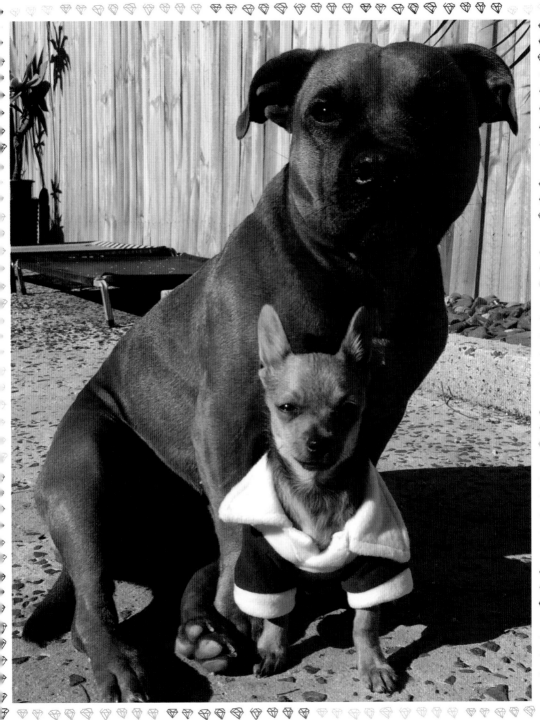

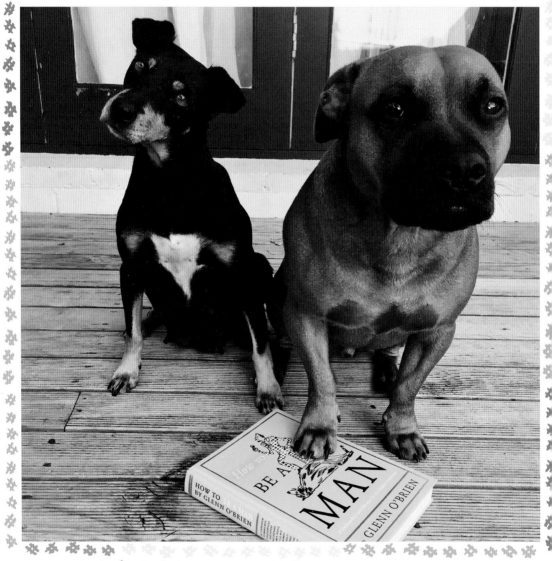

THE SWEETEST PIE of THEM ALL

PAPPLE HAD MADE HERSELF SASSY QUEEN OF THE CASTLE.

Winter was coming (and not just 'cause the Stark family told us so). Our little old gas heater was back on full fire. Things were seemingly calm as winter rolled in. Then Ma's phone rang once again (time to start putting it on silent, methinks). This time it was a request from the rescue. 'There is a very scared, small-ish dog sitting in a cold pound down south. She is heavily pregnant and we don't have anywhere for her to go. Any chance she could come and stay with you at HQ? Just for a few days, three or four at most, just until we find somewhere more long-term where she can have her babies?'

So the next day, delivered right to our door straight outta the pound, was a petite young soon-to-be single mother. Thought to have been a Manchester terrier mix, her belly was so big but she was still a few more weeks away from whelping. One of the first things I did was reassure my friends on FB and Insta that I was not the baby daddy, but I'd be proud to be a step-foster-daddy should the pups need a strong staffy influence in their lives when they were born.

The rents knew exactly what name to go with this time; this lovely black, tan and white beauty was named 'Pecan Pie', or 'Mamma Pecan Pie' as she was often called.

Pecan was very timid for the first few days but she seemed to get very attached to both my rents and me. I remember that when she was invited to sit up on the soft couch or down on one of the plush dog beds in front of the heater, she was so appreciative of such luxuries that she would barely move from either spot. I don't think she'd ever sat on a couch or in front of a heater before. In fact I don't think she'd ever been in a house! Pecan's teeth were all worn down, and she would flinch at simple movements and completely 'pancake' (this means to lie flat on the ground) when she was even a little unsure of something.

Her belly was so round and tight, but Pecan seemed pretty comfortable. Ma decided she needed some medical assessment and promptly took her up to see Doctor Nathan and the vet staff. Doctor Nathan booked Pecan in to have an ultrasound with Doctor Emma.

Up on the ultrasound screen, Ma and Doctor Emma counted at least four tiny skulls and, like all the staff at the pound and the rescue, Doctor Emma guessed Mamma Pecan Pie would have another few weeks before she gave birth.

Ma and Pa were relieved to hear this as they were not really prepared or equipped for Pecan to stay any longer than a few days, let alone give birth at our place. They still had my foster sister Papple to take care of, and with Pecan in the house it brought our numbers up to five of us pup kids. Hopefully another foster home would be secured in the coming week and Pecan could get settled in and ready to whelp.

Both Doctor Emma and Doctor Nathan gave Pecan a clean bill of health. They also both suspected that Pecan's worn-down teeth indicated that she had probably been kept in a cage for most of her life or at least for long periods of time. Her teeth were worn in a way very much like a dog that has gnawed and chewed on a metal cage.

Back home, Ma decided to try to get a little more info on how Pecan ended up at the pound pregnant. After piecing together reports from the pound and some info messaged in by a Facebook follower, it turned out that Pecan Pie was found as a stray. She was found standing on a street

where a pet store had suddenly closed up shop only days before. The pet shop was one of those typical puppy- and kitten-selling places where it was common local knowledge that they were probably puppy farmed. When it had been open for business, the pet shop would always have a range of puppies for sale, and mostly those puppies would be of smaller breeds like Pecan. One day the pet shop was just closed. Overnight it had been vacated and the business had disappeared entirely. And within a day or so, there was Mamma Pecan standing in that very location looking lost and scared. She had no collar, no microchip, a belly full of babies and her worn-down teeth. Doctor Nathan and Doctor Emma both also advised that this was clearly not Pecan's first pregnancy; her little body showed the signs of having had possibly many litters prior.

The people who found Pecan just happened to also be vet nurses and staff at a local animal hospital. They said they spent a good twenty-four hours trying to coax Pecan onto a leash, but she was very scared and unsure and wouldn't let anyone approach her, and didn't want to leave the street where she was found. Finally, after she spent a cold night hiding under a parked car on the road, the persistent vet staff were able to scoop her up and take her into work to check for a microchip.

Poor Mamma Pecan Pie! After hearing all that I understood why she was so frightened, and I understood why she felt so grateful for the luxuries of a warm foster home. Maybe she could stay a little longer, I thought . . . Time to have a chat with rents and see what they said.

The weekend had arrived and for the first time in a long time Ma had actual plans to spend a whole day away from us! A day without dogs! She had booked herself in to volunteer with some of her dog rescue friends at a wombat refuge and rescue down in Canberra. Ma got up super early on the Sunday morning and excitedly got ready, and we all went in the car to drop her off at the meeting point. 'Now Pikelet, I want you and Papple to be good for Pa today, and help him look after Mamma Pecan please.' Nodding and waving goodbye, Pa and I headed home, the two men in our house full of lady-dogs.

We got back ready for a nice easy Sunday breakfast and lie-in. Pecan didn't want to eat. Bit strange, as normally she'd be the first to finish her food, gobbling every last bite as if she'd never seen such food before (which was probably close to the truth, really). Pa noticed Pecan's lack of appetite but figured she might just be missing Ma or something.

Lunchtime rolled around and Pa placed another bowl of food in front of Pecan. Still nothing. I couldn't believe it! The Spinsters and I rarely got offered lunch – that was usually something only our foster siblings got, as they were usually babies or dogs who were sick and needed extra meals like lunch and second lunch. Pecan Pie just looked at the bowl and then back up at Pa. And that's when she started some heavy panting. Pa, having never been around a dog (or human) about to go into labour before, had to go with his instincts here. And his foster-Pa instincts were telling him that today, three days after arriving from the pound – today was the day that Mamma Pecan Pie would have her babies.

Staying cool, calm and collected, Pa ushered Pecan into our guest bedroom and closed the living room door, leaving me, Papple and the Spinsters with the heater on and Sunday sports playing on the telly. He placed Pecan on a nice soft bed and collected some clean towels, and settled in. Within an hour of Pecan's suggestive panting, the very first baby slug arrived, all wet and gooey, and still in its little birth sack. Pecan leant down and burst it open, and with lots of quick licking and gentle nudging, the tiny bright white baby slug came to life. Mamma Pecan Pie knew exactly what she was doing – this was her jam. Carefully and respectfully Pa scooped up the little fresh-born pup for a quick once-over and check. It was a boy! Pecan had a son!

At this point Pa thought he should probably get hold of Ma and let her know what was happening. After all, she had joked to Pecan earlier that morning, 'Don't you go having your babies on the one and only day I'm not here, okay Peaky?'

Pa took a quick snap of baby number one, with a simple message: 'First one, it's a boy!'

Of course, Ma recalls the moment she looked down at her phone to see the blurriest photo of what looked like a blood-covered white ball of . . . something? Without waiting a second she was calling Pa and demanding to know more. But wait, 'My phone is nearly out of battery, make sure you record all the times and which one is which. Oh, and don't forget to record if they are boys or girls! I'll be home as soon as I can.' Then her phone ran out of juice.

Back home at HQ, Pa was watching as baby number two came into the world. Pecan so effortlessly knew exactly what to do, just as she had with the first. This time a little Pecan mini-me – a baby girl who looked to be a replica of Mamma Pie. She was black with tiny patches of white and tan markings. With almost exactly an hour between each birth, Pa wasn't so sure Ma was going to make it back in time. She was at least a four-hour drive away, and that's only if they had left the very minute she called.

An hour or so after the little girl, out came number three. Another Pecan lookalike, but this time a boy! With three babies now latched on to their mamma, drinking milk and almost perfectly clean (after Pecan had given them a wash all over while making sure they were all doing well), time flew by and more than the usual hour had passed. Pa started to get a bit worried now. Pecan had started taking some heaving breaths and it looked like she was having some pretty painful contractions. One more, perhaps? Pa wasn't sure. Then the little white head of puppy number four started to crown. But something wasn't quite right.

By this time, help had arrived. Marina (the foster care coordinator who had placed Pecan Pie with us) had come to assist Pa for a while until Ma was home. Marina and Pa could see that this time Pecan was having difficulty. The little white pup, whose head

was only just showing, was taking forever to birth. So Pa decided that his canine midwifery skills were needed. Pa gently pulled the little pup free from Pecan and helped her break its birth sack. A couple of tummy rubs from Pa and licks from Mamma Pecan, and the little white puppy was breathing and ready to suckle and drink his first taste of milk.

A great big sigh of relief from everyone involved. Pecan seemed to really settle down and relax, and it was finally all over. Her babies were here, happy and healthy. Three boys and one little girl. Two white pups and two black pups, all with a range of markings of black, tan and white.

And just like that, it was dinnertime here at HQ. Pa left Pecan to attend to her babies in our guest bedroom while he prepared dinner for me, Paps and the Spinnies. We knew something had gone on, we could hear Marina and some other helpers from the rescue coming and going, but Pa was insistent that we not go and visit the new mum just yet. She needed her sleep after such a long and eventful day. Also, Ma was due home any minute.

Ma must have gone straight in to be with Mamma Pecan and her little babies, because we didn't see her until much later that night, though I could hear her talking.

She told me that when she got in from her day of wombat volunteering, Ma and her friend Kim (who also happens to be known here at HQ as 'the treat lady' or 'Mrs SavourLife', after the dog treat company she and Mr SavourLife own) did in fact go straight into the guest bedroom. Apparently Pecan was very happy to see Ma and was relaxed about Ma picking up her babies for first cuddles. Ma and Kim stayed with Pecan and were chatting away when Kim suddenly exclaimed, 'Look!' pointing at Pecan. Just in time, Ma looked down to see another white puppy arrive! Pecan moved quickly and broke the birth sack and went straight in for a clean. Another boy – another white boy!

So now there were five and, yes, this time Pecan Pie was all done having babies. I mean she was all done having babies forever! This little litter born in my guest bedroom would be her last, and she would never

have to go through the mammoth effort of being pregnant and delivering puppy after puppy again. Pecan would go off to be desexed in a couple of weeks, once the pups had started on their solid food.

But I'm jumping ahead a little yet again. Back to the five newly born pups; for them, it was now a matter of names. Before these were decided, the rents had some more special guests arrive. Two of my local human friends, Kimmie and Fabio, had just lost their own fur child, Nemo. Sweet old Nemo had been a pup friend of mine since the beginning. But as it goes with old dogs who keep getting older, their time is limited, and on this very day, about the same time that Pecan's puppies started to arrive, Nemo passed away peacefully with all his loving humans by his side. Kimmie and Fabio needed a little cheering up and Ma suggested that some newborn puppy cheer might be the perfect thing at a time like this.

So when Kimmie and Fabio edged into our cramped guest bedroom to meet the newborns, Ma had the idea that they should have the honour of picking out a pup and naming him or her.

With tears pouring down their cheeks they decided that the only little girl of the litter would have the name 'Nemo' bestowed upon her, a perfect namesake from a grand old gentle pup.

So the first puppy had a name – 'Nemo Pie', the 'Pie' part obviously taken from her mum's name. Now to name the others. Ma decided to take a little break from the food names that she usually went with. This time she chose the names as follows: the firstborn white pup with a black eyepatch was 'Pilot Pie'. Second-born was of course 'Nemo Pie', the only girl. Third-born, the biggest and only mostly black pup was 'Puffin Pie'. The little fourth-born white pup that had gotten stuck during delivery, and who was the smallest of all, was named 'Pigeon Pie'. And the fifth and last pup, all white with markings giving him a half black and half white face, was named 'Penuckle Pie'. Five unique names for the five babies of Mamma Pecan Pie. In not too long these babies would go on to become well known across my social media accounts

as the 'Pie Slice Puppies', a named conferred by Ma to make it easy for people to refer to them other than just 'the puppies'. Each was a sweet 'slice' of pie, Pecan of course being the sweetest of them all.

Milk-drunk newborn babies, a tired mamma and exhausted foster parents; it was time to call it a night. Ma got the guest bedroom all set up and ready for her, Mamma Pecan and the Pie Slice Puppies to settle in for the next few months together – this room would be base camp, as it so often is for my foster siblings. Ma would sleep in the guest bed every night, just an arm's length away, in case Mamma or the puppies needed her, though I'm not sure just how much sleeping Ma did during those first few weeks . . .

Over the next few days, me and my sisters (Papple included) saw very little of Pecan. She would just pop out and walk through the living room to have some toilet time in the backyard. As she passed through she would always sneak me a kiss. I kid you not, Pecan truly loved me, and I'm pretty sure she was letting me know that she had high expectations that I would step in as foster-dogfather when the pups were old enough to mingle with the rest of us. (Let me remind you all again that

I am not the baby daddy! No matter how good-looking those Pie Slice Pups turned out to be, I can assure you that it's not thanks to my good genes.)

Life in a small inner-city house filled with two humans and ten dogs is what I'd call 'organised chaos'. Actually, if I'm going to be truthful, at times it was just plain chaos. The poor rents had so much going on. Pa was out there working full time doing what humans do when they leave the house. Ma was working around the clock as a full-time dog and foster-dog Ma. She made sure to share her time and love around to me, Papple and the Spinsters as well as tending to Pecan and the needs of the puppies. And if that wasn't enough, we even had my bro Jack (aka puppy Balmain) come to stay for a few weeks while his parents were away. So that took the tally up to eleven canines.

Once the Pie Slice kids were around two weeks old, Ma started to bring them out into the living area and slowly introduce them to us. This mostly involved a lot of sniffing and watching as Ma helped out with a bit of extra bottle-feeding, because by this time Pecan had started to show signs that she wanted and needed some downtime from the pups. I guess all those many litters of kidlets before these Pie Slice Puppies had taken their toll on Pecan. And now she just wanted to be done with her mothering duties and enjoy being a dog. A dog that loved the comfy couch and the spot right in front of the heater. Oh, but please don't think that Pecan was shirking her duties as a mum! Quite the opposite. Pecan was so caring and nurturing of her bubs. She would make sure that each one was well fed and clean all the time.

In fact, it was Pecan's almost obsessive cleaning of one of her little babies, her focused efforts trying to get him to poop that had caused calluses to form on his belly from her overcompensating tummy licks, that eventually made Ma realise something was terribly wrong with baby Pigeon.

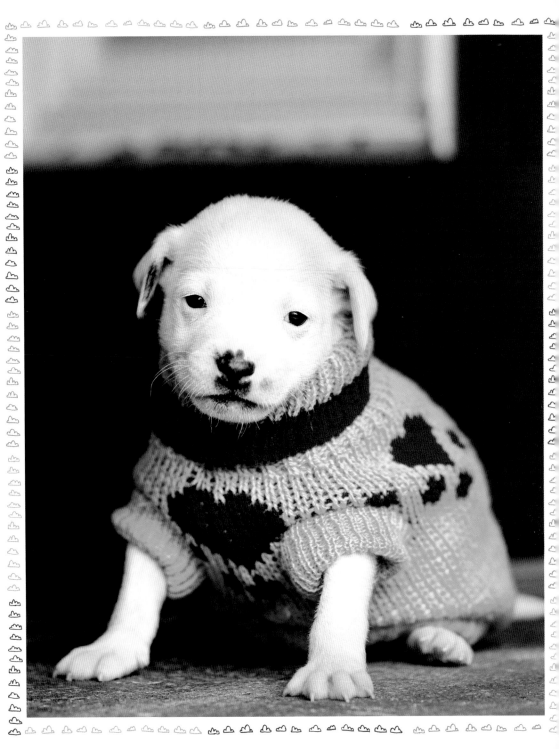

A PIGEON
WITH
WINGS

RIGHT ON PIGEON'S LITTLE BELLY, BETWEEN HIS BELLYBUTTON AND BOY BITS, A CALLUS FORMED FROM PECAN'S CLEANING LICKS... OR HAD IT BEEN THERE SINCE HIS BIRTH?

Looking back on photos Ma thinks maybe this was the case. Pigeon's little tummy was probably the only part of him that wasn't really that little. It was big and bloated right from the morning after he was born. Ma and Pa didn't think anything of it because he had been drinking milk all night and they just thought he was full.

Maybe it had something to do with the way he came into the world with a little difficulty, but the rents made comments between themselves that they thought Pigeon looked a bit different from the others, that he was special. His head was a little more elongated or squished – as Pa put it, he had a 'cone head'. (FYI, Pa thinks he has a cone head too.) Pigeon's belly was big in proportion to his little body and he was the smallest of all the Pie Slice Puppies. He was also the one pup that always, always, stayed close to Pecan at all times. And one very important thing Ma had noticed is that Pigeon had not once in the first two weeks of his life pooped on his own.

Being a good attentive foster Ma, she took Pigeon up to see some of the vets at our local vet hospital. Each time it was simply just too early to run any tests on the little guy and, in the words of one of the senior vets, 'With litters of puppies you sometimes get one or two born with abnormalities. You just have to let Mother Nature take its course and wait to see if they survive or expire.'

Ma knew the vet was a smart man, but she just couldn't stand aside and do nothing. This wasn't just any normal litter of puppies – this was her Pie Slice Puppies, and Pigeon was the special one. The rents joked that if they were to adopt one of the Slices themselves it would probably have to be Pidge. This made perfect sense, because he had a cone head just like Pa!

After a lot of research on the internet and YouTube on how to assist new baby dogs to poop, Ma found a technique that she hoped might work. It basically involved filling up a syringe with warm water and pushing a little up Pigeon's bottom, and then gently massaging it out with poop. This seemed to help so, diligently, once a day or every few days, Ma would get to work helping Pigeon to poop. Finally, when he was about three or four weeks old, Pigeon started to toilet on his own and Ma felt much relief. Still with a big bloated tummy, but now pooping on his own, Pidge seemed to be developing just as well as his siblings.

Something really interesting to know about newborn baby dogs is that they are not only born with their eyes closed, which most people already know, but they are also born with their ears closed. I mean we dogs are born with no ear holes. None! They open up after a few weeks of development, just like our eyes. And guess who was the very first to open his eyes from the whole Pie family? Yep, it was little Pigeon Pie. Well, not really eyes so much as *eye*. Of course, being special meant that he did things his way, and he had one eye open for about a day before the other opened. It was the only girl pup, Nemo Pie, who managed to be the first with two open eyes. Still, the title of first eye-opening must go to Pigeon.

Teeth also start to form later on, at about four to five weeks, and Pigeon's tiny toothies came in at the same time as his brothers and sister.

As they matured, the Pie Slice Puppies seemed to grow into their names. For example, Puffin still managed to be the big puffy kid of the family – he was very pushy at feeding time and knew exactly where to go to maximise the milk flow from his mamma. He had a favourite teat of hers and then a second favourite once that one was all out. Then, first-born Pilot Pie showed his interest in adventure and discovering new

aspects of the whelping box. He loved to climb the safety rail, looking over at the world outside the box.

From about four weeks onwards the rents started to bring the Pie Slices out into the living room to have some free time with the rest of us. Mostly I would just sit very still while they crawled all over me like little puppy-slugs. I have to admit that small baby dogs tend to freak me out a little. They are so delicate that I feel the best way to handle their fragility is to stay completely still around them and not move a muscle. Also I find that if you use this tactic then they either move on and go explore something else or curl up next to you thinking you're just a large hot water bottle.

Also around the four-week mark in the life of the Pie Slice Puppies they had their first try of solid food. Although I'd hardly call them solids in my books – it was more like mushy grey paste. Ma would blend up kibble with puppy formula and a bit of puppy milk, then place it on tiny teacup saucers for the puppies to lap up (or try to, at least). They'd get this mush a couple of times a day, alternating with milk feeds from Mamma Pie. Pigeon was right in there eating like a champ and pooping like a champ, but still that big belleh of his really worried Ma.

So Ma made another effort to figure out what was going on with baby Pigeon Pie. He seemed to be doing okay but he wasn't gaining weight at the same rate as the others, even though his belly region seemed to keep getting bigger.

This time Ma and Pigeon booked in to see Doctor Nathan at the vet hospital. Doctor Nathan agreed straight-away that an ultrasound and possibly an X-ray were needed to explore what was happening inside Pigeon. When the imaging from the tests was up on the screen, Doctor Nathan broke the news that Ma's concerns about Pigeon's inner workings were correct. His insides did not look as they should. At Doctor Nathan's advice, Ma was to take Pigeon to a specialist hospital where they could do a full CT scan of his body.

At times like this most breeders of dogs would either do nothing further or simply have the pup put to sleep. But Ma was not a breeder, she was and is a rescuer, and Pigeon was family. After chatting with the rescue who brought Mamma Pecan to us, it was decided that the further testing would go ahead. By now the Pie Slice Puppies had such a great following through my Facebook and Instagram accounts that when Ma put up details of urgently needing to raise some funds to cover Pigeon's predicted veterinarian costs, people rallied and donated nearly three thousand dollars in just a day or two. It was truly incredible – once again, the kindness and generous support of my social media followers had proved to be invaluable to my foster brothering/fathering abilities.

I stayed home to look after Pecan and the rest of the kids (including the still sassy-pants Papple pup) while Ma spent a few days going back and forth with Pigeon to the specialist hospital. Pigeon's CT scans were baffling to the doctor. It was something neither he nor his staff had ever seen before. It looked like perhaps Pigeon had been born without a bladder, but he couldn't be sure of that. Pigeon was far too tiny and young to have any exploratory surgery. His prognosis at this stage was that of the grim unknown. However, the specialist predicted that it was not likely he would live a long life. How he was functioning right now, and the fact that he had made it to this point, was almost a miracle. Reporting back to a concerned Doctor Nathan, Ma told him all that had been discovered by the CT scans and that there was still no certainty as to what exactly was wrong with Pigeon, only that his body couldn't keep going like this. Doctor Nathan, being the wonderful and compassionate doctor that he is, asked for those CT scans. He was going to send them off to some other specialists around the globe to see if there might be someone out there who had come across something similar. It couldn't hurt to try to find some answers and possibly a way to move forward and treat Pigeon for his dire health problems.

This all happened in a matter of days. On the sixth day after taking Pigeon to see Doctor Nathan, Ma woke up that morning to find a very lethargic and listless Pigeon. For the first time ever he was not interested in eating.

Not the puppy mush or warm milk from his mamma that he so loved to guzzle. A sense of dread flooded Ma and, with adrenaline coursing through her exhausted foster Ma body, she rushed Pigeon up to see Doctor Nathan.

Confirming the absolute worst, Doctor Nathan explained that Pigeon's body was shutting down. He was dying.

'Is he in pain, do you think? Are you sure he is dying? What should I do?' Ma asked as tears welled up in her eyes. Her vision was becoming blurry and a heavy sadness was creeping into her heart.

'No, I don't believe he is in any pain. You should take him home and let him be with his mum and siblings. He might make it through the night, but be prepared, I think he will pass soon.'

Doing exactly that, Ma bundled baby Pigeon Pie, the special little cone-headed puppy (who had become a little less cone-headed as he grew), and drove him home to be with his family.

Ma brought Pigeon into the living area for all of us to see him and possibly say goodbye. Not wanting to completely accept the prognosis, Ma filled a feeding syringe one last time and tried to get Pigeon to eat and drink some water. But it was no good. He was giving up. That big round belly of his had suddenly shrunk down to nothing. He had peed all the contents out. We knew this must be it.

Last cuddles – Ma wrapped Pigeon up in her hoodie and placed him on her chest, lying directly on the warmth of her skin. She whispered to Pigeon that he was loved, he always was and always will be. She told him he might not have grown to live a long life but his life meant something to her and she would miss him, but she knew he had to leave now. His breathing grew shallow and his breaths were few and far between.

Now Ma moved Pigeon down into the whelping box where his Mamma Pecan Pie lay very still. As Ma moved him into Pecan's embrace, Pecan knew her fourth-born Pie Slice needed the love of his mum. All the other Pie Slice Puppies were sleeping soundly close by. It was only baby Penuckle who woke up and crawled over to his dying brother and lay across him, as if to keep him warm.

And then Pigeon Pie drew his last breath.

Finally our Pigeon used his wings to fly up over the rainbow bridge. Like the rest of his siblings, he had really grown into his name.

Born, grown and nurtured in our guest bedroom, Pigeon passed away from natural causes in the very same room he had spent the majority of his life, surround by love and in the arms of his mother. It's painful even now, years later, thinking about the day Pigeon passed away. Ma and Pa were incredibly sad in the days that followed and Mamma Pie had a composed quietness to her. Ma still gets teary thinking about Pigeon, and even today sometimes her eyes don't stop leaking. Back when Doctor Nathan first discovered the seriousness of Pigeon's birth defects the rents had made the firm decision that, no matter how long Pigeon was to live, he would stay with them and they would adopt him as my forever brother. I guess that's why Ma took it so hard. But then I think she would have been just as sad had it been any of my foster siblings. Foster family or not, it's all the same – family.

Because of the uniqueness of Pigeon's health defects, the specialist doctor who had seen him asked whether we would be willing to submit Pigeon's body for a post-mortem examination so veterinary students could possibly learn from his case. As morbid as it is for me, Pikelet, to be telling you all this, I really think it's a good thing to know, because the results were very interesting. Not all the results are with the doctor yet – there are some we are still waiting on. But it turns out that Pigeon did have a bladder, but the tubes that normally link the bladder to the start of his boy bits were bypassing the bladder altogether and going straight from the kidneys to his willy. Had he grown a little more, corrective surgery could possibly have fixed the problem, but this is only a guess at a chance of what could have been. And we know that it was not meant to be.

Now, going through all this pain and heartache with baby Pigeon might have turned off even the best humans from wanting to go through

it all again. Fostering ain't an easy job, and I know the rents feel incredibly lucky to have not only the support of me, their best fur son, but also the support of my online pack via social media, cheering us on during the good times and extending kindness and heartfelt understanding and empathy during the sad times.

Funnily enough, there are always going to be people who question the reasoning behind trying to save a life like Pigeon's. And quite frankly that's a hard one to answer. At some point in my life, back when I was a tot, someone, some human, gave up on me, whether I was dumped, abandoned, or I escaped and no one came looking for me. Maybe it's because I was imperfect or deformed. Had Mina from Big Dog Rescue not taken a chance on me, had she not seen the value in me as a young dog, then maybe I would have eventually been deemed not worthy of life.

The lesson that's clear to me when I think about Pigeon is that every life matters. He mattered and he meant something to us. He had a personality; he was playful and even a bit cheeky at times.

Another lesson to take from Pigeon's short life is to reinforce that backyard breeding and puppy farming is so wrong on many levels. A female dog that is bred from over and over tends to have smaller litters as she matures and her body gets worn down. Her health is usually poor at this stage as she has been used as a breeding machine. Birth defects become more common too. Some litters of puppies born into over-breeding programs don't survive at all, the pups have such poor health passed down to them during pregnancy that they stand little to no chance of survival.

It really makes me wonder about the other babies Pecan had before the Pie Slices, and whether they are still thriving. These pups would be sort of like family to me too, so I hope they're all safe and happy.

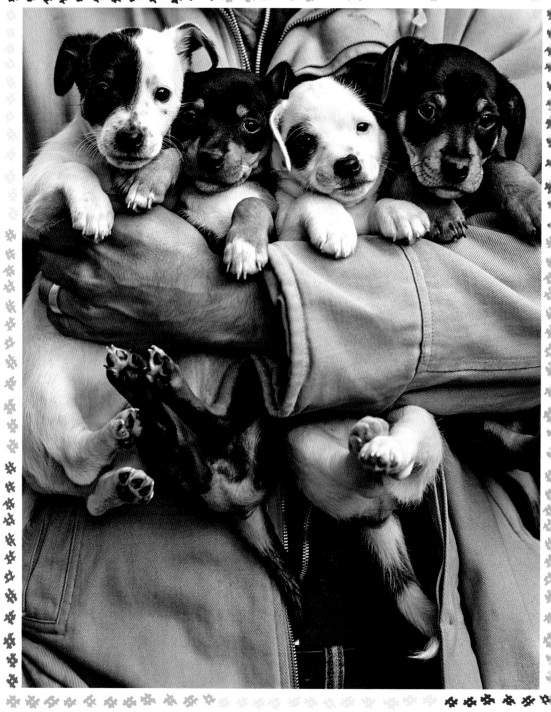

PIESLICE PUPPIES ON TREND

PINEAPPLE THE PUP, MOSTLY REFERRED TO AS PAPPLE, WAS STILL A BIG PART OF LIFE HERE AT HQ.

In just a few short months Papple had gone from new foster kid on the block to big foster sister to a bunch of puppies who were fast growing to reach her size and then some.

Now that the Pie Slices were really starting to get to the running around, chewing on things and exploring stage of their lives, it was time for them to become more integrated with the rest of us. Papple could not have been more delighted to have four little playmates to boss around and teach the best ways of howling and yapping in order to get the attention of our humans. She also loved that curling up for naps on the couch now meant more comfort with more little warm squishy bodies to snuggle up with.

Paps and I were still the dream team, and now with Pecan and her babies we became the talk of the town on our outings down to the park. Five-week-old puppies turned into six-week-old puppies who quickly turned into seven-week-old puppies. It was about the eight-week-old mark that my parents decided it was time for Pecan to have her big girl operation and to put a stop to breastfeeding her now big and chunky babies. It was also about this time that the rents started to interview for forever homes for the Papple.

After a few false starts with some lovely families, Papple finally seemed to agree on one particular family that my parents had selected.

123

And so a date was scheduled in a few weeks' time for Paps to go off on her adoption trial.

Peaky's big girl surgery went smoothly; however, upon her return she insisted on breastfeeding those fat slug pups of hers even when they were completely full. Ma remembers leaving the room for no more than thirty seconds one time and directing Pecan to stay on the couch, out of reach of her milk-greedy babies. Thirty seconds later, there she was on the living room floor feeding them as she always did, looking back up at Ma as if to say 'What? I can't help it if they are hungry!'

With lots of thought and a bit of planning, Ma reached out to the rescue network to find some temporary care for Pecan. The rents felt the time had come for Pecan to have some much-needed time away from her babies and learn how to enjoy just living as a dog, rather than being a twenty-four-hour milk machine. Ma and Pa agreed to have Pecan stay at another local foster carer's house intermittently while we got the Pie Slices ready for adoption. The rents insisted on visiting Pecan and wanted to make sure she still had some sleepovers during the few weeks she was in this temporary care set-up, so she could see the main thing she loved about our place – me! Again, I'm not even exaggerating when I say Pecan was in *lurvvvve* with me. Pecan was only a three minute drive away and a fifteen minute walk, and after about a week away she had a lovely reunion with her babies in the park one arvo. And of course the first thing they all did was try to drain any remaining milk reserves, and the first thing she did (after jumping at Ma excitedly) was seek me out for some smooches.

So after a few quiet weeks missing Pigeon, there was so much going on at our foster home. Pecan was on temporary vacay, Papple had an adoption pending and now the Pie Slice Puppies were almost nine weeks old, and in honour of all the outpouring of love my Facebook and Instagram pack had shown, my rents decided to throw a Puppy Pub Party and raise some funds for Pecan and the puppies' rescue group. Oh, and this just happened to all coincide around my second Gotcha

124

Day, but I was beginning to feel that was all getting a bit lost in the hype of all the Pie family/Papple fuss. Sometimes I think my rents forget, it *is* all about me!

I put the call out on social media for all my Sydney-based online pack members to come swing by the event. We were holding it at a trendy local bar-slash-pub, because a pub puppy party is all the rage these days (take it from me, a pup in the know). The event staff at the pub guesstimated fifty or so guests at most in the lead-up to the party. Boy, were they a little shown up on the day! They totally underestimated the Pie Slice Puppies' and my appeal, and thought my Ma was a little crazy when she said it might be quite a popular event.

Forty whole minutes before the official party started, what do you know? A line from the door of our party led through the entire pub and all the way down onto the street, with a crowd of eager Life of Pikers excited to meet their favourite famous fur celeb and all his cute little foster-stepkids. Also headlining the event we had invited some of my previous foster siblings, Pollywaffle and Porridge. The final small yet huge personality, as a last special appearance, was little Papple. It was her last day with me as my foster sis before she would head off with her new forever family.

When the doors finally opened, the party was simply super fun! And the rents and some of my dedicated social media pack friends who had come along didn't forget the main attraction of the party, the pup it is all about, and whose second Gotcha Day had just passed. There were presents and tummy rubs and people wanting to have a cuddle and get a photo with this famous mug of mine.

When the excitement of the day drew to a close and all the funds raised from the ten dollar door fee were counted, turns out that the last-minute Puppy Pub Party that my rents threw together in two weeks raised over $2200 for the rescue charity. The baby Pie Slices were utterly exhausted and probably a little overwhelmed from all the people treating them like they were famous (which by now they were, even if they didn't know it). I can confirm from experience that it does take a while to get used to it all. That night, everyone was happy to be home and we all slept like milk-drunk puppies.

The next day I sat down with Papple and gave her a few pointers before she left for her new home. I suggested that she tone down the sass just a little and make friends with her new older Chihuahua sister, and even suggested that she let her sister be the boss. Who am I kidding? We all know who was going to be the boss in that sister dynamic. We said our final foster sibling goodbyes and I hoped that one day I'd see that sassy little Pineapple pup again. I let her know that if ever she needed me or some wise sisterly advice from the Spinsters, we'd be here and she was always welcome.

The rents drove off with that little Papple-rat, such a character and special kind of dog (Ma's words, not mine). I think we all collectively held our breath those first few weeks after Papple's adoption, but her new family seemed to have taken to her, quirks and all! She was home and she was loved.

Ma had also been interviewing, both in person and over the phone, some great candidates for Mamma Pecan Pie. Finally she felt she had found the perfect family. One of the prerequisites was that there be at least one other dog for Pecan to have as a sibling, and it had to be male, because we all knew how much Pecan loved me. The rents wanted Peaky to have her own male pup-figure in her life, and she got exactly that. Mamma Pecan Pie had found that perfect forever family. She could finally move on, as they all do, and now she could really relax and learn how to dog.

It was time for the four remaining Pie Slice Puppies to start their adoption interviews and find deserving, loving forever families of their own. With a little sadness and great care, Ma began the process. Every foster puppy sibling that comes into our home, be they from the pound or dumped in a cardboard box on our doorstep, is all special and cherished, but there was something a little more special about these puppies, having been born right here in our guest bedroom. All that Ma and Pa had gone through with Pigeon, and the many late nights, bottle feeds, vet visits and hours of care that had gone into raising these Slices right from their first breath made finding their forever homes just that little bit more meaningful.

Preparing for their eventual departure, over the next few weeks Ma took the time to take me and the Slices out for some last adventures. Beach days, park days and days just full of fun. Imagine, if you will, seeing a human Ma walking around the dog park with four bounding puppies running in perfect form right by her feet. She looked like some kind of Pied Piper, and when I was out in front that was exactly what I looked like too.

The first of the pups to find his forever home was firstborn Pilot. Pilot was a gentle natured and kind kid (Ma tells me firstborns are usually like this, I was probs born first then I guess!), the only one out of the Pie Slice Puppies that didn't really howl and very rarely barked. That eyepatch of his gave him points in the looks department, though,

funnily enough, he had the fewest adoption applications out of the Slices. But numbers mean nothing in rescue. What really matters is the quality of the applications, and Pilot landed himself a forever family to make any rescue pup jealous. A stay-at-home mum, a dad who would take him into work on occasions, four human siblings (two brothers and two sisters), an older red staffy sister (yes, she did look a little like me but with more distinguished grey hairs showing and a much prettier feminine face), many chickens to chase around the yard and a couple of pet birds that lived in the big open family room. Sounds hectic, right? Well, this family is far from it. All the kids are incredibly sweet and very good with animals. Their parents have done an amazing job raising all their children, human, fur and feather – all are well loved in that family and Pilot was already adored.

Naturally it made complete sense for the second-born and only girl, baby Nemo Pie, to be the next to find herself a perfect forever home too. Out of all the Pie Slice Puppies it was Nemo who had the most adoption interest, probably because she was a girl, but also probably to do with the fact that she was one sweet, sweet little thing. She was about as perfect as a puppy could be – very intelligent and loving, and she had her mamma's gentle soulful eyes. Being spoilt for choice with Nemo's adoption, my rents found a family that was simply outstanding. Big rescue supporters, they had long ago adopted a rescue kelpie pup named Xena. Xena was still around and now nearing sixteen years old in human years. The size and age difference between the girls made for no issues. Xena and Nemo (who had now been renamed 'Velvet Pie') were a match made in heaven. And to top it off, Nemo/Velvet had a very loving and dedicated mum and dad and older human sister who would absolutely spoil her rotten.

Puffin Pie, the third Pie puppy born, did in fact find his home third! This was not at all planned, just one of those funny things in life. Puffin's family has a bit of a link to his Mamma Pecan. Remember how I told you that, back when Pecan was a petrified stray dog that refused

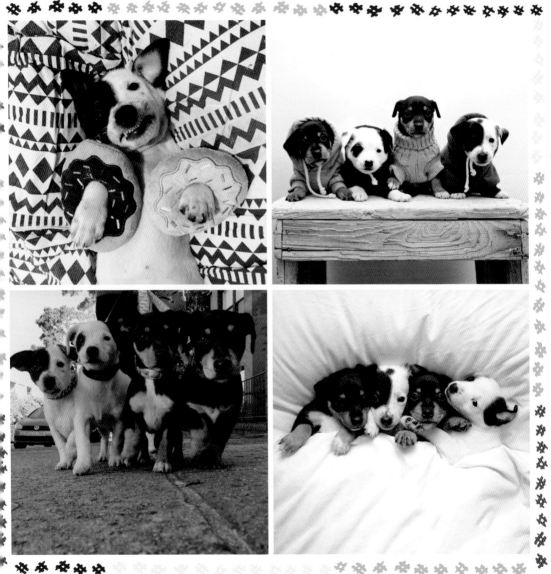

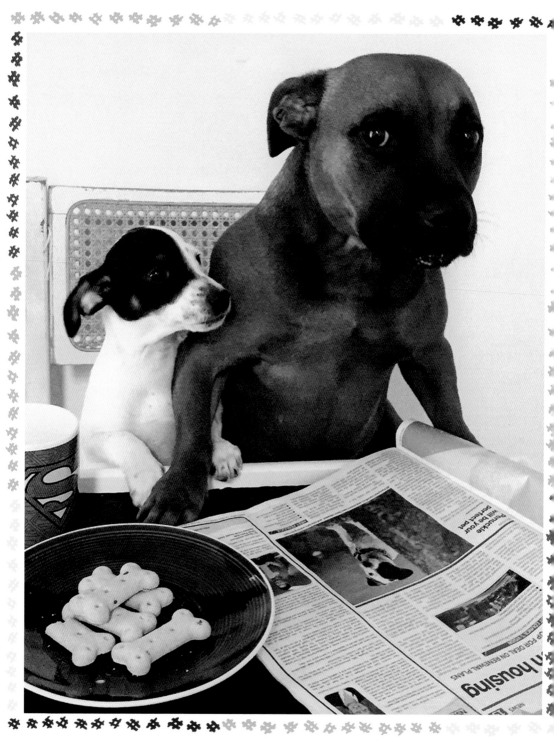

to move from her location until she was finally caught and taken into a local vet for health check and microchip scan, the people who found her and eventually coaxed her out from under a parked car were staff from a local vet hospital? Well, the vet that performed Pecan's health check and ultrasound that morning (to see if she was in fact pregnant or if her big tummy hid health problems like a tumour or something), that very vet who looked after Pecan way at the start, had stayed up to date with her foster care journey on my Facebook page. The vet had discussed with her family the possibility of adopting either Pecan or one of her babies. Lovely Pecan was not suited to live with young children, however, so it took her out of the equation. The vet and her family decided to put in an application for big boy Puffin Pie. It was a bit of a no-brainer for the rents, as not only would Puffin (now renamed Bruno) get to live with an experienced and qualified veterinarian, but he would have three human sisters, all under the age of five! What fun that house must be with all those babies and Puffin the only son.

So that now left me with one Pie Slice Puppy foster-step-son, little Penuckle Pie. He did originally have himself an adoption lined up but close to the last minute the family thought that the timing just wasn't quite right. So Penuckle, the fifth born Pie Slice (born after Pigeon Pie, whose little urn of ashes now sat atop our living room bookcase in pride of place) was left a bit high and dry. Not minding in the slightest having him stay with me a bit longer at HQ, I made sure Penuckle knew Ma and Pa would take the extra time now to locate his most perfect forever family and it wouldn't be long at all before he was moving on out like the rest of his littermates.

Our local newspaper did a little feature story on Penuckle being the last in the litter, giving him an extra boost of adoption interest. I had no idea he was going to appear in the newspaper, so you can imagine my surprise when I opened up the paper over my morning coffee to see his cute little face staring back at me! I'm not sure if it was the press coverage or the fact that Penuckle was announced on social media as

the 'last Pie Slice Pup' left, but a new round of adoption applications came flooding in.

As is often the case, sometimes an application just really stands out. This time a young and fairly local family, who had not long ago lost their previous little dog to old age, applied for Penuckle's adoption. An interview was set up and Penuckle's potential new human sister was eager to prove that she was ready to make the commitment of a big sister to Penuckle. How could the rents say no to a sweet, dog-loving five-year-old? Penuckle (now renamed Buddy) had waited just a little longer than his brothers and sister, but it was worth it. He found a wonderful forever family, which was his happily ever after.

And so an eventful chapter of my life came to a close. It had all started four months earlier with Ma leaving the house to take a trip to the pound to pick up a 'naughty' 700-gram Chihuahua puppy that no one could handle. I never would have guessed that a couple of weeks later I'd be responsible as a foster pup extraordinaire to six new kids in my house, and that we as a family would have so many highs and lows – more highs than lows, thankfully.

The rents and I agreed that we all needed a breather. Some time to reflect once again, a bit of downtime for me, the Spinsters and my hard-working parents to just be normal for a while. For us, though, normal was subjective.

It wasn't Ma's phone that rang this time but a Facebook message delivered to my inbox.

'A puppy needs your help . . .'

NO TIME FOR TIME OFF WHEN YOU'RE A FOSTER BRO

EMAILS, MESSAGES AND COMMENTS ARE A HUGE PART OF THE BEHIND-THE-SCENES STUFF WHEN IT COMES TO RUNNING MY OWN SOCIAL MEDIA EMPIRE.

Fame comes at a cost and at times that cost is simply the time consumed by opening and answering every single message. A lot of people might be surprised to know that I often get a few hundred messages a day. Some are short and sweet, with words of praise, or have attached to them adorable photos of other loved four-paw family members. Many are lengthy, asking for advice on dog behaviour, adopting a rescue pup or even just what our country is like. Yes, I've had a few messages from people overseas who are planning a trip to Australia but are worried about all the dangerous animals we have (like snakes, sharks and spiders) and they come to me, Pikey, wanting to know how I cope with this and how I manage to stay alive with all that danger around!

Out of all the emails and messages and comments I do receive, the absolute most frequent type of message I receive is a request for help. Sometimes it's a rescue or a charity asking me to do a special feature on them, maybe to help them raise their profile or funds, but mostly my inbox is crammed with pleas requesting help with a pound dog, a dog on death row or sometimes even a dog where the owner themselves contacts me directly saying they don't want or 'can no longer keep' their dog anymore, and could I and

135

my parents take him/her in, or at the very least put them up on my Facebook page. This is where I like to palm things off to my Ma and Pa, because it's incredibly hard to know where to start with this stuff.

So the day I started to read a message that began 'My friend has a puppy that she can no longer keep and is advertising it on Gumtree – can you help? . . .' I put it in the too-hard basket and asked Ma to deal with it. This message came through maybe about a week or so after Penuckle had left, during our 'break from foster care'.

Ma did as I asked, read and attended to the message. The next minute I heard a knock at our front door. A young couple stood on our porch with a chunky nine-week-old American staffy flopping around in their arms, looking all cute'n'stuff. They had bought the puppy from a trading website called Gumtree a couple of weeks earlier, for $3000 or some other ridiculous price, and now after a few weeks of having a bouncing baby dog in their city apartment they realised that perhaps they were in a little over their heads. Now they were convinced that either my Ma had to step in and take him or he would be going back up on Gumtree. Those sorts of ultimatums never end with Ma being able to turn a puppy away.

She made the young couple drive up to our vet and have his microchip scanned and his details transferred into her name. They may have been young and foolish in their pet ownership plans, but they had done the right thing with this puppy, having him vaccinated and microchipped and on appropriate food. He was a very good looking little guy, almost as handsome as me – almost.

After his owners left, Ma called Pa and told him about the events of the afternoon. She did advise Pa that this little guy seemed to be a very good-natured chap and that he was almost as much of a looker as me. But even Ma can admit when she is tired and worn down, and she discussed with Pa that this time they just didn't think they could take on another foster kid this soon. Ma had a good think about rescue groups that might be willing to help. She'd been in contact with one recently down in Wollongong that seemed to fit the bill. She gave them a call and

they said of course they'd help. Could this pup stay here at HQ, though, until Ma had the time to drive him down to Wollongong next weekend? 'Sure, why not? He is very sweet and seems pretty relaxed here with Pikelet and my girls.'

This time the rents had agreed that since they were not going to foster this puppy long term and he was only staying the week that they'd leave the naming part up to his new foster carer. For now this pup would just be called 'Pup'.

Pup was a great friend for the week he stayed with us. He was just a young little tyke but was almost the same size as me already, so I reckoned he was going to grow into a big chunky boy one day. He loved a good game of biteyface as much as me and also loved the typical staffy couch mooching. By the end of his week with us, as Ma was buckling him into the car, Pa stated that maybe he could have stayed with us longer as he was actually quite a sweet pup, and the rents were surprised at how quickly he had settled in. But it was too late now – a foster family had been lined up and his big boy operation had been booked, ready for him to get going on his search for a forever home. Upon Ma's advice, his new foster care mum renamed Pup 'Paw Paw' so he had just a little bit of that special Life of Pikelet magic to take with him on his foster care journey.

Okay, so I'm going to be straight with you. The rents claimed that they needed some downtime and some time off from foster care. I too felt I needed a little break and some time to relax and put my paws up. However, having Pup in the house being so sweet and all, and then leaving so quickly, may have made us all miss having some #stankasspuppybreath wafting around the house. Ma was definitely not actively seeking a new foster puppy, but one day while flicking through the many posts her rescue friends tag her in on Facebook, she stumbled upon a photo of a puppy out at a large shelter in Sydney. This puppy was pure white, deaf, and had a very striking look about her. She seemed to be a mix of Roman-nosed bull terrier and possibly something a little bit scruffy. A rescue puppy, a deaf rescue puppy and a bull breed

137

rescue puppy – all things that Ma has a soft spot for rolled into one dog. A bull terrier was also on the list of breeds that Ma wanted to foster if the opportunity ever came up.

The friend that had tagged Ma had suggested that maybe we could foster this little pup, since she was deaf and we had experience with deaf pups, and had such overwhelming success with Pollywaffle.

After some careful consideration, a little bit of inquiring and a lot of back and forth with the shelter's foster care coordinator, the rents filled out the pages of paperwork and went out to collect the little shelter pup. The name Ma had picked out this time was 'Piccalilli'. Something a bit spesh for a special girl.

Piccalilli was a big pup and she was very much full of life. She is best described as a big, floppy Duracell Bunny. If Ma or Pa carried Piccalilli a certain way you could easily be forgiven for thinking they had a giant hare or rabbit in their arms.

Deaf dogs are usually wonderfully smart and intelligent and Piccalilli was no exception to that rule. She was a high-energy, athletic girl, and I know the rents had a suspicion that maybe she was a mix of bull terrier and a working breed. If Ma had to guess, she would say that Piccalilli was probably mixed with a cattle dog; the texture of her coat showed some similarities and she also demonstrated great technique when rounding up the Spinsters and me.

Speaking of the Spinsters, they were not so pleased with the new addition of foster gal P'Lil. Normally the far end of the couch, with all the cushions piled high, was the domain and rightful throne of Shelly and Betty – Shelly naturally had prime spot, and Betty usually positioned herself next to or around wherever Shelly was. The couch is and always has been the safe haven for the Spinnies – too high up from the ground for most puppies to get to, so long, leisurely naps atop the cushions right under the skylight where the sun streams in can be enjoyed. With their safety assured, both Shelly and Betty can snore the day away.

Now, you try telling a deaf twelve-week-old bull terrier-cross-working breed puppy that she cannot jump onto the couch and pounce willy-nilly on top of the two small old dogs lying there in deep old lady dog sleep.

Even the warning growls that would start in a soft rumble from atop the cushions and would end with some in-her-face snarls to back off were not enough to concern Piccalilli. I think she actually thought my sister Shelly was playing or smiling or something. I mean, she was showing a lot of teeth after all, and perhaps P'Lil just thought she had one of those brilliant Hollywood smiles.

Besides her more crazy side and party girl attitude, there were times when Piccalilli was adorably gentle and sweet. Mostly this was when she was asleep, but really she was a very affectionate pup and loved to snuggle in close to my rents and me. Her intricate patterned speckled nose, black beady eyes full of innocence and those big white bunny ears made Piccalilli very popular on Instagram and Facebook. Deaf foster sisters of mine always seem to have a very loyal following. Deafness to these pups was never a disability; they all felt very comfortable in their own bodies and never seemed distressed being unable to hear. None of them, including Piccalilli, wanted a pity party. Piccalilli very quickly learnt all the hand signals Ma and Pa had used for Pollywaffle when they introduced her to them. Her brain worked so fast that holding her attention at times was tricky, but generally she followed my lead. She loved a good rumble game in the yard, and once she had her daily sun-cream rubbed in and zinc applied across her nose, she really enjoyed soaking up the warm sun.

When it came time to talk about adoption process for Piccalilli, things got a little tricky. Piccalilli, being a very high energy, intelligent, boisterous, deaf, bull-breed puppy meant that finding the right home was not going to be as easy as most other times. It was going to take a special kind of someone who had the time and patience to work with and truly understand her. The problem was that this time Ma and Pa

would not get to hold the interviews or be there for Piccalilli's adoption. It was the policy of the shelter that she be returned when she was ready for adoption and wait out the remainder of her time back there until she was adopted. This was a very uncomfortable scenario and procedure for Ma and Pa to accept; however, they respected the system and did what was asked.

After about four weeks in our care Piccalilli was ready to go back to her shelter. The day the rents were to drive her there they spent the whole morning typing up a letter describing her routine, all her hand signals and anything else they could think of to add to the letter, which they hoped the shelter staff would pass onto her new adoptive owners once they came along.

I think leaving Piccalilli at the shelter that Saturday morning really broke Ma's heart. She felt she had failed her foster pup, as this wasn't how things normally went. Leaving Piccalilli, knowing she had to go back to spending her days in a concrete kennel run after living the past month in a loving and warm home environment, was a hard pill to swallow. Ma worried all weekend, and come Monday was straight on the phone with the foster care coordinator requesting an update. No one had come to adopt Piccalilli yet, but there were some promising candidates due to come next weekend.

Ma put in a request to come out to the shelter to visit with Piccalilli, which was approved. On Tuesday Ma strapped me into the back of the car and out we drove to the shelter. We were taken to a fenced-in grass paddock where we waited for the kennel staff to bring out P'Lil. She was over the moon when she saw both of us, jumping and bounding about. Cuddles and treats were given in bucketloads. Talking with the staff at the shelter, it sounded to Ma like Piccalilli wasn't too fazed about being there. The weather was starting to get warmer and the cool concrete floors of her kennel were her preferred place to lie in the heat of the day. Also, because she was deaf, the noise of the other dogs in the shelter didn't worry her or stress her out. And the good thing about Piccalilli,

which Ma and Pa already knew of course, was that she was a very adaptable dog. She had used that good quality to just roll with it.

Ma and I headed home after many tight bear-hugs goodbye. Both of us felt a little better after seeing that Piccalilli was doing so well at the shelter. And the adoption coordinator said she had a few more interested parties coming out to meet her over the weekend, so possibly one of those could be her adoptive family.

That Thursday Pa took a day off from his work because it was his birthday! To celebrate, Ma and Pa headed out for lunch and a movie. Pa told me that just before they were about to head in to the movie, Ma's phone buzzed. Up popped a message from a shelter coordinator, asking if we had room for a tiny new foster kid. The next message that popped up was a photo. Pa asked Ma what was going on and she showed him the messages. Being in a good mood, Pa said 'Sure, why not? Write back and tell them we'll come get him later today. It's my birthday, so that seems like a good excuse for a new pup.'

Ma did exactly as Pa suggested and messaged back to say they were 'in'. I reckon the reason Pa was easily swayed by the idea of a new foster puppy was because the photo was of a tiny little Jack Russell puppy, and Pa had a soft spot for the tiny breeds. My sister Shelly was very much 'his' girl, though Ma would often say, 'I own Shelly and Shelly owns Pa.' Pa also took quite a liking to little Papple when she was in care here at HQ. He packed her into his work bag a couple of times and took her on the bus into the city to spend the day in his office.

After the movie, Ma drove out to go pick up the newest foster addition. The shelter staff had already given the little pup a 'P' name, thinking it would add to the appeal for my rents. They had named him 'Peanut'. And while that is a pretty cute name, my rents had always avoided commonly used pet names for their foster kids, reason being that there are just so many puppies out there listed on adoption sites, with many of the same names repeated over and over. Ma likes the idea that when someone is talking about one of my foster siblings everyone

else will know straightaway exactly who they are talking about. So Ma thought that she'd keep the 'Peanut' part and add on 'Butter', and then give this puppy one of our famous name shortenings, so 'Peanut Butter' would become 'Putter'.

Putter Pup was tiny, almost as tiny as Papple had been the day she came home. He had classic good looks and could fit in my Ma's (petite) cupped hands.

It was great to have another tiny sidekick. He reminded me so much of Papple, yet with far less sass and much more boyish charm. He was super speedy racing about the house and very crafty in the climbing department.

Like Piccalilli before him he managed to rockclimb up onto the couch, but unlike P'Lil, Putter was very respectful of the Spinsters, especially since he seemed to know that he looked a bit like a Shelly mini-me.

I also clearly remember that Putter was so tiny that when he ate his breakfast, lunch or dinner, his little back legs would lift off the ground. It was so funny, almost like he was weighted down in his front as he leaned over the bowl to eat.

That weekend Putter's shelter had been invited to attend the Super Furry Festival over in one of the city suburbs. They extended their invite to both Putter and me to join in on the fun sitting at the kissing booth and helping our friends at SavourLife dog treats to raise some funds. While we were enjoying a lovely busy sunny day with lots of doggy goodness, Ma received a phone call. It was Piccalilli's shelter, and they were calling with the best news ever . . . she had been adopted!

An experienced dog owner had come into the shelter and asked to meet P'Lil. She thought she would be a good match for another dog at another rescue that she was also planning to adopt. The shelter requested that both dogs meet before the adoption could go through.

The other rescue very generously brought over the dog to introduce the two pups to each other. It was a good match, so Piccalilli's new mum adopted her there on the spot, along with her brand-new adopted sister. On the same day, the two new sister pups went home to their new house to start their lives afresh and on the same terms. Piccalilli's sister was a black kelpie cross and very different to Piccalilli. Her name was Abby and she was a lot shyer than our girl P'Lil, so was happy to let her be the leader of the pair.

Ma had so many happy tears! It was truly the best news ever, and Ma felt like a weight had been lifted from her shoulders. The shelter confirmed that the letter Ma and Pa had written was passed on to the new adoptive mum. Hopefully she might reach out and possibly look me up on Facebook one day and see just how famous her Piccalilli was there on social media.

It only took around three weeks before little Putter had adoption interest himself. Similar to the process of Piccalilli's adoption, Ma and Pa didn't get to have much say or take part in the adoption interviews. They had to entrust the shelter staff with this process and hope for the best. An email came through one Friday morning saying that an adoption for Putter was pending. The rents just needed to bring him in and have him go through the interview, and if it all worked out then he would go home with his new family that day.

Very nervous about the unknown, my rents prepared Putter and drove him to the shelter. The staff came and collected Putter while my rents waited around outside to hear if the interview was a success. About forty minutes later the adoption coordinator came out to tell my rents that it had been approved, and to ask whether it would be okay if we sat down to chat with Putter's new family. Of course! So out came Putter's new family (with Putter in tow) – a mum, dad and twin human sisters. They sat down and told Ma and Pa that they had found Putter through my Facebook page and were big fans of me and the foster care work my rents did. They had followed both Piccalilli and then Putter,

and decided that they would apply for the little guy. They had been a family without a dog for a little while now as their previous pup had crossed the rainbow bridge about a year or so ago. They were very ready to open their home and their hearts to a new fur baby, and Putter was just perfect for them. After a long conversation and an in-depth chat all about Putter, my rents gave little Putt Putt some goodbye cuddles and wished him well with his new family.

As you know, the majority of my foster siblings and their new adoptive families do stay in touch, and luckily Putter's new family had every intention to keep this tradition going too.

A few weeks later a text message popped up on Ma's phone. 'Hi there, I got your number off of a letter that came with my dog when I adopted her. Her name is Piccalilli and I just wanted to contact you and let you know she is doing really well. If ever you want to meet up with us please let me know. I'd be more than happy for you to stay in touch with Piccalilli if you'd like.'

More happy tears! This was something Ma had only hoped for. How lucky are we that all my foster siblings come and go, yet we never seem to lose them? Our family just grows and grows, and all their wonderful humans become part of the extended family.

I did wonder if one day my rents would ever cave in and adopt another one of their foster kids. Maybe one day the right puppy would come along and I could have a new forever brother or sister, one a bit closer to my age. The Spinsters have each other, so it might be nice to have a wingman or a wing-gal . . .

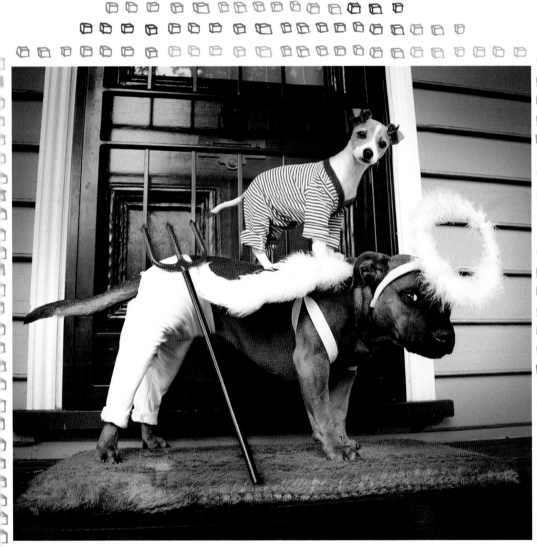

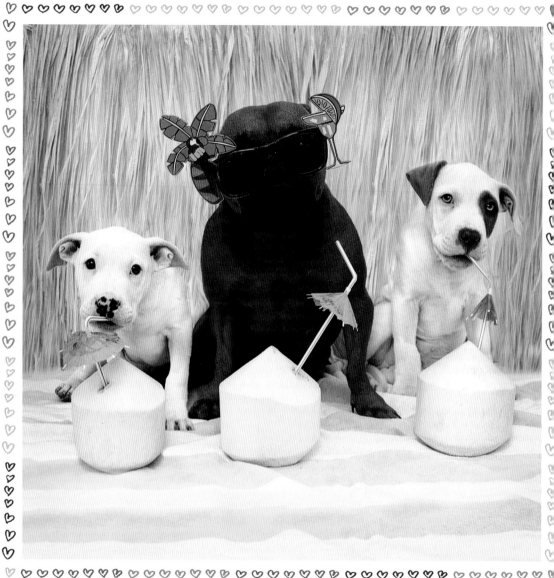

TWINS AND TRIPLETS

Out went little Putter pup and in came two squishy marshmallow #adorabull twins. A little pure white girl, one hundred per cent deaf, with a speckled nose of black markings, Ma decreed that her name would be 'Pixy Stix'.

A twin brother, also mostly white but with a smattering of light caramel-brown freckled markings, a brown left eyepatch with an opposite brown ear, and bright sky-blue eyes, to be called Patty Cakes. Two of the best-looking kids you ever laid your eyes upon.

Born into foster care with a rescue group called Wollongong Animal Rescue Network, these white twin babies were just two of a large litter of nine. Their mamma was saved when she arrived at a local council pound heavily pregnant and very underweight. The day after arriving into the safety of foster care, she had her babies. Her name was Tully and she was a dark brindle bull-breed mix that resembled a probable mixture of boxer, staffy and maybe mastiff. Tully had a gentle nature and kind soul. Her nine babies were born a complete rainbow of colours, ranging from dark brindle like mum to caramels and variations of white. Some had white, black or caramel markings. Some had green eyes, some black, brown or blue. All the pups were stunning and equally as beautiful as the next. Out of the litter only

one was pure white, my new deaf foster sister. The fourth deafie to join our family.

WARN (the rescue) had specifically reached out to the rents, knowing that they had fostered deaf puppies before. This little girl was gentle and very sweet. Upon arrival at the pup's original foster home to pick up Pixy Stix, Ma was asked whether she'd consider taking a second puppy from the litter into care to keep little Pixy Stix company. Ma decided to pick the cute, blue-eyed, caramel eye-patched pup, as she had not yet fostered a puppy with blue eyes and thought it might be nice to have someone a bit different. Little boy Patty Cakes was just as sweet as his sister. Bundled into a carrier crate next to two other sisters from the litter who were being transported back to Sydney to a new foster home, Patty Cakes didn't even make a peep when one of his sisters vomited all over him during the journey – he just slept right through it all.

Before I was introduced to the two newbies, they made a detour into the bathtub to wash away the results of a carsick sister. After a bath, Ma walked into the living room carrying those marshmallow twin pups all bundled up in towels.

I'm not usually one to gush over new foster siblings but I thought these two were pretty darn sweet. Barely making a single sound or fuss, they just settled right in.

Breaking the internet had become standard whenever we announced new foster siblings on my social media, and Pixy Stix and Patty Cakes were no exception. Referred to as 'the twins' because they were rarely without each other for a single moment, we started to receive requests for adoption applications before they had even spent twenty-four hours at HQ. Spotted by our friends at BuzzFeed media group, Patty Cakes was asked to take part in a video shoot in their studio with some of his littermates. Ma and Patty's original foster mum, Naomi, took four of the pups in for filming. So many squeals of delight around the office and many spoons of tasty peanut butter later, Patty Cakes and his siblings were on their way to instant fame.

148

But the limelight is often shared here at HQ, and the old saying 'when it rains it pours' couldn't be a better way to introduce the six little werewolf cubs that showed up only ten days after the twins.

At the same rescue that Pixy and Patty had come from, six little four-week-old Chihuahua, fox terrier, Jack Russell and Pomeranian mixed breed pups had been surrendered by a breeder when they were just three weeks old. The breeder claimed that the mother was too unwell to breastfeed her babies any longer. The litter was divided into two groups of three pups to go into emergency temporary care. Ma and my aunt Jessie had agreed to take on long-term foster care of these babies until they were ready for adoption.

When all six pups arrived at my house on the same day I felt like Ma was pranking me. But luckily she could see the concern on my face and promised that we would only be keeping half – we'd have a set of triplets to hang with our twins.

Still just tiny babies, the three little girls, Parsley, Paprika and Patchouli, needed round-the-clock care and multiple bottle feeds a day. The rents had signed themselves up for another full house without even consulting me or the Spinsters, and this time right before Christmas! All the important questions were asked. Would we have enough Christmas stockings? Would there be enough roast turkey to go round? Would I have to share what Santa brought me? Thankfully, Ma assured me that all five puppies should be in their new homes and adopted just in time for Christmas, so no, I would not have to share my Christmas goodies.

Summertime is my fave part of the year. Here in Australia it gets super-hot and the days are long – it doesn't get dark until late at night. Having a house crammed full of cuteness wasn't as bad as I had anticipated. The little triplet Ewoks/ werewolves would mostly eat, sleep, poop

and repeat. But when Pa got out my old paddle pool it was a good excuse to have a pool party every day of the week. Even those fluffballs looked forward to a daily dip to cool off.

Patty Cakes and Pixy Stix were at last progressing from awkward, squishy, roly-poly puppies into fun-loving baby dogs. Following me around, copying my style and often taking over my social media with their flock of fans wanting more cute photos. Eventually they had to head back down to Wollongong to have their big dog operations so I was left with the triplets for a few days. The Spinsters wanted no part in the triplets' bathing, bottle-feeding and dog learning activities, so that job was all left to me. When Pixy and Patty arrived back from their surgeries I quickly realised what a relief it was to see them both. I kinda liked having these two around. Neither of them minded sharing in the triplet duties and both of them worshipped the ground my paws walked on.

Pixy's adoption was already confirmed – she would be moving down to Melbourne with her new mum who already had another deaf pup sister waiting for her. Pixy's mum had been a Life of Piker for a while; she had followed both Pollywaffle's and Piccalilli's foster care journeys and had thought about applying for each of their adoptions, but had decided not to. As my Ma said on the phone to Pixy's new mum one day, 'I think you were just waiting until the right pup for you came along. Pixy may look like she is always sad or worried, and Patty does too, but these two are the sweetest pups you'll ever meet.' And the next thing out of Ma's mouth made me do a double-take. 'I've been bugging Pikey's Pa to adopt Patty Cakes – he is still acting all undecided but I'm pretty sure he is going to cave in any day now.'

Whaaaaaaa? Did I hear that right? Ma and Pa were considering adopting Patty Cakes? A new brother for me? A new brother for the Spinsters? Had they heard and answered my prayers? Did I even pray? (I don't remember doing so, but I'll own it if it means I finally get my own wingman!)

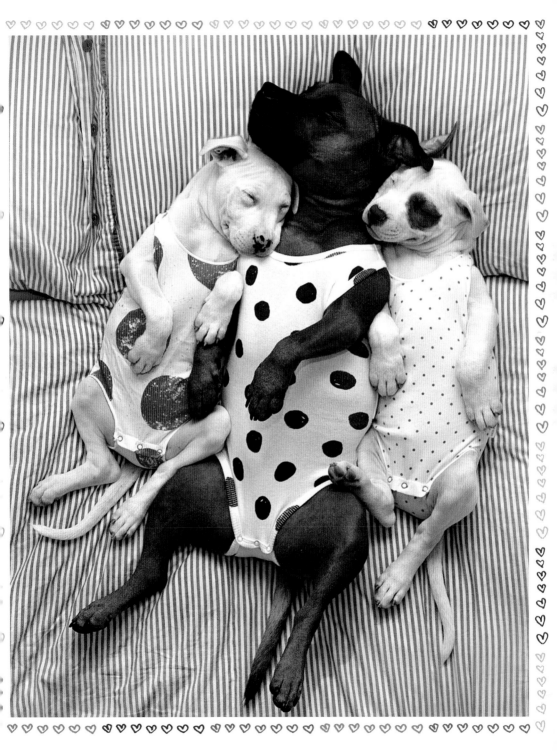

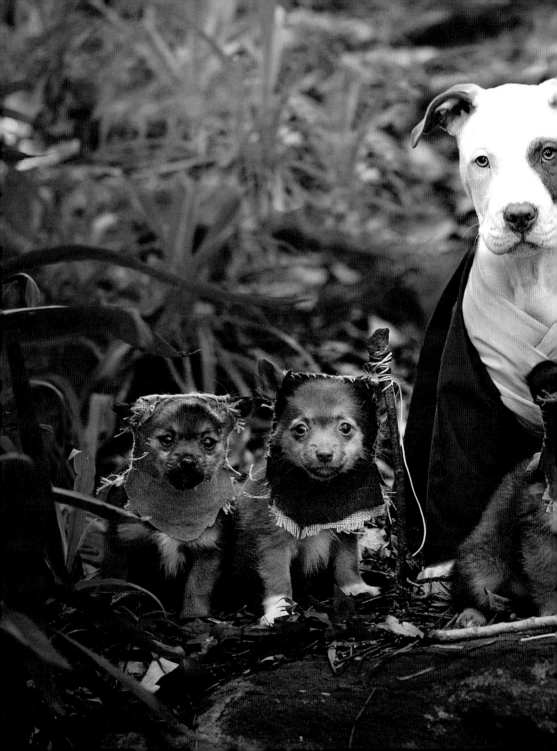

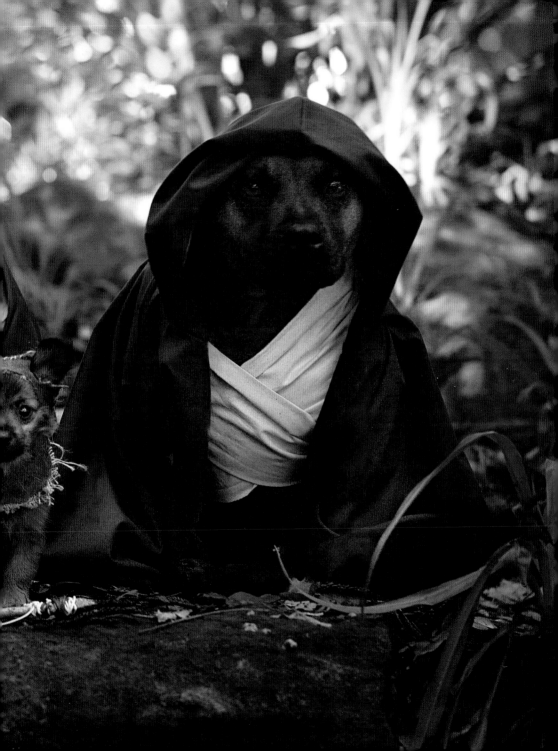

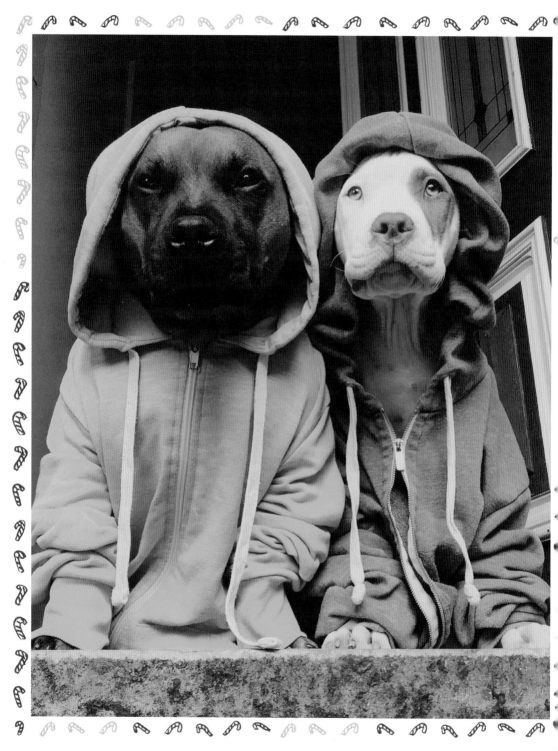

BROTHER FROM THE SAME FOSTER MOTHER

YOU'VE PROBABLY GUESSED BY NOW THAT MA DID IN FACT CONVINCE PA FOR US TO ADOPT PATTY CAKES.

This time no ring got eaten or pooped out, though don't think it wasn't suggested as a strategy a couple of times!

The decision to adopt Patty Cakes did come a little out of left field and it had to be made fast, because his adoption profile had already gone up and over one hundred and fifty applications had come in. With Pixy already planning to depart for her forever home, a decision about the adoption of Patty Cakes had to be swift, as Ma didn't like the idea of messing anyone around with interviews if at the end we were going to adopt him ourselves.

Many people ask why the rents decided on Patty after all this time, and after all the beautiful and sweet fosters we have had over the years. It's a hard one to answer. I think Ma's best explanation is that in Patty she could see a mixture of foster pups past. He was kind of a 'best of' of all the pups she almost wished she could have adopted but didn't. A little bit of Nox, with his laidback and chill persona (also, his squishy mastiff face made the rents think that Nox may have looked somewhat like Patty as a puppy, only jet-black in colour).

A resemblance to Porkchop not only in breed and looks but also in the close relationship Porky and I had, which was very similar to the one Patty and I were developing. There were also elements of the Pie Slices, Pollywaffle, Pancake and Porridge . . . the rents could draw comparisons to so many of the foster kids we had loved in the past.

Patty Cakes is just one of those dogs that people meet and fall a little bit in love with straightaway (just like me. I can't help it, I'm just so lovable). He has charm and a sweetness that even he doesn't realise. His low-energy, welcoming and nurturing temperament towards the triplets was one of the things Ma highlighted to Pa when they were considering adopting him. He reminded her of me as a puppy. If they were going to get me a brother he would have some pretty big shoes to fill (or share) when it came to fostering duties. He would need to be another dog that understood that, while other puppies would come and go, he would always call this family his own. And let's not forget probably the most important reason that Patty got adopted – he and I had become best buds. He let me be the main man and followed my lead no matter what.

Ma and Pa like to joke that Patty and I are like Arnold Schwarzenegger and Danny DeVito from the movie *Twins*. Patty's the big, okay-looking but slightly dopey one, and I'm the handsome, but shorter, brains of the duo. I haven't seen the movie yet, so I'm just going by what I assume the story must be, as Ma and Pa really do say this a lot. (Don't be surprised if one day they get us matching white suits and make us recreate the movie poster.)

So the Fatty Cakes (I can call him that 'cause he's my brother now, so it's brotherly love) and I were official bros and together we would see out the rest of the foster care time with the triplets, making sure our three little foster sisters had two great big-brother role models to look up to.

By now Christmas was just around the corner and, with the triplets having had their big girl ops, it was time for them to head off to their forever homes. Ma had secured wonderful homes for all three girls. The biggest and most laid-back of the tiny triplets was Parsley. Parsley was going to go live with her human mum, her mum's identical twin sister and her soon-to-be forever bro, a rescue Chihuahua called Otis. Parsley's mum and aunt were already very involved in the rescue community, having been foster carers themselves, so I have no doubt little Parsley will do us proud one day when she becomes a big foster sister to a needy rescued fur kid or two.

The second to head off to her forever home was the brains of the trio, the only dusty red-coloured girl of the litter, Paprika. Preki had also landed herself a new canine sibling, this time a sister who had a recipe much like her, a bit of this and a bit of that with probably some Chihuahua mixed in there. Lucky Paprika gets to live with her stay-at-home grandma, mum and fur sister. She gets the best of both worlds, having round-the-clock human and canine companionship.

Patchouli, the smallest and sassiest of the triplets, stayed one extra day before she left to be with her loving forever family, two days before Christmas. She didn't have to travel very far to be home for Christmas, though; she only moved five minutes away

to live with a local family a couple of streets down the road – a mum, dad and human big brother. Patchouli was renamed Chelsea and is treated like an absolute princess. Patty and I often bump into Chelsea on our walks around the neighbourhood, and she is just as sweet and pretty as ever.

I made sure that Patty's first Christmas and New Year's Eve as part of the family were special. We did all the things that siblings do.

We went in with the Spinsters for Secret Santa gifts, ate far too much turkey and ended up sleeping head to tail with matching food comas, barked until we could bark no more at the harbour fireworks on New Year's Eve; good times were had and great memories were made. It was probably the best holiday season I'd ever had. I had my brother by my side and the rents had stayed true to their plans to give us all a little break on the foster-care duties. We made silly homemade video clips and movies, played dress-up and invented new games to enjoy our holidays to the fullest. It was a carefree summer with just the rents and the four of us fur kids. Life was good and the living was easy.

The summer months flew by and before we knew it, it was autumn already. It had been months since the triplets were adopted and we had last fostered. Ma had not picked up her calls or answered the suggested fosters she was tagged in daily. She too was enjoying the much-needed break.

Patty was getting on to be about seven months old now and was on his way back from the shops with Ma when they got to the front door and looked down to see something unexpected – a small brown cardboard box sitting on our doorstep with the words 'Pikey and Patty' scribbled on the top in red pen.

Patty nudged the box and lifted the lid but it was too dark to see inside. Thinking it must be a gift of some donated toys for us boys, Ma was about to tip out the contents when she heard the strangest noise coming from inside.

159

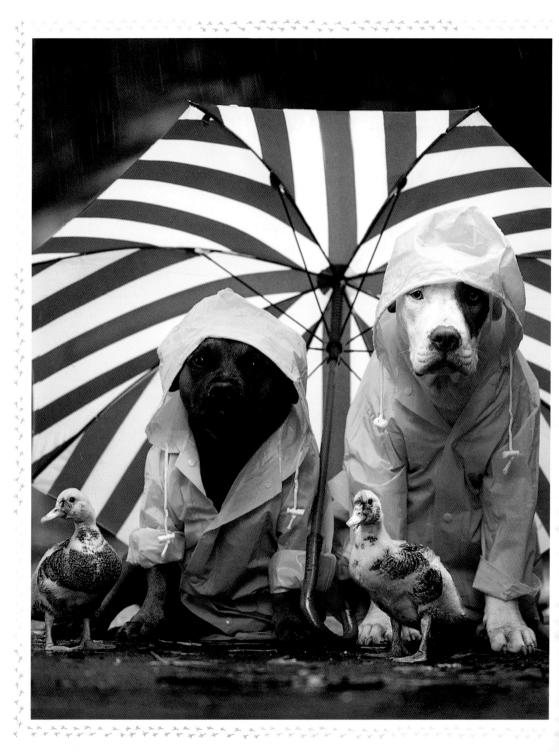

MOTHERDUCKER

IF YOU GUESSED THAT THE BOX ON MY DOORSTEP HAD TWO FLUFFY YELLOW DUCKLINGS IN IT, THEN BOY ARE YOU GOOD AT GUESSING.

'Cause never in a million years did anyone in my family ever imagine ducklings visiting our house, let alone being dumped in a box just like Periwinkle had been almost two years ago.

When Ma picked up the box, brought it out into the sunlight and opened the box enough to see inside, she really didn't know what they were. Were they chickens? They were yellow and fluffy and they made noises like baby chicks, so that had to be it. Without even putting the key in the front door, she walked Patty and the newfound chirping box straight to our parked car and drove them all over to Pa's city office. She called him when she was parked outside and asked him to come out to see her. Pa and Ma reached in and picked up a 'chick' each. At that moment Ma saw that the chicks had webbed feet.

'Ducklings!' Ma said. 'They are ducklings!'

They decided the best plan of action was for Ma, Patty and the ducklings to head home and get on the phone to the vet and rescue organisations.

When Ma and Patty finally walked through the door, the Spinsters and I were all over them like a rash. We could tell that they had something different and we wanted to know why we had heard them at the door earlier but they didn't come in. Ma ushered us all out to the

161

backyard and, setting down the box, she gently scooped up the contents and placed on the ground next to us the two yellow, chirping, moving, plush toys.

These two little things started to waddle around our courtyard and I've got to say, I've probably never been so scared! I crept up slowly to take a sniff. One of them spotted me making a move and came running over, with the other following in quick succession. As they were pecking at my feet and toenails with their beaks or bills or whatever they're called, I decided this was quite enough for me. I bolted up the back stairs and up onto the couch. Patty seemed fascinated by the quackers so I left him and the Spinsters to fend for themselves.

If I had to pinpoint a moment in time when my big-foster-brothering talents and skills had been passed on to, or rather rubbed off on, my little brother Patty Cakes, the unexpected arrival of these tiny ducklings would be it. From this moment on Patty got stuck right in as the second-in-charge big-foster-bro extraordinaire.

After a lot of research on YouTube, calls to all the local vets and the council, chats with some other duck owners and many Google searches, Ma had overloaded herself with some intense duckling ownership education. Patty's rescue group down in Wollongong were happy to accommodate our new arrivals as part of their rescue roster. The duck-lings would stay here in our little inner-city rental house with me, the Spinsters, Ma and Pa, and their new but willing foster 'Mother Ducker' Patty Cakes.

Ma lined our empty bathtub with newspaper and towels. At one end she placed the warmest desk lamp she could find, attached to an array of safety switches and extension cords. At the other end was one of my large water bowls, in which some stones from the garden and a few centimetres of shallow water had been placed. Our bath would have to become a makeshift 'brooder box'. Ducklings, especially tiny little ducklings,

162

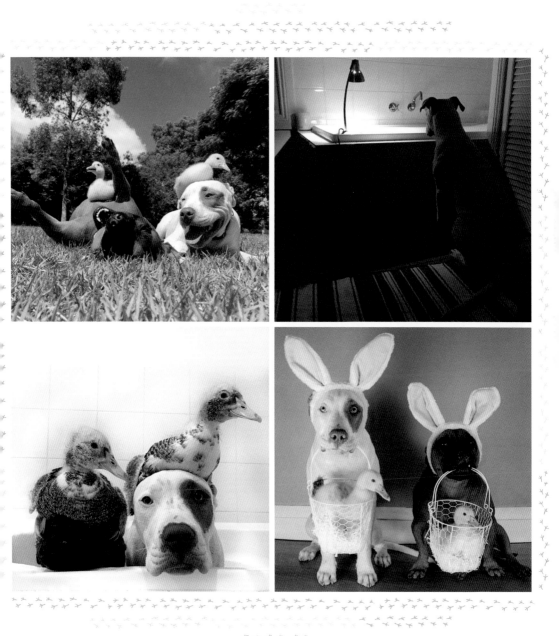

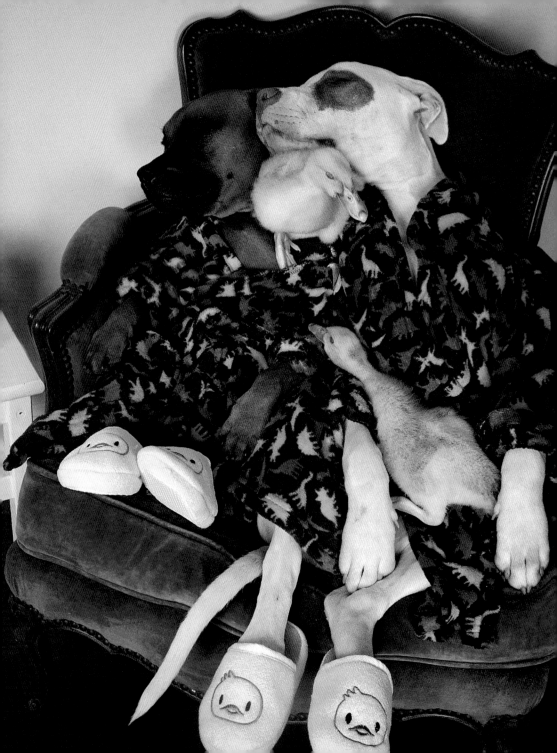

need round-the-clock heat, and right now in Sydney it was just creeping towards winter. We still had lots of sunlight but the evenings were cool, and that little hot desk lamp was just enough.

For the first few days Ma fed the ducklings a makeshift meal mash-up of grains, oats and berries. As soon as she was able to, Ma drove across town to pick up some 'chick starter' meal, as that seemed like a more appropriate diet. The ducklings made no complaints about their new specialised gourmet meals.

Not wanting to go too off track from our special 'P' name theme that was happening with all new fosters, Ma and Pa decided on the names 'Penguin' and 'Popinjay'. It was important to the rents that they pick names that were not food-related like ours, and they thought bird names seemed quite appropriate.

From that very first afternoon, little bro Patty Cakes stepped up and took his foster-parenting role seriously. While she was on the phone for the first few hours after Penguin and Popinjay's arrival, Ma noticed Patty was sitting close by. At one point the little fluffies waddled over to Patty's spot on the living room floor and nestled into Patty's outstretched legs. Ma watched on in amazement as Patty ever so gently curled his front paws protectively around them. Looking back up at Ma, Patty gave her a very thoughtful 'Don't worry, I help them' look.

When Pa came through the door that night Ma went over all the conversations she'd had with various people and the decision that had been made that our little foster family would keep the ducklings here until we could find them a forever home.

You might be wondering at this stage whether these ducklings seemed tame or wild, or if we knew any other info about them and how they came to be on our doorstep. A day or so later, the rents discovered an unread private message sitting in my inbox on Facebook. Someone had left a message to say that they were the person who had purchased these ducklings but they could no longer keep them. After sending us a donation in the past they had our address and thought it would be a

novel idea for 'Pikie & Patti' to 'have them' as their own pets to keep and raise. Unbelievable! I was astonished that anyone would think this was an acceptable way to treat an animal – or a foster family. The rents tried a number of times to message back, inquiring after more info on the ducklings. But each message was ignored and went unanswered till eventually the Facebook account that had sent the message blocked me!

After a number of Google image searches and after describing the ducklings' looks in detail to our vet, it was agreed that Peng and Pop were most likely Muscovy ducks. This is a fairly common breed that some peeps keep as pets. They grow to be big birds sometimes, with a wingspan of eight metres, and adults can weigh up to seven or eight kilograms. After all their soft duckling down falls off, black and white feathers start to appear. These ducks also have a red 'wattle' skin marking on their heads and around their beaks. They're not considered very pretty by non-duck enthusiasts, but apparently they can make great pets as they're not much for quacking and don't make a lot of noise. This breed of duck is also considered to be pretty close in behaviour to us dogs. They wag their tails (or tail feathers) when they are happy and, if reared by humans, some enjoy the odd couch cuddle with their owners. This all sounded like great news to the rents and made them think it could be possible to manage foster care of them for a few weeks. Two tiny ducklings surely couldn't be that hard to care for, not with 'Mr Mum' Patty Cakes so willing to lend a paw!

Each evening after dinnertime and an afternoon of gentle play and naps, the rents would place the ducklings into their brooder box bathtub. Patty would creep in when no one was paying attention and sit right up next to the tub. Sometimes Ma or Pa would catch Patty watching intensely with his head hung over the side of the bath, while other times he'd just be lying on the floor next to the tub making sure his babies were safe. He of course needed some respite from this very serious job so occasionally I'd step in and sub. As long as those little beaks kept their distance from me I was happy to pitch in.

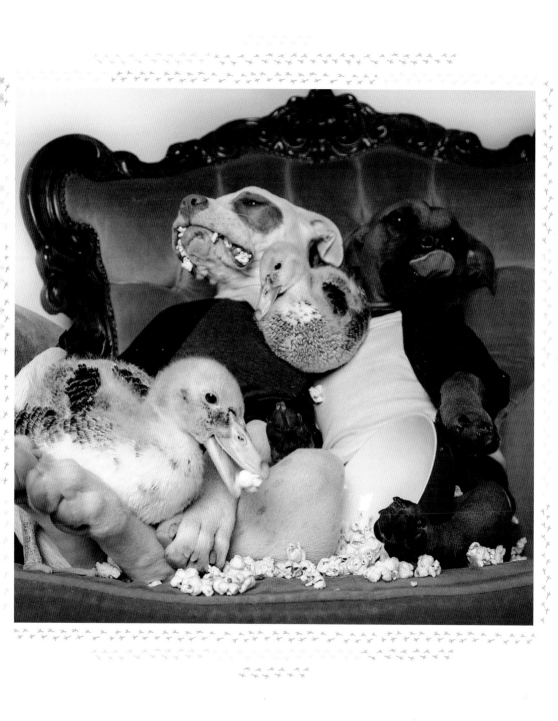

During the day over the first few weeks when the ducklings were still tiny and fluffy, and even when their adult feathers had started to come in, Ma would pack us all up on sunny days and either take us over to my neighbour and ex–foster sister Pudding's front yard or pop us all in the car and drive down to the local park. The ducklings (who by now we were pretty confident were girls) loved pecking and waddling about in the grass, catching ants and chirping away in the warm sun. People might find it odd to know that we'd visit the park regularly but Ma made sure to time it just right, knowing that most people would be at work, children at school and dog walkers occupied at other parks. We basically had my local park to ourselves. Patty and I would run about playing ball and the girls would run (yes, they were great runners) after us, never liking to lose sight of us.

Can you imagine what the reaction was on my Facebook and Insta pages once my rents allowed me to introduce the ducklings? If you weren't there on my social media at the time, I can tell you that the initial reaction was excited hysteria! Breaking the internet with my images was not unusual, but this was a whole new level. I mean, I know Patty and I – mostly me – are an incredibly appealing duo, which has inspired artists and admirers from all around the world, but I never would have guessed that adding two real-life fluffy rescue ducklings to the mix would encourage the explosive attention and hype that was to come.

Within two days we had become overnight internet sensations! Our photos and faces were popping up all over the World Wide Web. Many of the stories had holes in them or bits of wrong information. For example, a lot of articles called me and Patty *girls*, and made claims that we had adopted Penguin and Popinjay rather than fostering them.

But all in all, it was pretty darn nice to have all this attention. It wasn't long before TV news reporters

168

were even talking about us live on air. Not here in Australia, for some reason, but over in China, South Africa, Germany, Canada, the United Kingdom and the United States, we were the 'feel good' news story of the month. One media achievement was seeing us reported on *The Today Show* in New York City. It was rather funny seeing the hosts of the show discussing our unique names, as they had never heard of a pikelet, and they assumed the name Patty Cakes must be something to do with dog poop! It was great teasing material for me to be able to call my little bro 'Poop Dog' for a week (#sorrynotsorry).

The only local media that caught onto our story were our friends over at BuzzFeed here in Sydney. Tania, one of the video producers at BuzzFeed, had regularly filmed and captured many happy moments of me and my foster siblings in the past, including a couple of videos of Patty when he first came into foster care and was a fat little nugget of stank-ass puppy breath. Now Tania had the idea to capture a styled, in-studio story of my brother Mother Ducker and his duckling foster babes. So into the studio one day my Ma, aunt Kim, brother and the ducklings went. A very sweet video was the result of Tania's creative ideas. Patty and his chicks performed for the cameras and lapped up the attention (and free lunch).

Once the novelty and wave of media excitement wore off we got back to normal everyday living with our foster quackers. The difference between their first three weeks in foster care and the next three weeks was great. In the looks department, the ducklings started to shed their soft fluffy yellow down to make room for the spiky buds of black and white feathers starting to poke through. Peng and Pop's wings were quite naked for a time, as well as patches around their faces and necks. To us they just looked like geekier versions of themselves, but to strangers they could easily have been the classical definition of 'ugly ducklings'.

It was about this time that I had really started to accept the ducklings as part of my family. For one thing, they were my most captive

audience when it came to my usually solo games of ball out in the back-yard. When I was done and would head back inside the ducklings would be right behind me, navigating the back steps and doggy door. They still seemed rather convinced that Patty was their mum, but I was like the cool uncle or something.

Penguin and Popinjay had also progressed from taking small dips in their dog-water-bowl pool to my outdoor paddle pool. This had now been lined with pebbles, was equipped with a set of brick stairs to help them in and out and was refilled with fresh water daily. The girls made their way up the brick stairs that first day, hesitating a few times before plunging straight in. Penguin, the slightly bigger of the girls and the one that was developing more white feathers on her chest (Popinjay had more black feathers coming through), was always the one to try any-thing new first. This time was no different; in she went, with Popinjay watching closely. When she saw that it was all okay she happily followed her sister. Gliding gracefully across the water, ducking in and out, get-ting their beaks wet, sometimes driving right under and swimming fully submerged, these girls took to my paddle pool like, well, ducks to water!

After hours of swimming in their sun-filled city-backyard pond, when they were tired and ready for a nap, Peng and Pop would make their way back up the stairs, through the doggy door, dining room and kitchen, and make a beeline to the usually sleeping Patty Cakes. They would hop up and perch atop Patty and settle in for a good preen of their almost-feathers. Somehow, with their beaks or bills or whatever you call those things, the ducklings would remove all droplets of water from their feathers bit by bit until they were dry. Thirty minutes of this grooming later they'd then plod around on top of Patty, seeking the warmest area to settle in and snooze. Patty was one hundred per cent accommodating and would often encourage the ducklings to burrow up under his chin or armpit where it was warmest. What Patty didn't realise at the time was that the new feathers of his baby birds would give him an allergic reac-tion. Poor Patty, even with big blotchy red rashes appearing on his belly

and back he still encouraged his babies to nestle in, feeling that suffering the itches was worth it. He's a total weirdo, if you ask me!

A couple of months had 'flown' by. Life with two once-little ducklings and now almost proper-duck-looking foster sisters became something that I remember as feeling very normal. When the rents would buckle me and Patty in for car rides, there would be right beside us a soft towel-lined cardboard box in which the ducklings would sit (this was their makeshift transport carrier). Mealtimes, naps in the living room, paddles in the paddle pool, swimming at the local dog beach on the edge of Sydney Harbour, chasing the ball in the park or at night in the courtyard, getting the mail from the letterbox; you name it, the ducklings were there every time, keen and ready for the next fun activity. Sometimes Ma would even have them on her lap for a snuggle while watching TV, and she would pat them and scratch their bellies just like she would with us.

I kept waiting for a 'quack-quack' noise, but our ducklings might have been faulty as all they ever did was chirp, like 'peep-peep'. And their little bald chicken-looking wings were starting to get more feathers but I did not see any of the flying that was promised, just lots of running – they still loved to run, and fast!

Peng and Pop's makeshift brooder-box bathtub was still up and running; however, now the girls had figured out that with just one bound they could clear the top and get themselves out and about. Ma and Pa came home on a few occasions to find the bathroom floor looking like the floor of The Owlery at Hogwarts. This was when my rents knew that it was time for our little foster sister ducklings to find a forever home of their own, with more space where they could stretch their wings and just be ducks.

Early on it had been decided that, in the best interests of the sisters, Penguin and Popinjay would need to find a forever home together. They could not be separated as by now the sisters were very bonded and got upset if they were apart for more than a minute or two.

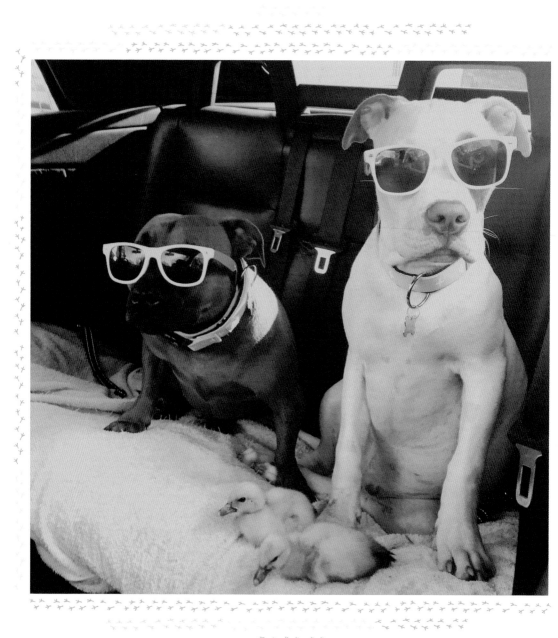

Their joint pet rescue adoption profile went up online, and within a few short days adoption applications were sent over to my parents to review. There were some great potential forever homes but one stood out and sounded near perfect, almost like a duck heaven on earth.

So Ma did what she always did and spent quite a few hours interviewing the family on the phone before a date was set. Unlike the normal process, this time the interview, meet and greet and adoption would all take place on the one day. This special adoption family candidate lived about two-and-a-half hours' drive south of Sydney, in a little coastal village called Berry.

Berry is just as sweet as its name, and beautiful too. The village's main stretch is full of shops that are quaint and welcoming. The houses sit mostly on large blocks of land, and many have real-life farms or hobby farms. It is also close to beautiful dog beaches and bushwalks. I've decided that when I eventually retire from my foster-brothering duties, Berry might be the place to live out my senior years.

Unlike any other adoption interview or adoption handover day, Patty and I were packed up in the car with Ma and Pa, and Penguin and Popinjay. We were all in this together, and our foster ducklings needed a proper send off. The Spinnies decided to opt out of this one, staying home to knit and catch up on *Golden Girls* re-runs or something.

We all slept on the car ride down the coast (except for Pa, who was driving, so was wide awake of course!). The four of us in the back seat woke to the sound of Ma's car door slamming as she jumped out to open a large farm gate across the top of the long driveway we were about to navigate. Driving along the dirt driveway the car was quickly surrounded by a very vocal, very alarming welcoming party. I did a quick head count and counted four barking kelpies, two on each side of the car. Naturally Patty and I responded back with our version of 'We come in peace,' though the rents didn't seem to appreciate our communication help.

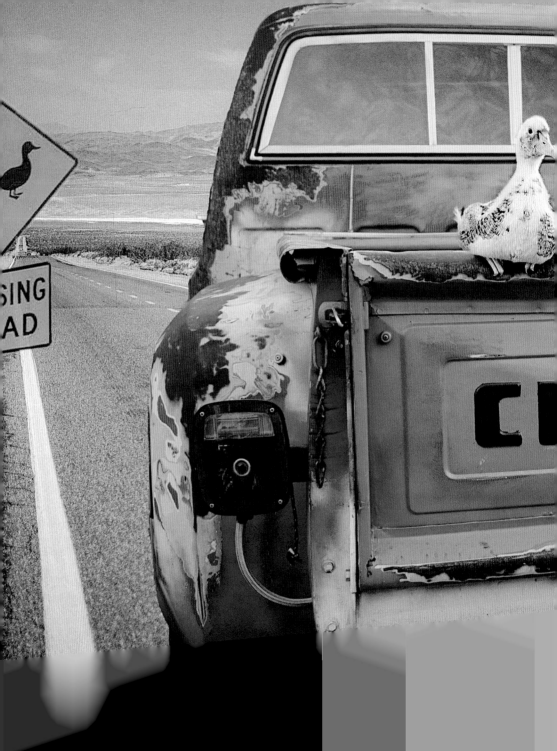

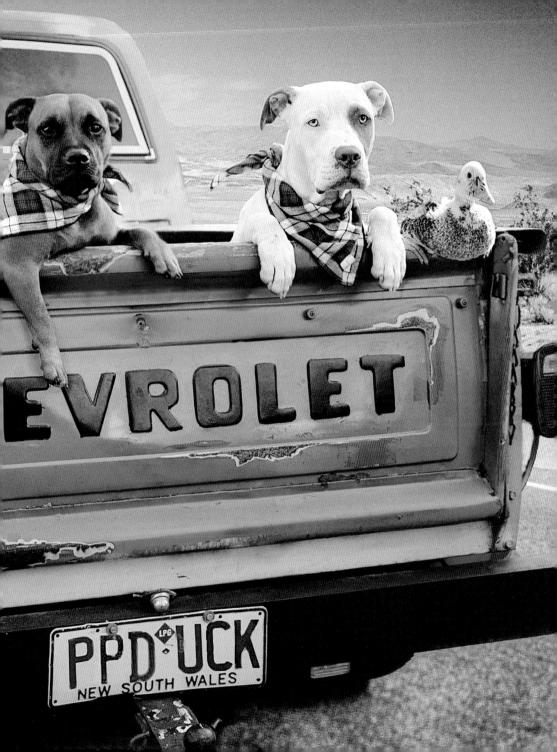

At the end of the driveway we saw the two human soon-to-be forever parents of our quacklets, standing before us with big warm friendly smiles on their faces. Ma and Pa opened the car doors and ushered Patty and me out. Coming face-to-face with the resident barking welcoming committee was a little intimidating, but with some polite sniffing and a few top dog words exchanged by their leader and me, we made fast friends. Turns out these four resident kelpie kids were all rescues like Patty and me. Makes total sense that we all spoke the same language, then.

The four humans chitchatted away as Pa reached into the car to pick up the very precious chirping cargo. 'Let's head straight to the orchard, shall we?' said the hopeful adoptive mum. Following the group, we walked towards what I could only assume was said 'orchard'. On our way we stopped by a paddock that housed the strangest-looking mutts I had ever seen. I have three words for you: They. Had. Horns. I 'kid' you not, these dogs were so funny looking and smelling that even Patty did a double take (he has the worst poker face). Apparently they were some fancy designer breed called 'Goat'. Now, I don't like to make judgements; keeping an open mind and accepting everyone as they are is my policy, so we exchanged pleasantries and I kept following the group. Next up on our path Patty and I spotted at the exact same moment the coolest and biggest backyard paddle pool we'd ever seen. Patty shot me a look that said 'Are you thinking what I'm thinking?' The answer was 'Yes' and we were off, running and launching into the paddle pool together. We'd gotten completely sidetracked from the reason for our visit, and the rents brought us back to reality by noting their loud displeasure at our little dip. Granted, we were now covered in mud, or something that looked a lot like it, but the paddle pool, or 'dam' as we were told it was called, was just too darn awesome to not test out. We city pups did not know such a thing existed.

Finally the group of us – six rescue dogs, four humans and a box of curious city foster ducklings – had arrived at the holy 'orchard'. In

went Ma and Pa with the other humans, but access for us, the two most important people, was denied. Inside there were birds, so many birds, all clucking and pecking about. The orchard itself was a huge, fully fenced enclosure, with a net that extended high up and across the whole top. You could see right in, but according to the humans' conversation it was fox, eagle and goanna proof. (It was also me and Patty proof.) Looking in, I could see lots of different fruit treats and a couple of miniature duck ponds spread around.

We watched through the net as Pa placed the travel box that contained our foster duckling sisters down on the soft grass. Popinjay was the first to be lifted out, and a second later Penguin followed. The girls looked bewildered (if there is such a thing as a look of bewilderment on a duck's face). Unsure what to do and uncertain about the clucking chooks, roosters and large white boy duck around them, Peng and Pop just sort of stood there for a minute. To get things rolling (or waddling along), Ma pulled out the ducklings' favourite mix of hipster kale leaf and spinach salad – they did grow up in Sydney's Inner West, after all. This seemed to do the trick and break the ice. The chicks and others came over for a bit of a stickybeak. It was Maury, the big resident ex-rescue Pekin duck, that everyone was watching for his reaction. If they were waiting for him to do something or show any signs of interest it seemed they would be waiting for some time. He looked indifferent if you ask me.

The first half-hour of Penguin and Popinjay exploring their new home on the orchard went swimmingly. So well that, I'm sure by now you've gathered, it was pretty much a green light from the rents. They had seen enough and they were ready to sort out the adoption paperwork. It could not have been a more perfect scenario for those two crazy kidlets of ours. They had really landed on their webbed feet, finding this family. Kind humans who loved their hobby farm and all the animals on it as family pets, part of their lives, not just something there to add to the 'farm' experience. Penguin and Popinjay's new life

would involve taking long walks with their new rents, the four kelp-
ies, the three unusual-looking designer mutts called 'goats' and big
duck brother Mr Maury. They would walk the big hills of the farm and
swim in the huge paddle-pool dam thingy while their human dad would
row his boat alongside. On cold and wet days Peng and Pop would stay
secure in their big beautiful orchard with their chicken siblings, keep-
ing snug together in the warm henhouse.

So, after the humans all sat down for a droolworthy lunch (which
we got no tastes of, might I interject here), and after Patty and I had run
ourselves ragged exploring the farm with the team of kelpies as our tour
guides, it was that time again. Time to say goodbye and wish our little
feathered foster sisters well for their new forever home and family. It
was a bit sad, and Patty did circle back up to the orchard to check on his
ducklets one last time before we got in the car. But, as we always say on
adoption days, our foster siblings are the lucky ones who get a perfect
ending to their foster care journey.

The rents, as always, are very much still in touch with Penguin
and Popinjay's family. The girls are now pretty much full-grown, big,
beautiful, mostly black-feathered, red beaked, confident adult ducks.
They love their family walks, swims on the dam and hanging out with
their bro Maury. However, they are very much homebodies, and when
they've had enough they waddle themselves straight back up to the
orchard and wait by the door to be let in, just like they used to with their
bathtub nest at HQ. They've also kept their names, kind of – now they
are just referred to as 'Peg' and 'Pop'. A few months after the ducklings
moved into their new home, the very first duck egg was found, and it
was of course *egg*cellent.

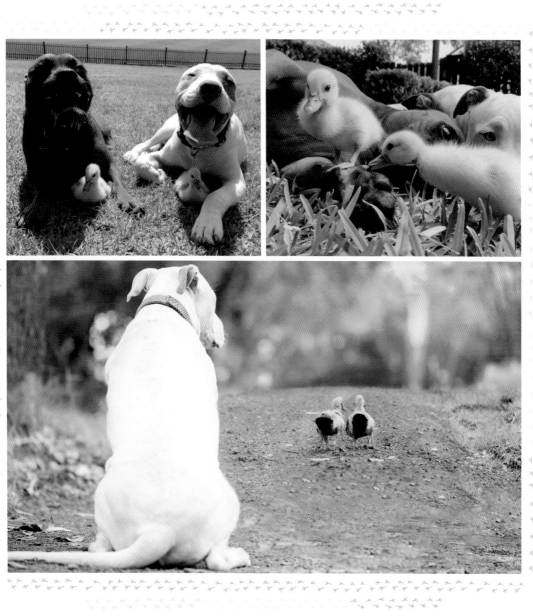

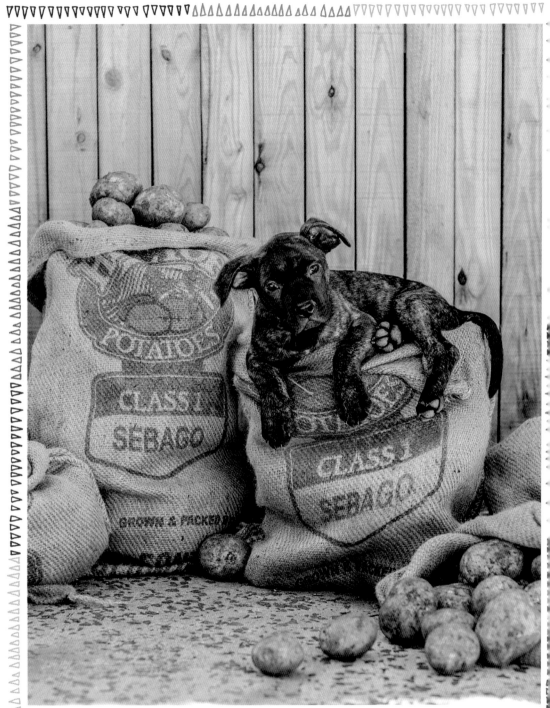

YOU SAY **POTATO**

I SAY **POTAHTO**

HOW MUCH IS THAT DOGGIE IN THE WINDOW?

The one with the flea-bitten tail?

Monday morning we awoke to a duckless home. The bathtub had been restored to the warm water pit of bubble bath hell that I had always loathed. My paddle pool had been drained and all that remained of our foster sister ducklings was our fond memories, Patty's allergic rash and a smattering of baby duckling down feathers that would continue to stick to things and show up for months in the most unusual places around the house.

Peace and quiet seemed like it might be a possibility, though of course to think that is to jinx it! Ma was on the phone debriefing Naomi from the ducklings' rescue when I overheard parts of the conversation (I'm always listening – if it's privacy the rents want then they need to get me a second line FDS). The rescue was looking at undertaking a very important rescue mission over the next few days. I heard my Ma volunteer her services should they be needed. Thankfully Monday passed with not much else doing. I cannot say the same for the next day, Tuesday.

Just after breakfast Ma had herself ready and packed to head off down to Wollongong. I was to stay home and prep Patty and the Spinnies for a possible new arrival.

When Ma arrived at the Gong there was a quick meeting and briefing. A week or so earlier, a lady had contacted the rescue asking them to investigate and possibly step in on a terrible situation that concerned a litter of mixed breed staffy puppies. The backyard breeders who had bred them had decided, as many do, to sell their puppies to a local pet shop to make a quick dollar. The problem was that these puppies were only four weeks old, an age that is not legal or ethical for them to be removed from their mum to be placed in a glass display in a shopping-centre retail window. The pet shop in question was also not exactly known for its high standards. They were going to pay the breeder less than one hundred dollars per puppy and then mark up the price into the thousands.

After the tip-off, the rescue had done some investigating. They had originally got in contact with the breeder with an offer of rescue help and complete veterinary care. The backyard breeder, not seeing any financial gain to be made from this offer, turned down the rescue point blank. So the next step was for the rescue to contact the pet store and let them know that if they had plans to take in these puppies at such a young age they would be reported. As is common practice, the pet store claimed naivety on the whole thing and washed their hands of the backyard breeders.

Now that the dodgy backyard breeders' easy-money pet store offer was off the table, they did what they thought would make them the next best sum of profit. They advertised the puppies for sale privately. Not giving up on these little babies, the rescue tried a new tactic. They called up the backyard breeder pretending to be potential buyers, and asked if they could come out and see the pups. Thinking they'd make a quick sale, the breeders agreed.

The team from the rescue went out undercover, hoping that their suspicions about what they might find were wrong. But unfortunately their experience proved them correct. Living in absolute squalor in an old, falling-apart backyard shed, two very nervous and scared mum and dad dogs were being kept apart from their litter of seven baby puppies, who were hungry for their mother's

warmth. All of the puppies were absolutely infested with fleas and many of them had big open wounds that hadn't been cleaned or treated. The dogs were sleeping on the dirt floor of the shed with a pile of old rags as their only comfort. Their food and water bowl was an old mouldy fry-pan, just the one for both water and food. The smell was putrid. This is unfortunately not an uncommon scenario – it's just one example of the terrible breeding set-ups that supply puppies to pet stores.

A lot of people nowadays tend to think that pet shops get puppies from either unethical puppy farms or 'responsible' breeders. Sadly this is far from the truth – you can be almost certain that a pup in a pet shop has not come from a reputable breeder, because it would be against their code of ethics to sell a dog into those conditions. Had these lit-tle guys gone to the pet shop, they would have been quickly cleaned up and placed on display within twenty-four hours. They would have been marketed as purebred or a designer breed and sold for thousands of dollars, as I mentioned before. The mamma dog would be left with her owners with no questions asked, and the breeding cycle would have more than likely started again.

Unable to unsee or forget what they saw, the rescue team left the backyard breeders' house feeling angered but passionate about making sure these babies would have a brighter future. With few options left, the rescue applied a little more pressure over the next few days, suggesting that if the breeder didn't surrender the young, sickly litter of puppies there would be no option for the rescue but to report them to the author-ities. The health and safety of these dogs were already in a dire situation.

A few days of persistent pressure finally paid off. The backyard breeder called the rescue and gruffly agreed to surrender six of the seven puppies; they had already sold the seventh puppy to a friend.

This is where Ma comes into the story. After her offer of help, a day and time was arranged for Ma and another rescuer to head out to the breeder and pick up the babies. The goal was to see if the breeder would also hand over the mum and dad dogs into temporary

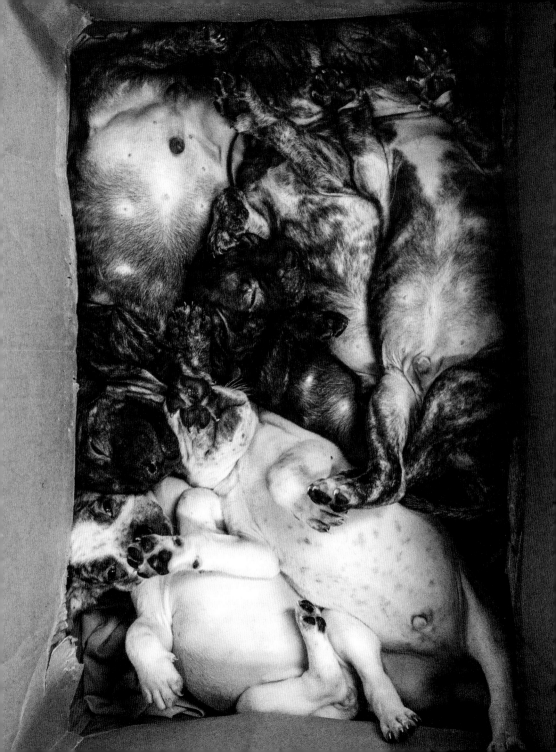

care so that they could be seen by a vet as well, and desexed to stop further breeding.

When Ma and the other rescuer pulled up in the car outside the breeders' house they saw a man and woman blocking the driveway, standing at the ready with a big cardboard box in their arms. Straightaway the man pushed the box into Ma's arms. Without giving them any time to change their minds, Ma walked the box of limp puppies to the car and placed them gently in the secure travel crate. Not taking any chances, she locked the car before returning to the breeders.

Ma and the other rescuer spent a good thirty minutes gently discussing the puppies and their parents with the breeders, trying to obtain as much information as possible and also trying to gently push the idea of having both parents of the puppies desexed. The rescue would pay for all veterinarian costs and would even offer foster care for the adult dogs while they recovered. The backyard breeder unwillingly signed the surrender paperwork provided for the pups, but was against his adult dogs leaving them and was starting to get irate. Why was he the focus of all this trouble? He couldn't figure out why his puppies needed to be saved. This couple firmly believed that they had done nothing wrong. They proudly exclaimed over and over that their litter of puppies that they had 'lovingly' produced was provided with the best care and that you couldn't find healthier puppies if you tried. Ma and the other rescuer knew at this point that things were getting a bit too heated for their liking. They could see that they had gotten about as far as they could with these two and it was time to leave before things escalated, so they thanked the breeders for doing the right thing for the pups, jumped back in the car and drove straight to the emergency vet hospital.

Waiting at the vet hospital, a bigger team of volunteer rescuers and doctors was on standby. The puppies were lethargic and dehydrated. The pups were placed on the cool ground next to some water bowls, and the little ones who could manage to stand lapped up the water in a hurry. It was very possibly the first time these babes had seen clear, fresh

water. In the consultation room the puppies were sprayed with flea medication, and Ma and the team watched in horror as thousands of giant adult fleas began to fall off every single puppy. The puppies with open wounds were cleaned up and those that were too weak to stand upright were monitored. All the puppies were just skin and bone; the only part of them that was big and plump was their large, worm-filled bellies. What should have been soft and silky puppy fur was on these pups coarse, sparse, dry and patchy. Their ears were full of gunk and, at just five weeks old, the puppy teeth on these babies looked like what you would find on a human after years of illegal drug abuse. These babies had been saved just in the nick of time. It takes very little imagination to think what might have been if the rescue had not intervened.

After a long day of saving lives the rescue team was almost finished for the day. The puppies were all going off into emergency foster homes that night and Ma of course put her hand up to help again. The decision was the littlest and darkest one of the litter would travel back home for some famous Pikelet (and Patty) foster-bro loving TLC.

It was late and almost bedtime when Ma crept in with the new little nugget. She went straight out to the backyard, where our routine new-foster-kid meetings usually took place. A bowl of puppy food was served up and a little dark shadow crept forward to devour the meal. Me, Patty, Shelly, Betty and Pa all watched on as the shadow-creature gobbled the food and Ma announced his name.

'Guys, I want you to meet "Potato".' Did she say *Potato*? Well, I could certainly see the resemblance. He looked exactly like a spud picked fresh from the ground still covered in earthy dirt. And he smelled a bit like compost too . . .

'Needs a bath,' I said. Patty agreed.

After some good scrubbing, more worming and flea treatments and a couple of meals in his belly, Potato, or 'Tater', as the nickname quickly stuck, got right into life here at HQ. The trickiest part of Tater's first few

days was that the rents and I were not able to share his photos or story up on social media. We weren't even allowed to tweet about it to my whole six followers on Twitter. The reason for this is that the rescue was still working very hard to encourage the breeders to bring in Potato's mum and dad for the doctor to look over and desex. Eventually Tater's mum was brought in, and even though she was in such a terrible condition health-wise, the breeder would only let the doctor perform the basic desexing surgery and treatment at the cost of the rescue. At least the poor girl wasn't going to be used as a breeding machine any longer; that was something.

To get around the social media lockdown rule, Potato's rescue did approve me taking some 'teaser' photos to announce and let my followers know that we did have a new foster kid here at HQ. It was a little bit fun, making people guess as to who we had. It was also a bit of a relief to take the pressure off for the first week and just let Tater settle in with us and hone his photo posing skills a bit more.

The day finally came when we could reveal his derpy little face to my online pack, with much fun and excitement. The phenomenal support for the great work the rescue had done in saving this litter and drawing attention to the terrible puppy pet-shop trade was truly wonderful to be a part of.

The ducklings had been such a novelty, and as it had been a while since I had just one tiny foster sibling and not a whole bunch at a time like I did with Patty and his sister Pixy and then the triplets, it was really nice to be able to give Potato all the limelight. He was a great addition to the trio with me and my little big bro Fatty Cakes. The three of us were so completely different yet all of us are staffy mixed breeds, all part of the nugget club. When it comes to staffies from breeders, the blue or grey coloured staffies are by far the most 'fashionable' to own. White, tan, red (my colouring) and then black (in that order) are next most popular according to trends of staffy puppy purchases. Brindles (fur that is tawny or shades of brown with streaks of other colours) are almost always on the bottom of the desirability list no matter what breed they are. Even

breeders of purebred, pedigree staffys will charge less for brindle-coloured pups. Who knows why the value of a dog is determined by colouring; I for sure know that I'm a priceless gift to the world and that my looks and personal style transcend the latest in *Dogue* fashions.

Tater had a fast-growing fan base online, as was becoming a habit for foster siblings of mine. Staffy lovers tend to love almost any staffy-type pup, but I think little Tatey captivated and changed the minds of some non-staffy lovers, and maybe even made brindle colouring a little more popular. I thought that maybe since he was just an ordinary rescue mutt the fifteen minutes of fame my social media had enjoyed with Penguin and Popinjay would pass over little sweet Potato. Nope! Very quickly news and media stories popped up all over the internet once again. Potato hadn't gone unnoticed. And for once my Ma's silly foster naming had worked a treat. People loved that his name matched his looks, and I was proud as could be to have my little foster bro out there making a difference, bringing up the street cred and helping to make dark brindle rescue staffy pups as cool as cool could be.

It wasn't going to be long before Tater tot would be ready for his big boy op and off on his adoption adventure. To be safe when desexing young puppies there are a few characteristics vets like to see. One is body weight – the heavier and bigger the pup, the better it is suited to early desexing. Also, if you're a boy pup you really need to have your boy bits visible. Potato certainly didn't have a problem with that second part – his little boy bits, his 'hash browns', were huge for such a little guy! He had no shame in airing them out either.

However, Tater was so small the night Ma brought him home that I mentioned to my rents they might need to bend the 'foster puppy three-meals-a-day' rule for Potato. Originally he weighed only 1.2 kilograms and was a whole kilo less than the next smallest pup in his litter. To get him up to the weight he needed to be for his op, they fed little Tato a good six, sometimes eight, meals a day. He did put on weight; however, he also developed an addiction . . . an addiction to food!

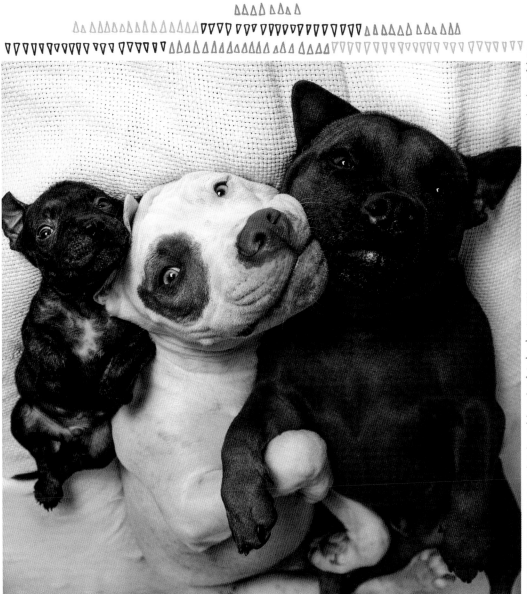

Now, I know what you're going to say, all dogs love their food, right? Even my bro Patty is sometimes called Fatty (mostly by me) because he has little to no self-control with eating. But Potato's love of food was something different altogether. When second and third breakfast was over he'd be back sitting by his bowl not even minutes later. There was no missing the hunger calls and rants of Tatey. His howling and yapping demands for more food were no gentle, polite Oliver Twist 'Please, sir, I want some more.' This little French fry lived for his food (and I'm pretty sure all he dreamed about was food too).

All those food-loving tantrums Potato threw paid off. He was finally able to head back down to Wollongong for his big boy op nice and chunky, at a good weight, and have those huge potato gems of his removed.

When he arrived back home after the operation Tatey's recovery was quick, although he drew out the need for recovery comfort foods. His gems may have been removed but his appetite was still just as great as ever.

Meanwhile, Ma's head was spinning just looking at all the emails we'd received with adoption applications. Everyone wanted themselves a little bit of this sweet Potato. One of the applications looked rather familiar: a big family with three other staffies. One of those staffies was a beautiful white deaf girl that went by the name of 'Waffy' – or, to be more official, 'Pollywaffle'. Almost a full year to the date after Pollywaffle had been adopted, her family had now decided to apply for the Poh Tay Toh.

The rents couldn't not put this one up above all the other applications. Pollywaffle's family had not only stayed in touch, they had been the family out of all my ex-foster siblings that stayed in closest contact. We often would catch up with the whole fam for park dates and parties. Knowing all the time, care, training and love they had put into little Pollywaffle over the past year meant that it was a no-brainer. The question was, would Potato fit in with Pollywaffle and her other canine siblings?

We scheduled a half-day Sunday play date. Tato took his play-lunch(es) and his favourite toy over to the house of PWaff. Six humans and three other staffies might have been just too overwhelming for my

little couch Potato foster bro. But after a day of cuddles, play rumbles and sunbathing, we knew it was going to be a good fit.

The adoption day was booked in, and off Potato went a week later. The early reports and updates didn't surprise us at all – Potato was still demanding at least a second breakfast, lunch and dinner, and spent the first few days hanging around the kitchen and the pantry trying to negotiate for more. Only a few weeks later we had our first catch up since Tater's departure. He had more than doubled in size and it was looking like he might one day be as big as Patty.

Not too long after Potato was adopted, the rest of his saved littermates also found their forever families and a happy ending. It was tinged with a little sadness, though, when Ma read a private Facebook message that had been sent to me from a lady who had followed Potato's foster journey.

Through this lady Ma found out that there had originally been nine puppies in Potato's litter, not just the seven that the rescue had seen while undercover. The first two puppies to be sold went to two 'friends' of the backyard breeder. The lady sending the Facebook message was one of those friends. She described how she had cut off the friendship between herself and the breeders after the puppy she took home had had a terrible seizure the first night. After rushing the four-week-old baby puppy to the emergency vet for life-saving care she had confronted her breeder friends about the pup's health issues. The vet treating Potato's sick little sister confirmed that the puppy had a string of preventable health problems, many to do with poor nutrition and extreme dehydration. Imagine taking home a little puppy and almost losing her in the same night. The breeder friends washed their hands entirely of the puppy's problems and even requested further payment for the puppy as they no longer wanted to give her a mates rate discount.

This is what pet shops call 'reputable breeders'. The moral to Potato's story? You already know this one – don't buy from pet shops. Adopt, don't shop!

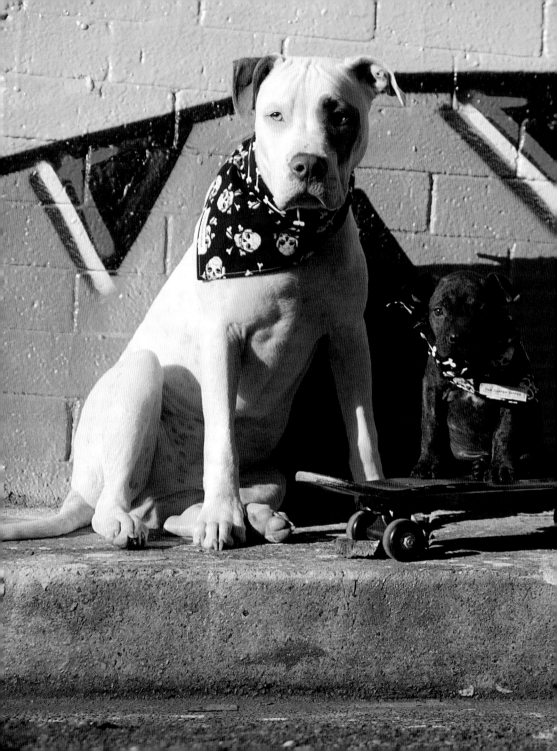

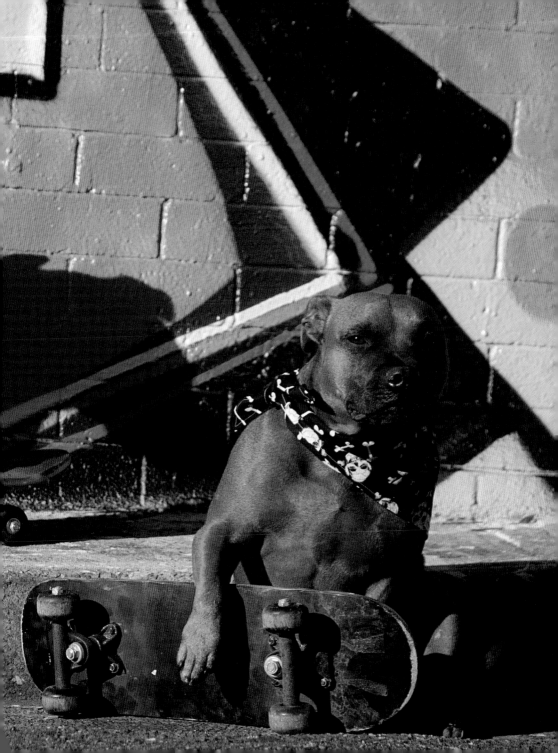

#PIESLICE PUPPIES

A PIE FAMILY REUNION

I CAN REMEMBER LIKE IT WAS YESTERDAY THE DAY MAMMA PECAN PIE GAVE BIRTH TO HER FIVE BABIES IN OUR GUEST BEDROOM.

The months spent training those little yappy slugs, showing them the wise ways of being a dog according to me, their step-foster-dogfather, the sadness we felt as a family losing baby Pigeon to untreatable birth defects, and then happiness as all the remaining members of the Pie family went off on adoption to each of their perfect forever families, is all fresh in my mind.

But it wasn't yesterday – it was a year ago, exactly a year ago today, which happened to be the first birthday of the famous #PieSlicePuppies.

Having stayed in close contact with the owners and families of Pecan Pie and three of her four babies (the family of the fourth pup, Puffin/Bruno, live quite a distance away and are a little more private), we thought there could be no better way to commemorate the momentous day than with a big family reunion, which would also double as a first birthday party for the puppies.

We were first to arrive over at Velvet Pie's house (remember Velvet was originally called Nemo and was the only girl in Pecan's litter), which was lucky, as Ma had baked a giant birthday cake and needed time to make sure it was set up and out of reach until it was time to blow out the candles. Our whole family was invited, but as usual my Spinster Sisters opted to stay home as the party was timed right in the middle

of their second morning nap-time, and both get well cranky if they miss out on their all-important naps. Just like our Spinnies, Velvet too had an older Spinster Sister called Xena. Xena was a kelpie and an ex-rescue dog who would be turning eighteen human years old this year, so she said brief hellos and then took herself off to bed for her own morning nap.

Because Buddy's (formally known as Penuckle) human mum had just had a baby, Buddy had come for a sleepover at our place for the weekend, because his family didn't want him to miss out on the Pie family reunion and birthday party. Buddy and Velvet were psyched to see each other. It was very funny to watch the two little rat-terrier-type mutts running about the garden in excitement, as they were just so alike. Patty totally forgot that he was not a Pie Slice, nor a small dog for that matter, and tried very hard to get in on the sibling reunion play rumbles that were going on between Velvet and Buddy but, bless him, they only had eyes for each other.

Next at the garden gate entrance we could hear the guest of honour herself, Pecan, with her mum and dad. She walked in a little timidly; however, knowing that she'd be fine once she saw me, I ran up to greet her and offer to take her bags. Sure enough Pecan gave me some of her famous puppy kisses and came to join in on the party and reconnect with her two babies, Buddy and Velvet.

We always knew that Velvet looked just like her mum, but now that Velvet had grown up and was almost full adult size, it was near impossible at times to tell them apart. Pecan was very much one of those young, hip, trendy mums that could easily pass as a sister.

Last to arrive was firstborn cutie Pilot Pie. He and his big human family arrived with much cheer and celebrations, and presents for all. Pilot

took a few moments to figure out who everyone was, but once the recognition kicked in he, Velvet and Buddy were a trio of sibling happiness. Oh, and there was still my dopey big little brother trying so hard to fit in and get some of the action. He really has no clue sometimes.

Later the cake was brought out and we all sang 'Happy Birthday'. The humans crowded round and then, after the pups blew out the imaginary candles, it was a free for all. Ma's special gluten-free peanut butter and dog biscuit pupcake with cream-cheese frosting was a success as always. Once the pups and Pecan had gotten a good helping into their bellies, Fatty and I were allowed to join in on the cake smash. We even saved a little plate for Xena to have with her afternoon tea.

The Pie family reunion and first birthday party was a day to be remembered, and I just know that baby Pigeon Pie was watching over us all, proud and happy to know that his family were living their best lives and were loved.

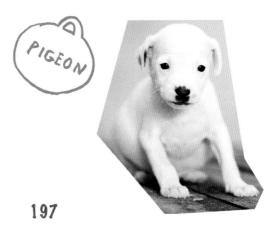

197

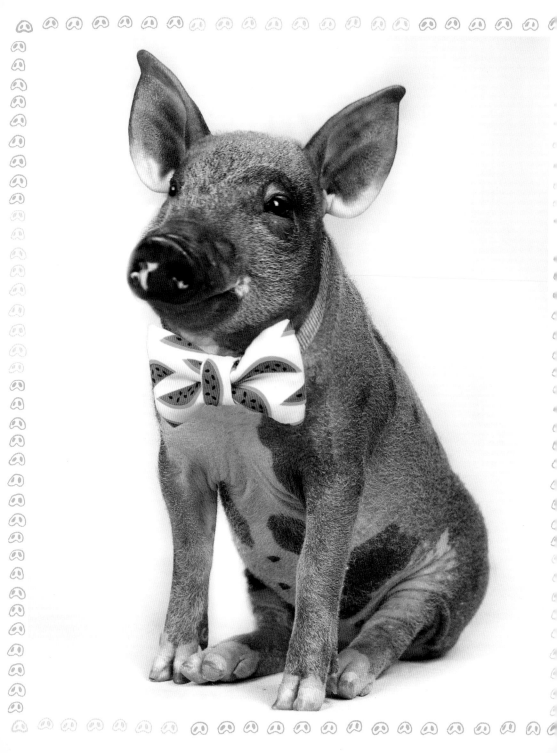

I'M OFTEN COMPARED TO A PIGLET.

I mean, not in the 'Patty Cakes eating like a pig that's why we call him Fatty' way. In the way that I'm about the size and shape of a piglet and my rents seem to think my rickety bowlegs have a resemblance to trotters. And then there is that common comparison that comes with being a staffy, many humans think we all snort and even squeal like piglets.

Four or so days after little Potato had gone off to live with Pollywaffle, the rescue got a call from someone requesting to surrender a baby piglet. The owner had originally bought the piglet with the intention to keep it as a pet. It had been found listed on a trading website going cheap with no questions asked. This piglet was approximately eight days old. The rest of the piglets from the family had been sold from as young as four days old, apparently some to be pets and some probably food.

The idea of fostering a piglet had been one that my rents, along with all their other rescue friends, had often joked or dreamed about. But they had never thought that these passing comments might one day become reality. Weeks earlier, while Potato was still hanging about, the rescue had been called out to assess a nine-month-old pig needing foster care. The owner in that scenario had bought the pig

199

when it was a piglet but had decided it was too hard to keep it now that it had grown big and unruly. The suggestion that my rents foster the nine-month-old pig had come up then. Ma and Pa did a lot of pig care research but ultimately they had to say no in that situation, as they felt a nine-month-old pig knocking about in a tiny inner-city rental house with four dogs probably wouldn't end too well.

But an eight-day-old surrendered piglet – well, that just wasn't something my rents could turn down. What an opportunity, they thought. Pikelet and Patty are going to love having a foster piglet for a sister!

Ma woke up early and packed Patty into the car. At this stage in his life Patty went almost everywhere with Ma when she had to leave the house. This wasn't because he was better company than me or the Spinsters – it was because he couldn't be trusted not to eat the furniture.

The little piglet had been returned to its original breeder temporarily. Ma was to pick her up from there, otherwise the piglet would be resold, but this time she may not end up as a family pet. The place that Ma and Patty arrived at was a small, family-run farm with lots of chooks and other animals. Ma says when she was taken to the place where the pigs were kept she almost squealed at the sight of the piglet she was there to collect. She had thought it would be small and cute, but never did she imagine just *how* small and *how* cute! This must be why so many people think it's a great idea to buy themselves a piglet; the sheer cuteness alone is enough to make anyone want to impulse buy.

Walking back to the car with a tiny piglet in one hand and some baby animal formula in the other, Ma quickly put this new foster child of hers in the little pet crate carrier that was usually used for baby puppies. After a twenty-minute drive away from the farm, Ma pulled the car over to the side of the road in a nice shady spot and opened the pet carrier up to let the baby piggy out to meet one of her foster brothers.

Patty sat frozen, not sure what to make of this little thing. Piggy wasn't like anything Patty had ever come across in his whole nine

months of life. This particular piglet also didn't exactly have that classic pink piglet look to her. She was a sort of greyish-brown colour, completely hairless, and resembled a mix of a wrinkly aardvark with elephant-like eyes and a hippo body shape that had been shrunk down to the size of a soft-drink can. As little piggy climbed over the back seat of the car, making a beeline for Patty, she let out some little anxious pig snorts. Patty leaned down and gave her a lick. Ma took this as a great start and felt confident that things would work out okay. After all, this little pig was so tiny, and it's common knowledge that piglets are similar to puppies (or so she thought).

Back home and straight out to the courtyard for our first meeting. My sisters and I were pretty eager this time. We could hear and smell that this puppy was different. Ma placed the piggy on the ground and we all crowded around. It was fast-moving and pretty noisy, making little grunts with the occasional quiet but high-pitched squeal. Poor little thing, I could see that she was confused and seemed scared and hungry. I wasn't a bit scared of her, though, I was completely intrigued, and I finally understood why the rents had nicknamed me their 'little piglet'. We could be siblings!

Ma set to work mixing up some formula. She called my aunty Ali to come and help as Ma wanted to go and find some goat's milk to mix in. Ma had done a lot of research and wanted to make sure that this little piggy was as happy as possible, and she had read that the best way to make pigs happy was through their bellies. Interestingly, that's also the best way to make Pikelets happy! Food makes the heart grow fonder, I say.

Pa made sure to get himself home from work early that day, as it's not every day you have a foster piglet waiting to meet you. After all the regular home-from-work greetings, Pa turned his full attention to the tiny piglet. He told Ma that, out of all the names she had suggested, he thought we should name our new piglet foster family member 'Punk'. This was a name that Ma had been saving for a special puppy one day in

the future, but she agreed with Pa that it suited our once-in-a-lifetime foster piglet sister. Punk the rescued piglet, like no other before her.

The first night Punk settled into the nest of dog beds by the living room gas heater. This was a favourite spot for puppies and my Spinster Sisters, and it looked to be the fast favourite of our little Punk sis. The research the rents had done said that, much like the ducklings before her, baby piglets need a lot of warmth when they are without their mums. The sleeping arrangements had come down to Ma having to set up in our guest bedroom with a fenced-off playpen area right next to the human bed. Punk would sleep on a plush dog bed placed on top of a billion puppy pads right within Ma's arm's reach. This was how it would be until the day Punk left us for adoption months later.

On the second day little Punk was with us, Ma worked really hard to settle her into urban city living. As we don't have any grass or dirt in our back courtyard, Ma thought it might be a nice adventure to take Punk, me and Patty down to our local dog park. She waited until all the humans would be at work and the mini-humans at school. Patty and I went about our serious park business of ball games and chasies, and Punk oinked alongside us the whole time, not daring to lose sight of us. She already knew we were her crew.

Back home after a good time in the sunny park, it was time to announce the new arrival to my social media pals. Who knows if this would be considered as exciting as it felt? Maybe Punk the rescue piglet wouldn't hit it off with my followers, she wasn't a duckling or a Potato after all. Silly me – of course the first photo and announcement was received with much excitement and a truckload of questions. People wanted to know her backstory, and what breed she was, how big she'd grow, and if we could keep her!

As usual I pointed out that asking me how big any of my foster siblings are going to grow is a question that is near impossible to answer. That's like asking a human mum who's just had a baby the same question. The answer I usually like to give is 'normal dog size'/'normal duck

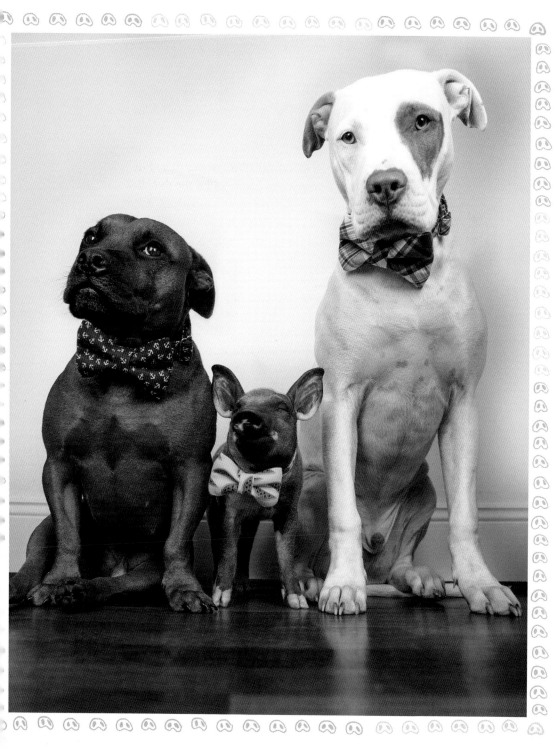

size', and now my answer was 'normal pig size'! There are no such things as mini or true micro pigs here in Australia, and most pigs sold as 'mini' pet pigs turn out to be one of the common breeds such as Large White, Berkshire or Saddleback. We knew from Punk's breeder that she was indeed a mixed-breed Saddleback. She did come from two small-sized adult Saddleback pigs, but she was still a Saddleback – one day this little tiny 700 grams of Punk would be big, round, chunky, hundreds of kilograms' worth of piggy goodness. Oh, and speaking of the comments, I would not even entertain those questions or remarks from people thinking she was only good for food. No bacon or pork dumpling jokes from me! These were not appropriate. I had heard that pigs were highly intelligent beings, apparently even smarter than the common dog (present company excluded), so I knew it wouldn't take long at all before Punk got the hang of looking up my social media, and I wasn't about to be offensive by calling her food!

Punk did indeed love our gas heater, she got so attached to lazing in front of it that she would guard it from the rest of us. Poor Spinster Sister Shelly Shoe was not impressed with this idea. When she wasn't lying about heater-hogging or demanding Ma feed her another serving of milk and formula, Punk's other favourite daytime activities were playing with and on Patty, chasing him around the house and imitating what she seemed to think were typical dog noises. She was pretty darn good at this as her snorting, honking noise did sound uncannily like barking – yes, my piglet foster sister taught herself to bark so she could fit in with her doggy foster siblings.

The other of her favourite pastimes was having a good old itch and scratch. Her elephant- or hippo-like skin was getting pretty dry and itchy from lying right up close to the heater. She would have either a jumper or onesie pyjamas on most days as it was winter again here in Sydney, but that still didn't stop her skin from drying out a little more than what is considered normal. Ma and Pa

took to oiling her up every night with coconut oil (which Patty and I very much enjoyed licking off her straight after). But piglets tend to be quite itchy anyway. Some are very unlucky and have mite infections or mange, but Punk had already been checked over by Doctor Nathan and he had confirmed that she had neither and her skin was pretty normal aside from the extra dryness coming from all the heater time. According to Punk, the best item in the house to get a good scratch from was a toss-up between the legs of the coffee table or the giant sleeping Patty Cakes. Watching Punk shake her moneymaker up against Patty was both hilarious and a bit raunchy. I was just so thankful that she was still too much of a midget piglet to reach the couch, and I would make a conscious effort to join the Spinsters up on the high parts. Patty was not so clever but he didn't seem to mind (or notice).

After the success of making the bathtub into a wonderful brooder box for Penguin and Popinjay, Ma had the brilliant idea to make the bathtub a makeshift pen for Punk. Punk was tiny but she sure was a bit of a pig when it came to eating. She made such a mess, so Ma thought she could line our bathtub with puppy pads (for trotter traction) and place Punk's saucer of milk formula inside for nice clean mealtimes. Ma also thought this would mean she could have a minute or two to herself, with Punk safe and occupied, and, being so tiny, not able to get herself out of the bathtub. Of course, Ma forgot a very important fact she had uncovered in her research, which is that pigs are not only highly intelligent but also amazing escape artists and problem solvers. One morning Ma left Punk in the tub and went out to make herself a cup of tea. As she was filling the kettle up with water she felt the cool, familiar sensation of a piggy snout pressed against her bare foot. Looking down – you guessed it – Ma spied Punk! Yes, the cola-can sized Punk had jumped her way out of the tub. This was an indication of things to come, and also the moment that Ma had to resign herself to the idea that she would not be able to leave 'the Punkinator' alone, unsupervised, ever.

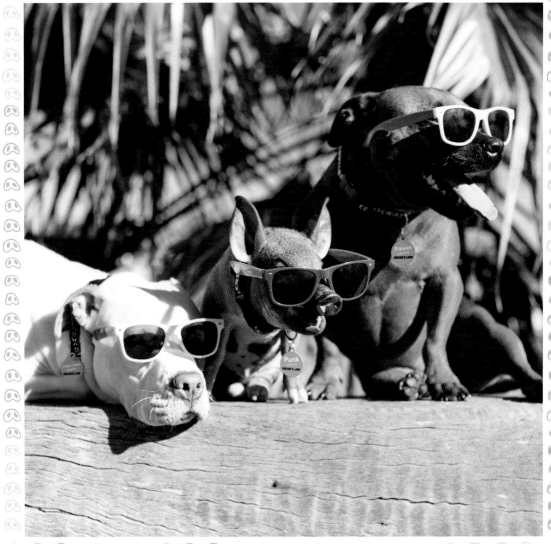

Some of the most memorable quirks of living with Punk, which may or may not be a pig thing but might just be a 'Punk' thing, are as follows: she loved to 'root' around with her snout, pressing it on the closest person (be it the rents, Patty or me – the Spinsters dared not let her get that close). I'm told this is pretty normal of piggies, but Punk was doing it almost obsessively, particularly when she was sleepy or hungry (which was always). We figured her clingy behaviour was probably the result of being taken from her mum at such a young age and not having a normal piglet development. Again, Patty didn't seem to mind this, but I certainly did. I would turn and give her a warning to back off and she would just copy my growl as if to tease me. She knew that if it was Ma that she 'rooted' on then Ma would cave and pick her up for cuddles. With Pa, Punk had a favourite ankle of his – the right one. She would lift up the bottom cuff of his trousers or jeans and push away the sock just enough so she could find Pa's hairy ankle to press her snout into. The left ankle was apparently not as nice.

Another of Punk's quirks, or rather two that were combined, came out at nap time. She had decided that the comfiest sleeping position was to sit on a rent's lap with her head supported by placing her chin in the palm of their hand. It kinda looked like they were strangling her, but she really did find this so comfy. Then she would slurp the air, moving her tongue in and out of her mouth like Hannibal Lecter from *The Silence of the Lambs*, and when she'd lulled herself off to sleep her tongue would remain sticking out. What a weirdo!

Punk was not a breed of piglet that is known for fast growing; in fact, she is one of the slower growing varieties. Weeks had gone by since she had arrived at HQ, so she did manage to get a bit of growing in, but at her biggest after eleven weeks she was still only just a bit smaller than me (and I'm a very runty, small-sized staffy). Her famous onesie and striped PJ wardrobe had to be replaced with the next size up a couple of times. Her walking and car harnesses also had to be replaced a few times, and my rents had long since given up on fitting her with collars as her fat little neck was the fastest growing part of her. By the end of her foster care stay

I would confidently say Punk had no neck – her head just went straight to her shoulders. She did have about five chins though.

The more confident Punk grew in her life as Australia's only city-living rescued foster piglet, the more my rents knew our time with Punk in the house must come to an end. She was getting closer to needing to find her forever home. Doctor Nathan had been researching and prepping to perform Punk the pig's desexing operation – not something that city vets get to do a lot of.

With just a few weeks left before she would hopefully head off to a wonderful forever life we made the most of our remaining time together. There were lots more park visits, including one particularly eventful trip where Patty went to the toilet on Punk's head just as we were all leashed up ready to leave the park (and no, it wasn't the kinder pee option but the painfully messy runny poop option. Ma was in tears at the drama of her clean-up task. One chaotic bath session with a squealing piglet later, a whole bottle of wine may have been consumed by my Ma that night). Punk got to visit the local dog beach and try out her sea legs. She had trips to the shops walking down the main street on a leash next to Patty and I gaining many stares, honked car horns and laughter and pointing from passers-by (as if two dogs and their piglet sister taking a walk to the shops is something to make a fuss over. Have some respect, people – how would you like it if we laughed at you when you were just hanging out with your fam?!).

And we can't forget that Patty and I threw our famous Punk Pub Party. We modelled this idea on last year's Pie Slice Puppy Pub Party. This party was held almost exactly a year to the day at a different pub, inside this time, with fancy food and drink. Out of respect for Punk we made sure no pork was served. We presold tickets and made it an exclusive, small guest list. The whole day was amazing as we had friends come from all over just to meet me (and Patty and Punk), raising a few thousand dollars for Punk's (and Patty's) rescue group, Wollongong Animal Rescue Network, in the process.

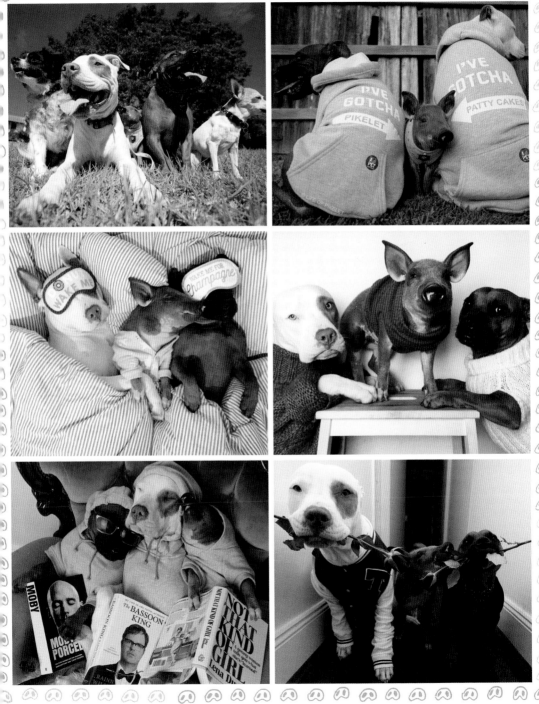

Punk's desexing surgery was performed by a nervous Doctor Nathan without a single hiccup. Considering how sensitive pigs are to anaesthesia, because they don't regulate their own body temperature too well, and that the inside of a pig looks a fair bit different to the inside of a dog, Doctor Nathan was an absolute hero with the surgery and after-care. Ma went in to check on Punk as she was waking up. She was expecting that Punk would squeal the hospital walls down like she had done earlier that day during a twenty-five-second warm water bath at home. Instead, to her surprise, Ma said she'd never seen a sweeter version of Punk. She was so sweet and sleepy and just wanted to be held and cuddled in nice and close, which Ma was happy to oblige.

Just a week later Punk's stitches were ready to come out and her scar was all but invisible. After all the time she spent up at the vet surgery during her operation, Ma decided to give us all a few days off over the last few weeks and give Punk some special day care time at the vet. Punk *loved* this. She'd walk herself into the crate area on arrival and begin to tear up all the puppy pads and bedding. So much fun! The vet nurses would beg Ma to bring her in more often as they all took it in turns to take Punk out for walks on the leash and give her unlimited cuddles. Oh, and the novelty of feeding a piglet was still considered enthralling for the vet staff, so Punk enjoyed her job of eating for entertainment.

As you can imagine, there was a flood of adoption interest unleashed once Punk's adoption profile went live on the internet. I am proud to say that this had become the norm; no matter the foster sibling – puppy, duckling or piglet – people wanted to have their own part of the Life of Pikelet family. And, of course, all my siblings were the best of the best, so it wasn't difficult to understand they were so sought after. People from all around Australia sent in applications to adopt Punk. Ma knew that many of them were probably driven by seeing all of the cute photos and videos on social media and were sent without much thought about the reality of her one day becoming a big

giant pig. The rents and Punk's rescue agreed that the right adopter for Punk needed to have thought a bit further than just the cute piglet-owning novelty factor. They knew what they were looking for, and they would take their time to find only the best for Punk. The potential adopters were narrowed down to six or so serious applications, with one in particular that stood out above all the others. It looked like this might be an easier decision than the rents had thought, because so far this application ticked all the boxes.

After a lengthy phone interview, Ma decided that a face to face interview and a meet and greet at the potential new home of Punk was in order. Ma and Pa wanted Punk to meet the whole family and see how she reacted. This time Patty and I had to sit this one out and stay home with the Spinsters.

The rents drove out to a rural part of Sydney, about an hour's drive away from the city. They turned into a long dirt driveway and passed rows and rows of colourful rosebushes. This was a rose farm, and Punk's hopeful adopters lived here on a big property, as did many other human family members. Punk's adoption applicants lived in the last house at the end of the drive. Waiting eagerly out the front of the house to meet her were her potential mum, dad, canine puppy brother Ralphie and piglet (yes, another piglet!) brother Frankie.

As Ma lifted the Punklet out of the car she could tell Punk knew something was up; she was a little nervous-looking but she also had her snout in the air and her ears pricked up on high alert. She knew that there was another piglet nearby.

Not wanting to introduce the piglets and pup too soon and cause a commotion out the front of the house, the rents handed over Punk's leash to her potential new dad and they all walked towards the house to have a proper snout-to-snout meeting.

Inside the yard, everyone was let off their leash, and Frankie the boy piglet started frothing at the mouth with excitement. It was love at first sight for him! Ralphie the golden retriever was also excited. Both

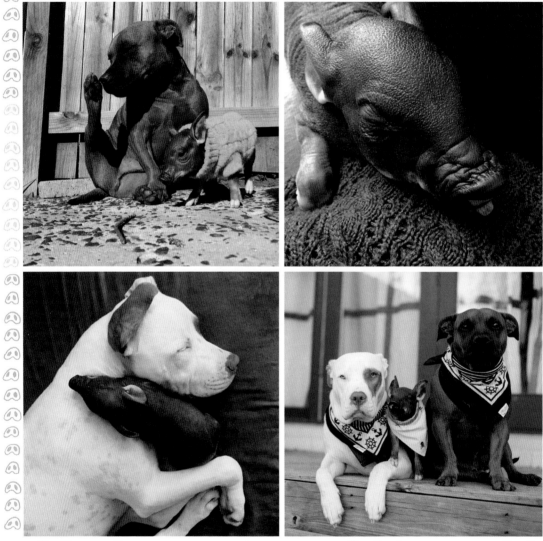

were so friendly that it was a little overwhelming at first for Punk, but that soon changed. Punk is a confident, sassy gal, and once she knew that those new potential brothers of hers meant her no harm she was keen to get in on the excitement.

Sharing some treaties of peanuts in the shell, the trio quickly relaxed and started to get properly acquainted. A good game of chase and then a crashed-out nap on the couch later, it was decided that if this family would like to have her, Punk was all theirs to adopt.

An hour or so later the rents buckled Punk back into her car seat and headed off home. Not too long after the meeting Ma received a message from the potential adopters confirming that they had all agreed that they would love to adopt little sassy pigpants Punk as part of their family.

Punk had lucked out, like many of my foster siblings before her, and found herself a forever family that dreams are made of. She would live as an indoor/outdoor pig with a piglet brother, dog brother and a loving mum and dad on a beautiful rose farm not too far away from her foster family.

When the last week of foster care rolled around for my foster sister Punk, the reality really sunk in for my rents. Patty and I had taken her in as we always do with our foster siblings. She was one of us, and no different from any of our other siblings in our eyes. But the rents, they had grown to love that pig. She had been hard work at times – she was time-consuming, fussy, difficult, challenging, a stealer of sleep and the screamer and squealer of nightmares – but Punk was also one of their foster kids. She was incredibly sweet, the funniest, most entertaining, most affectionate, silliest, cheekiest, cleverest and downright the most unique little foster poppet my rents had ever had in their care. (This doesn't mean she overtook me in the category of most loved by my rents – I will always have been their fave foster child!)

I often read people commenting on my social media to say that they could never become foster parents. And maybe they are right, because it does take a certain kind of selflessness and desire to help, and not everyone has a Pikelet or a Patty Cakes or even a duo of Spinster Sisters to help with the all-important team effort that takes place at my house. It does take lots of effort and it is a huge and important commitment.

Whenever we announce an adoption online, someone always comments 'I could never do what you do because I wouldn't be able to let them go, I'd keep them all!' However, when you become seasoned foster parents like my rents or a foster brother extraordinaire like yours truly, you quickly understand that each adoption means that the foster puppy (or duckling, or piglet) is going to a home that is perfect for them. They will never want for anything and will become a treasured part of their new family. All the effort, time and love you poured into your foster kid or sibling have resulted in a gift of love to some lucky family. You're also probably not saying goodbye forever, as you know you can stay in touch and get regular updates, and maybe have a reunion catch-up or two. (Sometimes there is even cake involved.) And after all that, as time and time again has proven, it's not long before a new baby squib is on your doorstep and it's time to give another foster their second chance.

For all these reasons, it had been a long time since Ma had cried when sending off a foster kid to their new home. Normally saying goodbye was a bittersweet affair but the sadness of saying goodbye had long since been an issue for Ma and Pa. But the morning after Punk's adoption handover, Ma came home and had herself a little cry. It may have been from the delirious exhaustion of looking after the most high-maintenance city piglet known in history, or it may have been because Ma knew that she had just lived through eleven weeks of pure fostering magic. Punk sure was some pig.

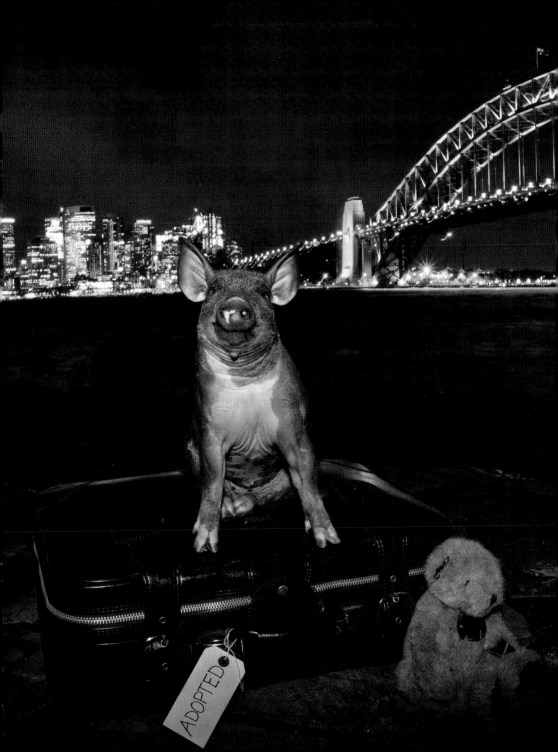

THE LITTLE OLD DOG
WITH THE SECOND NAME SHOE.

There was one major event that I left out of Punk's story for rea-
sons of needing to give it the sensitivity it deserves. This event
took place just a week before Punk left for her forever home. It was an
unexpected moment that none of us were prepared for and that my
family is still in shock from.

Two weeks before Punk the city-living foster piglet went off to
live on the rose farm with her new family, my Pa's lovely grandmother
passed away. This made the rents very sad and upset. My great-grand-
mother was a kind lady who I only met once or twice. I remember she
gave me some good pats and imparted a few wise words. Her farewell
party (or funeral as humans call it) was on the Friday after her passing.
Ma and Pa got dressed in their most respectful black clothes and me,
Patty and the Spinsters tried hard not to leave our hairs all over them.

There was nothing unusual about that morning, only that my rents
seemed a bit stressed and a lot sad. They kissed and hugged us all good-
bye and went off to say their goodbyes to Pa's grandmother. On their
way they took the Punkinator up to the vet for day care, as she was not
to be trusted home alone now that she had figured out how to open the
pantry and fridge, and wouldn't listen to Patty and me when we told her
not to be such a pig.

Ma said that she'd try to come back early so as not to leave Punk terrorising her day care friends or the vet staff for too long. When she finally got back home that afternoon I could not have been more relieved to see her. I was pretty panicked. While the rents had been out that morning, everything seemed normal until my oldest Spinster Sister Shelly Shoe started to feel a bit odd. She said that she was having chest pains and wasn't feeling the best. Shelly moved herself along the couch from her usual regal position on top of the pillows to a spot a bit closer to the living room door. This was a worry to me as I had never seen my sister do this; normally she guarded her high-up place on the couch pillows, only leaving on warm days to take sunbathing breaks out on the back deck. Sitting on the couch by the door was not her thing at all. But she told us that she was sitting there because she needed to get Ma's attention as soon as she got home, because something was just not right.

Barely two hours later, in walked Ma and Punk, back early as promised. Shelly's clever position on the couch and her less-than-enthusiastic greeting were indeed enough to grab Ma's attention. Gosh my sisters are wise, I don't know why I ever question them.

Ma asked Shelly what was wrong but by this time Shelly could barely lift her head. She was all limp, and breathing very heavily. Her ears, nose and paws were cold to the touch, and Ma knew she needed help immediately.

Getting changed out of her funeral attire, Ma watched poor Shelly struggling to stay upright. She dressed my oldest sister in one of her warm jumpers, bundled her in some blankets and cocooned her in a favourite plush bed. Ma grabbed Punk's leash and ran both the girls out to the car. Not thinking much about leaving us behind, Ma simply yelled out a strained 'Be good! We'll be back soon.'

Ma calmly but quickly rushed Shelly into the vet hospital. Doctor Liisa was the vet on duty and kindly prioritised Shelly to get her into the surgery room for some immediate oxygen and a thorough examination. Even with heat packs

218

and oxygen, Shelly was quickly declining. Punk was in her travel crate nearby, making concerned grunts.

Shelly was nearing the age of seventeen, but until now she had appeared to be in great health for an old chook, with no ailments, aches or pains. Her hearing and eyesight were not great but not too poor either, and her appetite was as good as ever. But she was elderly – in fact, being a small-breed dog, Shelly was considered to be in the 'geriatric' phase of her life.

Things were looking grim. Shelly's temperature was extremely low and her veins were so cold and constricted that Doctor Liisa could not administer an IV. After some X-rays and scans the news was of the kind that no dog Ma ever wants to hear. There was no hope. Little Shelly seemed to have suffered a blood clot, which led to a stroke in her lungs. Unpredictable, untreatable and at her age, deadly.

With her heart breaking painfully and her head spinning, Ma knew what Shelly now needed. She needed her Ma to understand that it was her time to leave and to give her one last gift, the gift of leaving in a peaceful and painless way. Ma tried one final time to reach Pa on his mobile and he finally answered, and then he was on his way, running through the streets to make it in time to say goodbye.

Pa picked up his little doghter and whispered that he loved her and she would never be forgotten. As Ma always said, Ma may have 'owned' Shelly but Shelly had 'owned' Pa.

Ma took over for her last cuddles with her baby girl. She told Shell that she had been the best dog she had ever had and that she had done good. She had always loved her and always would.

Doctor Liisa placed the oxygen mask back over Shelly's nose and the oxygen turned to relaxing sleeping air. Shelly Shoe gently drifted off into one last deep slumber, dreaming of the long life she had lived and the family she had loved. She felt nothing as the needle left her heart, and then she was gone.

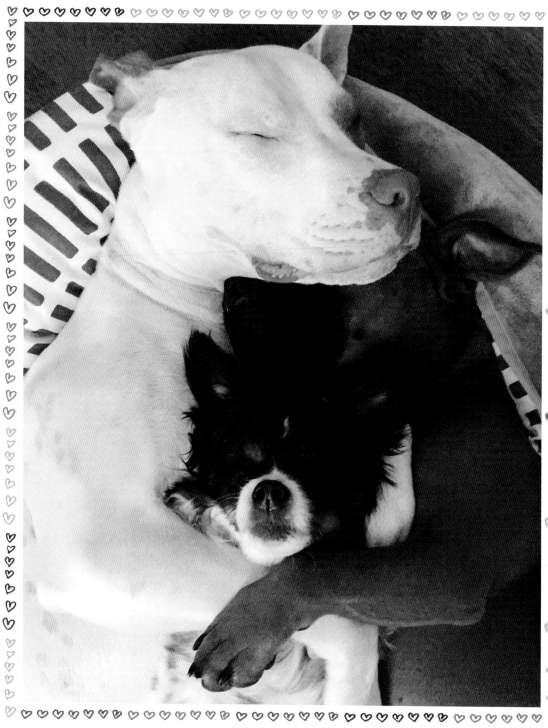

AND THEN
THERE WERE
THREE

I NEVER WOULD HAVE GUESSED THAT THE PASSING OF THE LITTLEST AND OLDEST PERSON IN MY FAMILY WOULD LEAVE SUCH A BIG HOLE IN MY LIFE.

Shelly Shoe's absence was felt deeply by all of us. We were lost without her – she had always been there, the matriarch of the family, the boss, quite literally the top dog.

The night that Shelly died, the house felt empty. Ma and Pa, Punk and only three of us dogs. A week later Punk left for her adoption, and then there were three.

The dynamics of our daily life had drastically shifted. I was now second-in-command, and Betty Boo, the remaining Spinster, didn't know what to do with herself. She stuck by Ma's side like glue and sought out the comfort of Patty's and my paws for cuddles and naps much more than usual. We spent days reflecting and reconnecting as a family, figuring out how things were going to work now.

Weeks ago, Ma had already agreed that once Punk had left us we would welcome a special someone new into foster care. At this time there were some very important things happening in Australian politics. The New South Wales government was in talks to decide if closing down the greyhound racing industry was a viable option. Information about some terrible treatment, including live baiting of animals, had come to light and was featured in the media. Greyhounds and other animals were being abused and horrifically killed all in the name of this so-called sport.

Patty, Punk, Penguin, Popinjay, Paprika, Patchouli and Parsley had all come from the same rescue, Wollongong Animal Rescue Network. This rescue was starting to get inundated with ex-racing greyhound surrender requests in anticipation of the possible future racing ban.

A greyhound in need of foster care would be the next pup we would invite to stay here at HQ. A couple of days after Punk left, our new foster sister was delivered. Tall, dark, slender and leggy, Ma had named this beautiful ex-racing greyhound 'Pennyroyal', with the instant nickname 'Roy'.

Roy was a beauty. She was a gal who had been through the worst and only known a life of harsh neglect. Her trainer was one of the most notorious around. He made his living by racing his 'pet' dogs, and when they were not making enough in prizes, not running fast enough and winning, he would 'get rid of them'. WARN had offered to help out and, after surrendering a number of greyhounds in the past, he approached the rescue to take on some more. His words were 'If you don't take them then I kill them. They are nice dogs but they are worthless to me. This one a complete failure, she even failed at live baiting.' He was talking about our Roy.

Her home with her trainer had been a very small concrete kennel run. She was only let out of this run for intense live-baiting training, treadmill training or to race. Roy had never known a soft bed or comfy couch, or a gentle touch. She had never even been in a house before. At approximately two years old, Pennyroyal may have been the oldest foster sibling I'd had in a long while, but since everything was brand new to her she was very much like a puppy.

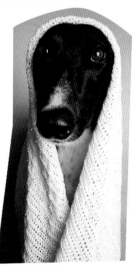

Her first night at our place was spent adjusting to an open space (as much as you can call our tiny house an open space!) and getting used to having the freedom to get up and walk around or lie down where she pleased. She did have to wear her muzzle for the

first few hours – this is standard practice for ex-racers who have been through baiting. Remember, my sister Betty is a small fluffy girl who has three legs. When she walks it is more like a bounce or a skip, so this would be very tempting and confusing to a dog who had been trained to run, catch and kill fluffy little creatures.

But don't worry, Patty and I could see straight away that Roy's trainer had it backwards – she wasn't a failed racer, she was a winner at life. She had the manners of a typical gentle greyhound. She was shy but respectful, and she was smart too.

Roy was going to fit in just fine here at Life of Pikelet HQ, and we knew she was going to be well loved once Ma shared her pretty face and long snooter on my Facebook and Instagram accounts.

So, this is pretty much us! You're almost all caught up to where things are today. There's just one more person I need to introduce you to.

You see, Shelly leaving us all so suddenly left a huge gap in our family. There is no such thing as replacing an icon such as Shelly Shoe; you couldn't make another one of my sis even if you tried. But there was certainly a vacant spot in our family going to waste. Now, as a once-stray dog roaming the streets with no family – as a once–pound puppy sitting on death row – I'm a firm believer that when good dogparents and families lose their fur kids or fur siblings, those families need to get back in there and pay it forward to honour their dearly departed. An empty dog bed in a loving home is a terrible waste when we know there are so many homeless pups out there with no one to love them like we all deserve.

Around the time of Shelly's passing, across the state, about ten hours' drive away from Sydney, a park ranger had stumbled upon a tiny two-kilogram ball of scruffy black dog scurrying around deep in the bushland, at least twenty kilometres away from the nearest town or home. Did someone dump this little scrapper? Was she left behind on a camping trip? Who knows? The ranger scooped up the fluffy mutt and took her into the country pound. Just like someone else we all know and love, there was no microchip found and no one came looking for

their lost dog. This little girl could not have been more than nine or ten months old. She might have been a Chihuahua mixed with terrier of some kind, but whatever she was, she was tiny.

The local rescue, Animal Welfare League North West branch, put a 'save' on this puppy and after her mandatory stint at the pound she was released into a wonderful and experienced foster home. Her foster mum was a long-time experienced foster carer with her own cult-like following of rescue fans on Facebook.

Fast forward two weeks and a lovely Sydney family spied this little rescue gem's adoption profile. Her personality description sounded somewhat like another little dog that not long ago had been a cherished family member at Life of Pikelet HQ. The young, scruffy pup was described as being an all-round well-adjusted, friendly, happy dog.

An adoption application submitted and a few lengthy phone interviews later, Ma packed up the car one Thursday morning and left the house, yelling out for us to all behave while she was gone – when she came back she would have someone for us to meet.

When Ma arrived at the airport she had butterflies in her belly. She had never ever adopted a dog without meeting them first. When the small plastic pet carrier was placed on the freight collections counter and after Ma scribbled her rushed signature on the docket, she nervously lifted down the precious container. Opening up the little metal door, she found two deep brown innocent eyes peering up at her. Reaching in and clasping her hands around the soft belly inside, Ma gently lifted out my new baby sister. With her eyes leaking Ma bent down and kissed her little head and whispered 'Welcome Blanche Foofoo, I love you already.'

♡ ♡ ♡

And now we really are all caught up. This, my friend, is the end.

Not the end of my story, oh no. Don't be silly!

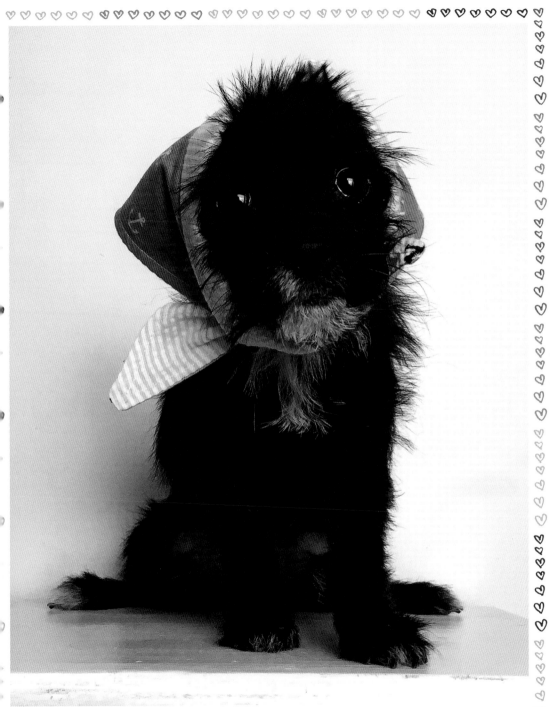

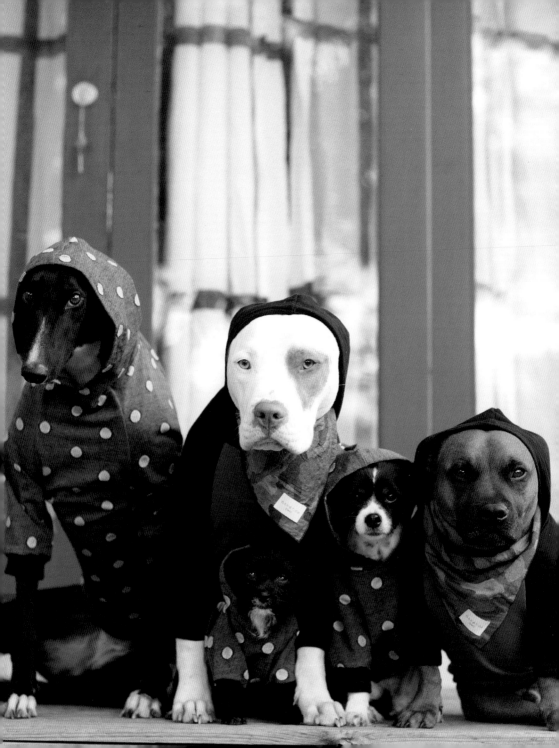

Gosh, I might be starting to grey around my chin. I may need extra naps on hot days and I may hand over a few more foster-bro duties to my protégé and younger brother Patty Cakes. But I, however, am far from done. I have my current foster sister Roy here, she's yet to start her adoption process and really needs a bit more instruction and tips from yours truly on how to dog.

Betty Boo and Blanche Foofoo have only just started knitting next year's sweaters, and are discussing forming a mahjong club with some other local Spinnies.

Ma and Pa are considering a second ex-racing foster greyhound to 'maybe' join us at HQ in the coming weeks (but when does 'maybe' ever really mean maybe around here?).

And I, Pikelet Butterwiggle Stoll, have some exciting plans of my own. I've always wondered what fostering one of those designer mutts they call 'goats' might be like ... I guess we will just have to wait and see what comes knocking at my door next.

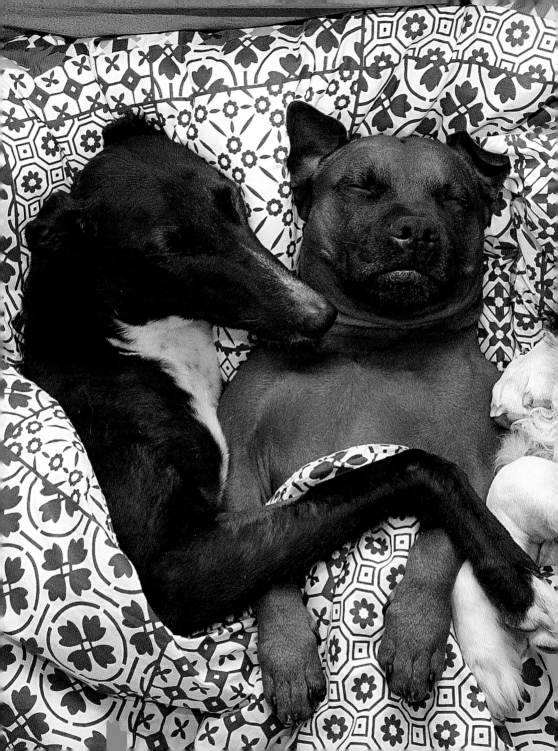

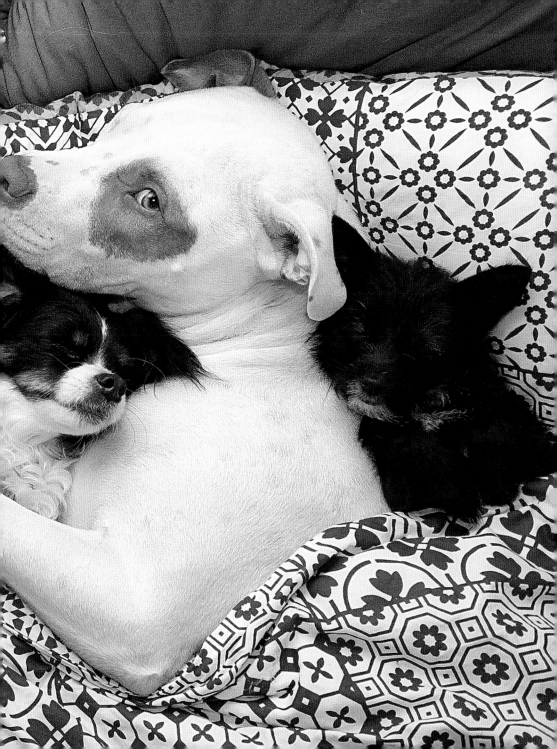

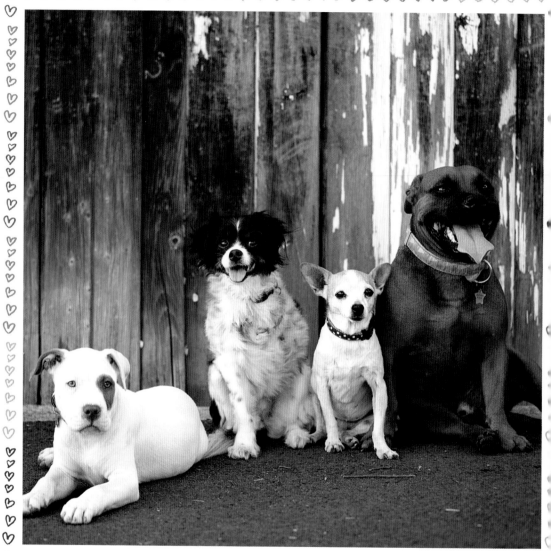

LIFE OF PIKELET

arvo	afternoon
Chi	Chihuahua
doghter	dog daughter
FDS	for duck's sake!
froyo	frozen yoghurt
the Gong	an abbreviation of 'Wollongong', a coastal city south of Sydney
Gotcha Day	the day your forever parents gone out and gotcha!
Jug	a crossbred dog of a Jack Russell terrier and a pug
live baiting	the practice of using live animals (such as rabbits, possums and piglets) as quarry to train racing greyhounds
mini-humans	human pups
obvs	obviously
ocker	archetypically Australian
–oodle	any crossbred dog of a poodle with a name ending in '–oodle' (i.e. labradoodle, schnoodle)
pawtograph	paw autograph
rainbow bridge	an otherworldly place to which a pet goes when it dies, to wait for the day when it is reunited with its owner. The name comes from a poem whose creator is unknown
rents	parents
sighthound	a breed of hound that traditionally hunted by sight rather than scent
staffy	Staffordshire terrier
stank-ass	stinky
staycay	like a vacay, but staying at home
Straya	Australia
tripaw	a pup with three legs or paws
U-ey	U-turn
vacay	vacation
WARN	Wollongong Animal Rescue Network
zorsted	exhausted

ACKNOWLEDGEMENTS

Rescue and charity organisations:

Big Dog Rescue, Wollongong Animal Rescue Network, Animal Welfare League Moree, RSPCA Sydney, Oscar's Law, Pet Rescue, Sydney Dogs and Cats Home, Monika's Doggie Rescue and WA Pet Project.

Businesses that have supported us along the way:

Aussie Dog Products, BarkPost, Battery Booster, Bayer, BeerDog Brewhouse, Biggles and Bailey, Bissell, BonéFide Collection, Bully Bundles, BuzzFeed, Canvas Collective, Clever Canines, Dawg Grillz, Dogue Balmain, Domayne, Doxies Down Under, Elna Kubur Photography, Fabric Pop Art, Fine Art Imaging, Furry Peach, FuzzYard, *Girlfriend* magazine, Haus of Harley, Hem Nine Nine, ID Pet, Imanii, Inner Sparkle Pets, *Inner West Courier*, Jo Lyons Photography, Joseph Lyddy, K9 Pawspective, Lexie And Lil, Love That Pet, Loyalty Pet Products, Lululemon Australia, Matt Blatt, Mini Minx and Mama, Mr Paw, My Pet Warehouse, Oboe & Piccolo, Olly's Box, Paws to Paper, Perth LifeCasting, Pet Haus, Pet Shop Girls, PetO Annandale, Red Cordial Kids, Rescue Strong, Rose-Hip Vital Canine, Rescue Your Fitness, Rosy the Pet Nanny, SavourLife, Shine for Dogs, Silly Buddy, Skipping Girl, Stella & Co, T&S Pet Products, Tail Wag, *Take Five* magazine, *The Australian*, The Balmain, The Dapper Yapper, The Dodo, The Dog Lovers Show, The Hanging Ladder Cafe, The London Balmain, The Riverview, The Workers Bar Balmain, Walks N' Wags Balmain, Wild Orange FroYo.

Our vet Doctor Nathan and his staff at Balmain Vet Hospital.

Special thanks to human aunts and uncles that have lent a paw to us and the animals in our care us over the years: Ali, Angie, Rosy, Andrea & Steve, Sandra, Kimmie & Fabio, Theresa & Mike, Irini & MJ, Jessie & Mitch, Kim & Michael, Melissa & Barn, Linda & Mark and the Chin-Nam family.

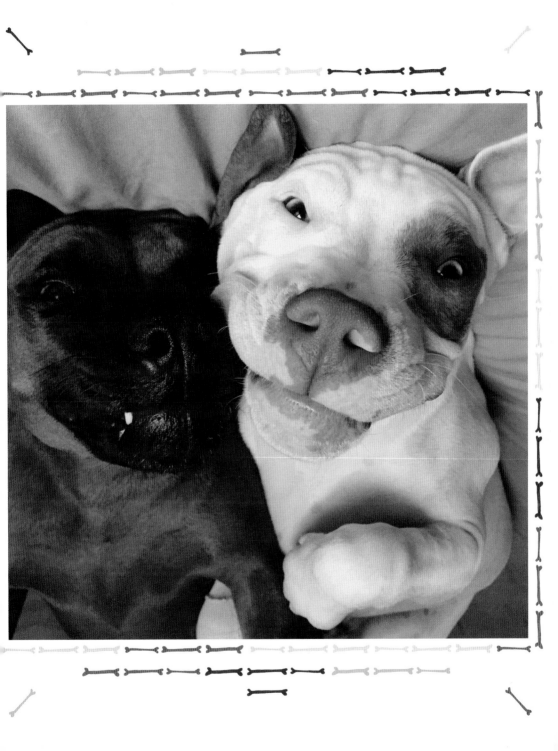

An Ebury Press book
Published by Penguin Random House Australia Pty Ltd
Level 3, 100 Pacific Highway, North Sydney NSW 2060
www.penguin.com.au

Penguin
Random House
Australia

First published by Ebury Press in 2017

Addresses for the Penguin Random House
group of companies can be found at
global.penguinrandomhouse.com/offices.

Cataloguing-in-Publication information is available
from the National Library of Australia
trove.nla.gov.au

Designed by Evi O. / OetomoNew
Illustrations by Rosie Whelan
Photography by Calley Gibson
Printed in China by Leo Paper Group

Penguin Random House Australia uses papers that are
natural, renewable and recyclable products and made
from wood grown in sustainable forests. The logging and
manufacturing processes are expected to conform to the
environmental regulations of the country of origin.

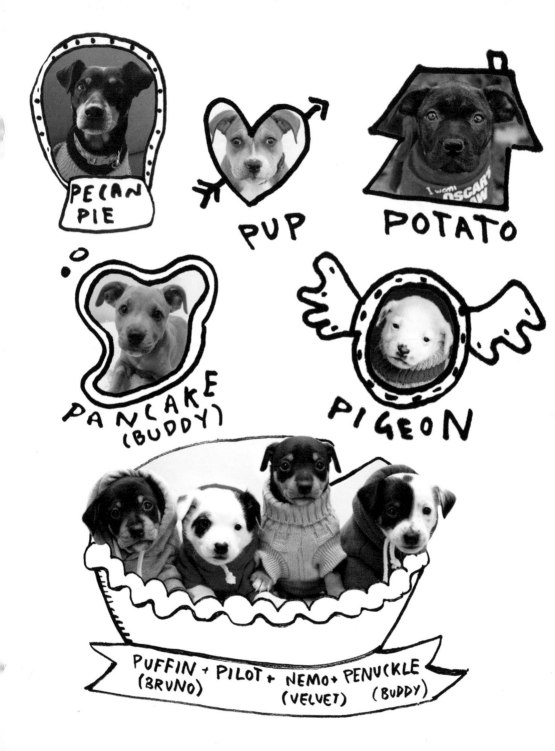

PECAN PIE

PUP

POTATO

PANCAKE
(BUDDY)

PIGEON

PUFFIN + PILOT + NEMO + PENUCKLE
(BRUNO) (VELVET) (BUDDY)